ANTIQUITIES

WHAT EVERYONE NEEDS TO KNOW®

ANTIQUITIES
WHAT EVERYONE NEEDS TO KNOW®

MAXWELL L. ANDERSON

OXFORD
UNIVERSITY PRESS

OXFORD
UNIVERSITY PRESS

Oxford University Press is a department of the University of Oxford.
It furthers the University's objective of excellence in research, scholarship,
and education by publishing worldwide. Oxford is a registered
trademark of Oxford University Press in
the UK and certain other countries.

"What Everyone Needs to Know" is a registered trademark of
Oxford University Press.

Published in the United States of America by Oxford University Press
198 Madison Avenue, New York, NY 10016, United States of America.

© Oxford University Press 2017

CIP data is on file at the Library of Congress
ISBN 978–0–19–061493–5 (pbk)
ISBN 978–0–19–061492–8 (hbk)

1 3 5 7 9 8 6 4 2

Paperback printed by LSC Communications, United States of America
Hardback printed by Bridgeport

To Chase and Devon

CONTENTS

3 Framing Today's Debate 34

4 The Cosmopolitan Argument 47

5 Divining Originals, Pastiches, and Forgeries 57

Part II: Settled Law and Open Questions

6 International Conventions and Treaties 73

7 National Laws and Statutes 85

8 Modern National Identities 95

9 Chance Finds, Excavation, and Looting 104

10 Acquiring Antiquities in the Marketplace 114

Part III: Scenarios and Solutions

11 Realities of Storage, Dispersal, and Display 127

12 Capturing Antiquity: Documentation 136

13 Replication of Ancient Objects 145

14 Retention, Restitution, and Repatriation 154

15 The Prospect of an Enlarged Legal Market 167

16 Evolving Perspectives on Ownership 172

17 Looking Ahead 180

ACKNOWLEDGMENTS

The call from Oxford University Press to undertake this book was a welcome surprise. Nearly forty years of studying and caring for public collections of ancient art should logically have equipped me to offer something useful. But the challenge of even-handedly assessing relevant issues in such an important, complex, and ever-changing field was not one I took lightly. While debates about ethics and practices with respect to collecting antiquities can quickly become heated and personal, I have done my best in the present book to be fair to divergent positions and refrain from impugning the motives of those with strongly held beliefs.

Antiquities: What Everyone Needs to Know does not pretend to be comprehensive or unbiased, since neither attribute could describe an enterprise so brief and of necessity colored by personal experience. It is instead offered up as a toolkit to help the reader develop informed opinions when confronted with information about the past—whether during a visit to a museum, monument, or archaeological site, while reading a news item, or upon encountering an archaeological artifact for sale.

As is the case with any publication demanding months of research and writing, the author is obligated to many people. My principal debt is to my family for allowing me to slip away and burrow into the project. Archaeologists, museum administrators, curators, conservators, legal experts, and dealers have

also enriched my appreciation of the divergent positions in this field, from undergraduate days to the present. Professor Matthew Wiencke at Dartmouth College cajoled me into applying to graduate school in ancient art. Harvard's inimitable Professor George M.A. Hanfmann was unfailingly encouraging as I pursued my PhD, reminding me when I was juggling research, writing, and teaching that "there are twenty-four hours in the day, and then there are the nights."

The Metropolitan Museum of Art's Dr. Dietrich von Bothmer gave me an office in the Department of Greek and Roman Art for ten years, throughout my passage from graduate student to curator. While I came to recognize that his swashbuckling methods of collecting were anachronistic, he generously extended to me and others a memorable and lasting scholarly platform. The Metropolitan Museum's peerless director Philippe de Montebello supported my evolution as a curator at every turn, and taught me much of what I took into a subsequent career as a museum director. The Metropolitan's General Counsel, Sharon Cott, has been an unflappable source of evenhanded wisdom for over two decades, as has Josh Knerly, general counsel to the Association of Art Museum Directors, and Susan Taylor, former president of the Association of Art Museum Directors and today director of the New Orleans Museum of Art.

My dear friend Professor Eugenio La Rocca, former director of the Capitoline Museums, and among the world's leading scholars of Greek and Roman art, introduced me to the key protagonists in Italy's archaeological establishment, helped see to my appointment as a visiting professor of Roman art at the University of Rome, and graciously opened doors at every turn, as did archaeologist Dr. Luisa Musso, his wife.

The expertise of Professor Stephen Urice was indispensable in my quest to represent accurately the legal landscape of antiquities, but I bear complete responsibility for any errors or omissions. One of his best students, Katherine Brennan, consented to take on the critical role of research assistant. Besides

researching references and importing footnotes, she was a first-rate reader and sounding board, and I owe her a great debt. She too is however blameless for any missteps made in the book.

My editor at Oxford University Press, Sarah Pirovitz, first approached me about this undertaking, and marched me ably through every sequence in its realization. A good editor is all that stands between a book's welcome reception and ignominy, and I thank her warmly.

May 2016
New York City

FOREWORD

Over three million shipwrecks are at rest on the ocean floor, many laden with priceless art treasures and artifacts from thousands of years ago; their fate is uncertain as the technology of underwater exploration improves. Back on land, museums ringing the Mediterranean, the Black Sea, and countless other bodies of water are crammed with unphotographed objects lacking scientific documentation. The legal case for a source country retaining all objects found within that nation's borders is clear. What's not so obvious is what is best for those objects. If extant museum basements are full, yet most of the ancient world is still underwater and underground—a good part of Pompeii awaits excavation—how will the resources be found to safeguard, document, and share the importance of tens of millions of as-yet-undiscovered artifacts?

The continuous terrestrial development and modernization of every nation reveals evidence of the remote past on a daily basis, much of it unreported and ending up in a black market of indeterminate size. Modern-day iconoclasts including the Taliban and Islamic State are destroying monuments or selling objects on the same illicit market. They are but the latest entrants into an ignoble history of looters that stretches back to ancient Egypt, including a range of actors from farmers to unscrupulous excavation guards to members of syndicates and organized crime families.

Today's wanton destruction of ancient monuments, tem-
ples, and other public buildings in Syria and Iraq strikes at the
very core of our humanity. Any lavishly made structure that
has stood reasonably intact for 2,000 years has been a backdrop
to the lives of countless millions over centuries. Its intentional
obliteration, born of a quest to conscript young people by eras-
ing their heritage and history, wipes away not only the evi-
dence of ingenious engineering and design talent. It also robs
us all of a touchstone of the human experiment's continuity.

This book is intended for any reader curious about the
world behind these dramatic headlines, including those who
might reasonably assume that antiquities pertain only to the
past. Everyone alive today is literally standing on top of layers
of history extending back to the Paleolithic era. Our contempo-
rary surroundings often reveal little or nothing about the past
beneath our feet. But that largely invisible past defines us—it
shapes the ways in which we live, work, and play, the values
we hold, and the ways our civilization will in time be judged.

The study of antiquities is as old as human history. But the
public's attraction to its study has ebbed and flowed over time,
and is stirred up by momentous discoveries like the Tomb of
Tutankhamun in 1922, or by tragedies like the current destruc-
tion of monuments and sites in the Middle East. There is no
agreement on what is to become of these objects in the fullness
of time. International waters are just that. Antiquities found by
chance or intentionally looted appear in fashionable galleries
without a passport or a ticket home, and these displaced arti-
facts circulate in a murky trade, the ill-gotten gains of count-
less and faceless protagonists.

Questions raised by chance discovery and intentional loot-
ing of the past are legion, as are questions about the policing of
amateur exploration, the efficacy of scientific state-sponsored
excavations, treasure laws rewarding metal-detector-bearing
individuals, national laws forbidding export of ancient objects,
and the creation and promulgation of public and private col-
lections of such material.

Tens of millions of people visit museums annually. These visitors spend countless hours examining objects both with a well-known history and those with very little. This book will equip museumgoers with a fuller understanding of the questions they should have when considering antiquities in any setting—in the modern nation where they were discovered, in the international galleries and auction houses where they may be offered for sale, and in the private residences and public museums where they often end up.

Readers of this book may have observed the volley of accusations and retorts about antiquities in the media, popular press, and previous books. However, they may have done so without a frame of reference to make their own judgments. *Antiquities* is intended to provide a reasoned summary of the fairest way to assess these controversies and the new ones that will inevitably arise.

Antiquities is divided into three sections. The first explores the fault lines between archaeologists and those seeking to own antiquities. The second offers a readable guide to the international treaties and national laws that govern the discovery and trade in antiquities. And the third section elucidates the likely fate awaiting works yet undiscovered and those that are the subject of study or of claims by others.

I strive to take a balanced and nuanced approach to the issues, assessing arguments on both sides of the debate, and providing insight into how these positions were formed. The primary objective of the book is to equip readers with what they need for an informed encounter with examples of ancient heritage and with those professionals who today devote their lives to the protection and enjoyment of our common past, and the last chapter forecasts potential approaches to caring for our archaeological heritage.

Part I
LEGAL AND PRACTICAL REALITIES

1

DEFINING ANTIQUITIES

What are the differences among antiquities, archaeological materials, and ancient art?

"Antiquities" are defined in the Oxford English Dictionary as the "remains or monuments of antiquity; ancient relics"; the first cited use is from the early sixteenth century.[1] This chapter will spell out how 'antiquity' may be reasonably defined in each of a number of distinct cultures. But we begin by dividing 'antiquities' into two separate but related categories: archaeological materials and ancient art.

How is archaeological material defined?

We'll start with a legally binding definition adopted by the United States. The Cultural Property Implementation Act (CPIA) was enacted by the U.S. Congress in 1982 to implement the 1970 UNESCO Convention on the Means of Prohibiting and Preventing the Illicit Import, Export and Transfer of Ownership of Cultural Property. In the language of the Act, the phrase "archaeological material" is defined as an object that "(I) is of cultural significance; (II) is at least two hundred and

1. The first recorded use of the phrase antiquities was in 1513 by Thomas More's *Hist. Edward V*: "The great care . . . that hath alwaies been observed . . . for the preservation of antiquities."

fifty years old; and (III) was normally discovered as a result of scientific excavation, clandestine or accidental digging, or exploration on land or under water."[2]

The CPIA's classification of the circumstances of discovery bears further consideration. Objects found through scientific inquiry are normally documented from the moment of their discovery.[3] Objects retrieved through scientific excavation are typically afforded the protection of state authorities, and are retrieved, documented, and stored by academic and museums officials within the source country, also known as the country of origin. That they may be subsequently stolen is the reason for their mention in the CPIA. Objects that come to light as a result of clandestine excavation or chance finds are also afforded protection by the Act.

How are scientifically excavated objects removed from under land or water?

Field archaeologists painstakingly record the discovery of virtually every single element of a professional excavation—even the humblest, mass-produced artifacts that are purely functional, bearing minimal or no decoration. The archaeologist makes on-the-spot decisions about the significance of finds, concentrating on those discoveries that may shed the most light on their context. The goal in recording evidence of the past is to speculate about the character and attributes of a human settlement, religious sanctuary, burial, place of assembly or commerce, shipwreck, or any other of a number of contexts revealed through excavation. Integral to the act of excavation is exploring features of the natural environment in which human activity took place, and surmising both the

2. "Convention on Cultural Property Implementation Act (CPIA) of 1983, 19 U.S.C. § 2601(2)(C)(i)(I)–(III)," 1983. https://eca.state.gov/files/bureau/97-446.pdf.
3. Peter Drewett, *Field Archaeology: An Introduction* (London: UCL, 1999), 31ff.

conditions original to a context as well as the factors over time that may have disrupted or altered the "findspot," or location of a discovery.[4]

The documentation accompanying each find normally begins with the context, consisting of geographical coordinates, followed by categorization and dimensions of finds; soil composition and attributes; the stratigraphy, or measurement of the layer below ground in which a find was made; drawings of sections (the vertical surfaces revealed) and plans (the horizontal surfaces); and photographs. The "finds record" describes those elements of a site that are removed; when 'special' finds are made, such as artifacts deemed deserving of further examination, they are separated from general finds that aren't initially presumed to warrant immediate attention. Special finds made of inorganic or water-resistant materials like limestone, marble, and fired ceramics are typically washed soon after excavation to prevent the hardening of deposits on them as a result of fresh exposure to the elements. Objects made of metal, wood, or other organic materials are best reserved for examination and treatment in a conservation laboratory. The finds are then identified with discreet but legible markings somewhere on the surface, typically including the site and context numbers.

Once all of the steps above are completed, a scientific excavation is followed by "finds analysis." In this phase, information

4. One of the best, and rarest, ways for archaeologists to obtain this sort of context information has happened when natural disasters suspend a civilization in time. The most famous examples are the archaeological sites of Pompeii and Herculaneum. However, more recently in September 2015, excavation began of a Late Bronze Age settlement in East Anglia, England. The site had been hurriedly abandoned during a fire between 1000 BC and 800 BC and perfectly preserved artifacts—including clothing, cooking equipment, and house structures—provide an invaluable snapshot of daily life in that community. See Alison Sheridan, "Unearthing the Secrets of East Anglia's Bronze Age Settlers." *Apollo Magazine*, January 26, 2016.

that can be gleaned either from the particular circumstances of discovery or from comparison with other similar or identical finds leads the archaeologist to offer interpretations about the typology, date, and function of an artifact. The consideration of a critical mass of artifacts removed from a findspot then leads the archaeologist to informed speculation about the context as a whole. The excavator then offers a plausible scenario of how the finds made their way to a context and what transpired there.

For a field archaeologist, the fact that an example of archaeological material may be 'precious' by virtue of its material, such as gold or silver, or because it happens to be ornate, poses a challenge. Its 'inherent' value may be obvious to even an uninformed observer. But unless the circumstances of its discovery are clear, its utility as a piece of the puzzle explaining the context may be inferior to an undecorated pot shard bearing an inscription. Archaeologists understandably tread carefully when confronted with ancient luxury goods, because the quest in excavation is not to find precious objects—it is to tell a complete story about the people who left traces of their life behind.

Accounts in popular culture, such as the Indiana Jones movie franchise, gloss over the painstaking practices of scientific excavation, and glamorize the discovery of baubles. These reenactments fuel an anti-scientific impulse, manifested across a spectrum of activities ranging from amateur excavation to looting. Thus the sensitivity of the archaeological community about the discovery of objects with an imputed high market value is completely understandable. Scientists obviously recoil at the possibility that the fruits of their rigorous, objective methodology could incentivize the intentional destruction of undisturbed sites in a search for treasure.

It is human nature for an archaeologist to recognize that a gold vessel found among plain pot fragments deserves particular attention and appreciation. But that doesn't countenance fetishization. Years ago at a conference of the Archaeological Institute of America, I heard the great underwater archaeologist

George Bass presenting recent finds from his excavation off the coast of Kusadasi, Turkey. As he clicked through slides showing finds, a gold vessel appeared on the screen. As an art historian—not a field archaeologist—my pulse quickened. But Professor Bass offered this object no more screen time than an assortment of shards from glass vessels. The audience of archaeologists evinced no trace of interest in the gold vessel greater than that accorded the glass fragments. Their emotional equanimity in the face of what was doubtless just as prized in antiquity as it is today revealed a great deal about how differently archaeologists and art historians view evidence of the past. For archeologists, finds are information indispensable in elucidating a context for human habitation. For art historians, some finds are more deserving of attention than others simply by virtue of rarity or quality of craftsmanship.

The contest for supremacy between these two points of view has led to a standoff that serves neither the scientific record of the past nor the public interest. It hinders agreement on a concerted, shared plan to disincentivize looting and interdict stolen artifacts. And it renders each constituency incredulous at the shortsightedness of the other.

Archaeological materials that see the light of day from clandestine looting, public works, private construction, and other circumstances will be considered in detail in chapter 8. But in summary, these are objects that were normally removed from an archaeological context with minimal or no accompanying trace of scientific evidence about their findspot or context. The spectrum of circumstances ranges from innocent discovery in the course of digging a building foundation, to the rapacious strip-mining of known sites in Syria and Iraq that we witness at the hands of multiple factions today.

How is ancient art defined?

For the purposes of this book, ancient artworks consist of objects created in antiquity that lack a known archaeological context

or setting. An example would be a Roman marble portrait in a museum display, which found its way into a collection without evidence of its discovery, and typically with a less than complete record of its past ownership history. It might be classified and dated by means of comparisons with other portrait heads discovered in a context including coins, inscriptions, or other precise means of assigning a date. But it comes down to us through history with no equivalent of a birth certificate or passport.

While archaeological materials normally end up in museum storerooms near their place of discovery or in a regional or national museum in their country of origin, ancient artworks can be found in almost any setting—a public museum, auction catalogue, gallery storefront, private collection, or on eBay. Objects separated from their ancient findspot may have appeared on the legal or illicit art market recently or in the distant past. They may have been part of centuries- or decades-old collections, or may have been 'deaccessioned' or officially removed from a collection for any of a variety of reasons.

Like archaeological materials, ancient artworks range from a level of extraordinary quality to utterly negligible significance. While mass production as we understand it today is automated or digital, yielding multiple or even unlimited examples of a given form, the precursor to mass production in antiquity involved molds yielding multiple casts or impressions that still required an artisan's touch to complete it. Such would be the case for bronzes cast from a mold, molten glass poured into a mold, terracotta vessels bearing stamped decoration, or struck coins requiring burnishing. But we may generalize that ancient artworks run the gamut from unique to commonplace.

That spectrum of rarity is connected with another characteristic distinguishing ancient artworks from the best-known category of archaeological materials—those that were scientifically excavated. Since archaeological materials excavated under state supervision cannot be sold legally in most countries, they technically have no fair market value. Ancient art, by contrast, is traded, and has a fair market value that contributes

to its continuous appreciation and protection from damage, neglect, or loss. The word 'art' attached to this category of antiquities implies that they are worth our contemplation. Their market value may run from hundreds to millions of dollars.

In the past, the market value of works of ancient art was indexed to, as suggested above, their degree of rarity and ornamental sophistication. Since the three-decade-old tightening of export controls, prosecution of those involved in illicit trade, and the advent of more stringent standards for proof of good title by museums, there has been a sea change in the art market's appraisal of ancient artworks. Those objects that have reliable evidence of ownership predating the 1970 UNESCO Convention on the Means of Prohibiting and Preventing the Illicit Import, Export and Transfer of Ownership of Cultural Property today have a significantly higher valuation, regardless of their intrinsic quality as artworks.[5] This is a salutary development in signaling to looters that objects without a verifiable and legitimate ownership history are worth much less in the market than those with such a trail. It is to be hoped that over time the stigmatization of antiquities lacking credible and documented history will discourage both looting and trade in illegally or accidentally discovered artifacts.

Are there accepted arbiters of these definitions?

Bundling these two categories—archaeological material and ancient art—into the larger category of 'antiquities' helps our

5. For the impact of the 1970 UNESCO Convention, see chapter 6. In December 2008, Sotheby's auctioned a small limestone figure of a lioness (the Guennol Lioness), for a record price of $57 million, even though presale estimates were only between $14–18 million. The lioness figurine, which was admittedly of high artistic quality, had been documented in numerous publications since its discovery in Iraq in 1931. See Neil Brodie, "Provenance and Price: Autoregulation of the Antiquities Market?" *European Journal on Criminal Policy and Research* 20, no. 4 (2014): 427–44.

inquiry, since sometimes objects can move from one category to another based on newly uncovered evidence. Such is the case with the upper half of a statue of Herakles, purchased by the Museum of Fine Arts of Boston in 1981. It entered the collection as a work of ancient art, without any awareness of the circumstances of its discovery. In 2011 the Museum restituted the sculpture to Turkish authorities after it was proven that it joined the bottom half of the statue, which had been excavated in 1980 in the South Bath complex at the site of Perge. Overnight it went from being a masterwork of ancient art to inheriting archaeological significance. The display in Boston simply identified it as one of a number of versions of the "Weary Herakles" derived from a lost original by the fourth-century BCE master sculptor Lysippos. But its identification as part of the excavations at Perge has yielded a more nuanced and complete understanding of the object. The statue figured in a sculptural ensemble adorning the long hall of a bath complex in Perge, accompanied by multiple statues of other Greek gods and heroes, commissioned by one Claudius Peison, whose name was inscribed on each. Instead of being a freestanding statue, it was part of an opulent dedication, attesting to the refinement and wealth of its donor, in a procession of figures connected with the practical function of the baths.[6]

There is no professional body dedicated to determining which of these two categories of antiquities a given object belongs to; that classification is not legally relevant. Categorization is nevertheless a practical necessity, since an object with archaeological context is more likely to be of material interest to potential claimants, including government agencies responsible for tracking down examples of heritage that belong to a given country. An ancient artwork may be harder to claim, since there may be no legally compelling or even circumstantial evidence that it was obtained illegally.

6. Elizabeth Marlowe, *Shaky Ground: Context, Connoisseurship and the History of Roman Art* (London: Bloomsbury Academic, 2013).

There is an understandable reluctance on the part of academics to parse the definitions of these interrelated categories too precisely. In general, the archaeological community finds the term "ancient art" to be unscientific, since "art" invokes a universal but completely elastic category of creativity.[7] To a scientist searching for signification from artifacts, the word 'art' is a problematic one, implying as it does an inherent virtuosity separate and apart from functionality. A museum curator might describe an ornate seventh-century BCE *fibula* as a work of art, whereas for an archaeologist, it is, however intricate, still just a forebear to today's safety pin.

The discipline of archaeology has a long history, and has been practiced in varying ways. In Europe, where it may be said to have been invented in the eighteenth century, it is a separate discipline born of early encounters with the legacy of Greek, Roman, Near Eastern, and Egyptian civilizations. Within the United States, archaeology is normally considered to be one branch of anthropology—the other three being cultural anthropology, physical anthropology, and linguistics. More broadly, the field is practiced by scientists focused on prehistoric, historical, classical, and industrial archaeology.

Museum professionals are keen to arrive at clear definitions, since within the larger rubric of 'antiquities' they would normally find archaeological materials to be ineligible for acquisition by gift, bequest, purchase, or transfer. By its very nature, an archaeological object once pertained to a particular site or findspot, and new evidence might eventually come to light that could prompt a claim by a state party. Thus for museums still acquiring antiquities, the evidentiary standard is ever higher, and responsible museum directors and trustees are increasingly reluctant to acquire objects that may later invite scrutiny, claims, or restitution, at times accompanied by

7. Alexandra Perloff-Giles, "Artifacts Take Their Rightful Place as Art." *The Harvard Crimson*, March 30, 2010.

legal bills, reputational harm, and a loss of funds expended to purchase, conserve, publish, and display a given work.

How have these definitions changed over time?

As early as the Greek historian Herodotus (c. 484–c. 425 BC) there have long been inquiries into the art and archaeology of the past. His set of nine books titled *The Histories* provides the first known written accounts of ancient cultures.

The ancient Romans identified their Greek forebears as ancient. Livy (64/59 BC–AD 17) wrote negatively about the triumph of Gnaeus Manlius in 187 BC, which introduced to Rome a large array of luxury goods from Asia Minor, or modern Turkey.[8] For Livy, this influx of Greek art contributed to a decline in the moral integrity of Republican Rome.[9] While lamentations about art's damaging influence on social order continue to this day, it is clear that for Livy and later Roman authors who wrote about art of the Greek world, veneration of the art of antiquity was a powerful force in contemporary society.

Archaeology as a discipline began in earnest during the Enlightenment in the eighteenth century. Its evolution toward a more scientific line of inquiry throughout the nineteenth and twentieth centuries led to nuanced demarcations of the function, style, and dating of ancient objects, and indeed to

8. Livy, Liv. 39, *Ab Urbe Condita* (*The History of Rome*) chapters 6 and 7.
9. "[3] The better and the happier becomes the fortune of our common-wealth day by day and the greater the empire grows —and already we have crossed into Greece and Asia, places filled with all the al-lurements of vice, and we are handling the treasures of kings —the more I fear that these things will capture us rather than we them. [4] Tokens of danger, believe me, were those statues' which were brought to this city from Syracuse. Altogether too many people do I hear praising the baubles of Corinth and Athens and laughing at the fictile antefixes of our Roman gods." Liv. 34, *Ab Urbe Condita* (*The History of Rome*), chapter 4, Sections 3–4.

divergent opinions about the definition of art as a category separate and apart from the entire material inheritance of the past.[10]

But the trend to classify ancient artworks separately from archaeological materials is a recent one, precipitated by increased attention to national patrimony claims and the legal battles that have followed. At the close of this chapter we will grapple with the dividing line between antiquity and the period(s) that followed it across multiple cultures, typically described as medieval.

How do different countries define antiquities?

There are great differences of opinion among countries in how best to describe their cultural inheritance. We will review the current positions in chapter 6 when considering treaties, laws, and statutes. For now, let us say that such definitions are largely political in nature, rather than grounded in scientific inquiry.

What are the differences among countries, nations, and 'state parties'?

The terms are often used interchangeably, which can lead to confusion. *Country* is the most informal locution, which is loosely used to describe a nation as an historical construct without regard to its exact current borders. *Nation-state* is an antiquated locution denoting a country in which the population is from a single ethnic stock, cohabitating with a shared cultural identity.[11] *Nation* is the most commonly used term to define a contemporary country. And *state party* is a diplomatic

10. Michael Squire, "Conceptualizing the (Visual) 'Arts,'" in *A Companion to Ancient Aesthetics*, eds. Pierre Destrée and Penelope Murray, 308ff. New York: John Wiley & Sons, 2015.
11. "Nation-State," United Nations Educational, Scientific and Cultural Organization.

term to refer to a nation that has agreed to be party to a treaty or international agreement.

How do scholars define antiquity differently from culture to culture?

While national interests dictate hard and fast 'bright lines' defining the date after which an object is determined to have left its country of origin illegally, that is not synonymous with a definition of antiquity. The challenge is that most modern nations under whose land and water lie remnants of the past are not focused on arriving at a date with a scholarly explanation. They instead take the position that more important than specifying the date of inception of a post-ancient era is the protection of cultural heritage. As a result, the dates that are the focus of most countries have little to do with clarifying relevant historical periods, and everything to do with prohibiting the outward flow of cultural property that they consider their patrimony.

Scholars have long grappled with a definition of the end of antiquity.[12] But the majority of interested parties are content to leave definitions of the end of antiquity in a given culture or civilization to the modern nation resting above its remains. For our purposes, it is useful to clarify when antiquity may be said to have ended in each major culture from the past. Every ancient civilization developed at its own pace, and underwent changes from without or within that led it to break with what we commonly define as antiquity. There is no universally agreed-upon moment when Chinese culture ceased being ancient. But without our putting a stake in the ground—subject to debate and disagreement—any attempt to define

12. Redha Attoui, ed. *When Did Antiquity End? Archaeological Case Studies in Three Continents: The Proceedings of an International Seminar Held at the University of Trento on April 29–30, 2005 on Late Antique Societies, Religion, Pottery and Trade in Germanica, Northern Africa, Greece, and Asia Minor* (Oxford: Archaeopress, 2011).

fair approaches to cultural heritage in circulation will have no point of departure.

We are better off not relying on a politically motivated approach, detached as it is from a scholarly consensus on the end of antiquity and the onset of what might typically be described as a medieval period. Instead, we may turn to the perspective put forward by the Task Force on Archaeological Materials and Ancient Art of the Association of Art Museum Directors (AAMD), the leading professional organization of North American art museums.[13] In 2014 the Task Force sought clarification about how leading institutions choose to define the 'end' of antiquity in order to know what belongs on an object registry of unprovenanced objects acquired by museums, and what would fall outside of its purview.[14]

Gleaned from surveying experts at eight leading museums and universities across North America, the dates proposed below provide a framework from which our inquiry begins. While reasonable people will disagree about any or all dates, the AAMD survey has the benefit of informed inquiry, uninflected by any motivation to move the goalpost closer to the present out of self-interest. The cultures in question are those specific to Egypt, the Ancient Near East, Greece and Rome, China, Japan, Korea, Southeast Asia, India, and the Americas.

Egyptian Art

Egypt's artistic heritage reaches back to the fourth millennium BC with ceramic objects surviving in pristine condition. Of the cultures in question, there is the most disagreement

13. Task Force on Archaeological Material and Ancient Art, "Memorandum to Members of the Association of Art Museum Directors: Definition of 'In Antiquity.' " July 31, 2015.
14. Association of Art Museum Directors, "Strengthened Guidelines on the Acquisition of Archaeological Material and Ancient Art Issued by Association of Art Museum Directors." January 30, 2013.

as to the end of Egypt's artistic heritage. Among the seven dates proposed for the end point of what we would commonly describe as antiquity, three curators proposed the Muslim conquest of Egypt, in AD 641, one cited the Edict of Milan, in 313, and another cited the Sack of Rome, in 476. One curator invoked the end of the Roman Empire and the establishment of the new Byzantine Empire under Justinian in 527.

Ancient Near Eastern Art

For six out of seven museums, the consensus regarding the end of antiquity in the Near East was the advent of Islam. That said, four different dates were proposed: 622, the date that Muhammad and his followers set out to Medina from Mecca; 644, the end of the Sasanian era and the beginning of the Arab invasions; and two museums proposed 651 and one proposed 700 as the dates of the real advent of Islam.

Greek and Roman Art

Most curators relied on one historical event as representing the end of antiquity and the beginning of the medieval period: the Sack of Rome in 476. One proposed an earlier date—the Edict of Milan, in 313. Another museum proposed a round date of 500 BC as the time by which the western empire could be said to have fallen.

Chinese Art

Chinese history is well documented, and offers clearly defined choices for the end of antiquity. Three museums focused on the end of the Han Dynasty, in 220. Two museums relied on the beginning of the first unified empire under the Qin Dynasty, in 22 BC. Two others posited that the Tang Dynasty ruled during the first post-ancient period, founded in 618, while two others cited its end, in 907.

Japanese Art

For five of the seven museums responding, the Nara Period ushered in a more modern period at its beginning in 701. Within the Nara Period, argued two museums, the establishment of its capital in 710 was fundamental, while one argued for an earlier date, 645, marking the passage of the Taihō reforms and the establishment of a central authority and legal system. A single museum proposed 1185, when the majority of periodization systems were launched, inaugurating the medieval Chusei era.

Korean Art

The unification of the Korean peninsula under a single rule represented for most museums the end of antiquity. More specifically, two museums relied on the beginning of the Silla Period in 668 as a watershed year, while two others cited the full unification of Korea upon the expulsion of the Tang Dynasty in 676. One museum proposed the establishment of the new state of Goryeo in 918.

Indian (South Asian) Art

For most museums, the Gupta period was the dividing line between antiquity and a medieval period. Three proposed the beginning of that period, in 320. Three others cited the end of the Gupta period, two proposing the beginning of its disintegration in 500, or the late sixth century. One museum saw the Muslim invasions of the twelfth century as the critical juncture.

Southeast Asian Art

For three museums, the beginning of the Angkorian period (800 or 802) offered a definitive date. One turned to 500, when historical records began. One cited the end of the twelfth century, which is defined as the post-Classical era. Another cited the end of the Khmer empire in 1462, while another offered

more specificity, proposing Cambodia's *terminus post quem* as the beginning of the Khmer empire in 802, Vietnam with unification under the Ly Dynasty in 1009, Laos with the beginning of the Lan Xang Kingdom in 1353, and Thailand with the beginning of the Chakri Dynasty in 782.

Art of the Americas

For every museum surveyed, the European conquest of the Americas represented the end of antiquity. But within that rubric, varying dates were proposed. For four museums, the beginning of the Conquest period, in 1492, was the right demarcation point. Others proposed the time by which Europeans were exercising substantial control of the New World, at the beginning of the Colonial period, defined as 1550, or alternatively 1532.

2

CULTURAL OWNERSHIP

PAST AND PRESENT

Did people collect in antiquity?

In 2014, new scientific findings revealed that the world's earliest evidence of human creativity was not, as previously thought, in Europe, but on the wall of a cave in Sulawesi, Indonesia, dating back 40,000 years ago.[1] This discovery moves the earliest recorded instance of creativity back at least 2,000 years earlier than comparable cave paintings in Europe. The earliest known example of figurative art is the 40,000-year-old carved ivory *Löwenmensch* figurine, or Lion man, of the Hohlenstein Stadel, discovered in a German cave in 1939.

This figurine, together with surviving drawings on cave walls and ceilings in Asia and Europe, reflects an early human impulse to use visual representation to represent and communicate. The accumulation of such representations in prehistory constitutes not only the earliest known instances of what we today call art, but also of the act of collecting.

As would seem natural to hunter-gatherers, our species has never stopped accumulating acts of creativity. From prehistory to recorded history, our ancestors surrounded themselves with hand-crafted objects and decorative programs

1. M. Aubert, A. Brumm, and M. Ramli, et al., "Pleistocene Cave Art from Sulawesi, Indonesia." *Nature* 514, no. 7521 (October 9, 2014): 223.

on the surfaces of built environments, ranging from humble dwellings to palace complexes, temples, sepulchers, and every other known context. Often as not, public settings were replete with a combination of the indigenous artistic achievements of their civilization alongside war booty seized from vanquished enemies.

The greatest civilizations of the Old World spanned millennia and thousands of miles. Egypt, Assyria, Greece, Persia, China, and other dynastic centers were the wellspring of court-inspired creativity that filtered down to every segment of society, and individual creativity that filtered up to the courts. True collecting of ancient art as we think of it today, as distinct from highly centralized royal or imperial conquests, may fairly be said to have begun as the Greek world began to assimilate indigenous traditions as a result of expansion and absorption of city-states from far-flung regions as far west as Italy, to Egypt in the south, to India in the east.

Collecting art is one instinct that has endured throughout history. A more recent instinct is to do whatever possible to ensure that what is presented today approximates to the greatest degree possible the original intention of the artist. The tendency to renovate and reconstruct artistic environments rather than preserve a fragmentary or partial inheritance from the past has bedeviled cultural observers for centuries. The clumsy reinvention of the Palace of Minos in Knossos on the island of Crete is one example of this instinct; another is recent repainting and remaking of historical elements of the Forbidden City in Beijing.[2]

During the Hellenistic age and the reign of Alexander the Great, the famous Library of Alexandria stood as a testament

2. More recently, India's department of archaeology has come under scrutiny for its reconstruction of Buddhist heritage sites in Thotlakonda and Bavikonda due to its choice to restore the structures using new bricks rather than integrating original materials found at the excavation site. Mehta, "Heritage Lovers Question Mode of Renovation of Buddhist Sites." *The Times of India*, March 22, 2016.

to the continued erudition of the Greek tradition, and fidelity to the intentions of ancient cultures. Built in the third century BCE and standing until the Roman conquest of Egypt in 30 BC, it was a project of Alexander the Great's (356 BC – 323 BC) successor, the Macedonian general Ptolemy I Oster (c. 367 BC – c. 283 BC). While there was ample ransacking of conquered territories and consequent accumulation of treasures from afar, we have no concrete evidence of the creation of an art collection within the Library during this period.[3]

There were, however, known to be royal collections formed during the Hellenistic age, notably by the Attalid Dynasty in Pergamon, located on the Western Coast of Asia Minor, today Turkey. The example of the Pergamene court had a profound impact on the Roman general Gnaeus Pompeius Magnus, more colloquially known as Pompey the Great (106–48 BC), who had an outsized influence on taste during the later years of the Roman Republic (509–27 BC). His visits to the Pergamene courts were followed in Rome by collecting on a grand scale, belying the assumption that men of the time were all grim-faced, practical, and eschewed luxury. Instead, many well-known protagonists in the worlds of politics, letters, and commerce—including Luculus, Gaius Verres, and Julius Caesar—devoted vast sums to creating collections attesting to their erudition and worldliness.[4]

With the victory by Octavian over Julius Caesar and Cleopatra, the Roman Empire was born, and Octavian was renamed Emperor Augustus. His reign from 27 BC to AD 14 ushered in a period of artistic magnificence that resonates to the present day. Public monuments commissioned by Augustus and his circle within the imperial court remade the Empire's capital; the author Suetonius quotes the emperor as

3. Jerome Pollitt, *Art in the Hellenistic Age* (New York: Cambridge University Press, 1986), 131.
4. Maia Gahtan and Donatella Pegazzano, *Museum Archetypes and Collecting in the Ancient World* (Boston: Brill, 2014), 11.

saying "I found Rome a city of brick and I leave it to you in marble."[5] That was no idle boast; the massive reconstruction of every part of the city, from its heart in the Roman Forum and Imperial Forum to sanctuaries like the Ara Pacis, the Mausoleum of Augustus, and countless other monuments involved massive architectural and sculptural commissions, drawing heavily from the artistic precedents of the Pergamene tradition of the Hellenistic period. Augustus and his friend and ally Marcus Agrippa, who oversaw the construction of the original Pantheon, introduced a new visual language blending contemporary political narratives with allusions to the Trojan Empire, a mythical antecedent to Augustus's claim to the throne.

The emperors who followed Augustus added to his legacy, with continuous elaboration of public spaces, and the concurrent development of private collections. Most notably emperors Nero (reigned AD 54–68) and Hadrian (reigned AD 117–138) commissioned enormous palace complexes, in the heart of Rome and at Tivoli, respectively, spawning sizable artists' workshops and decorative programs that undertook palatial construction projects comparable to the extravagant expanse of the court of Louis XIV in late-seventeenth-century Versailles. Hadrian was known as a 'philhellene,' or Greek-loving aesthete, who avidly embraced the ancient artistic heritage of Egypt and Greece. In many ways, Hadrian's collecting instincts helped codify our enduring understanding of Greek art, and had a profound influence on how classicizing tendencies continue to inform the built and decorated environment in both the developing and developed worlds.[6]

5. Carlos A. Picón and Seán Hemingway, *Pergamon and the Hellenistic Kingdoms of the Ancient World* (New Haven, CT: Yale University Press, 2016).
6. Elise A. Friedland, Melanie Grunow Sobocinski, and Elaine K. Gazda, *The Oxford Handbook of Roman Sculpture* (New York: Oxford University Press, 2015), 633–634.

Roman emperors augmented the artistic legacy of the Empire right through the first quarter of the third century BC, during the reign of the Severan Dynasty. The empire reached its greatest geographical extent in AD 117, during the reign of the Spanish-born emperor Trajan. The extensive border began to be tested by various insurrections and incursions during the Antonine (AD 138–193) and Severan (AD 193–235) Dynasties. During the Era of the Soldier-Emperors (AD 235–284), emperors sported crew cuts suited to donning helmets in a hurry—with limited time for art collecting and no time for reveries about the great legacy of the Greek past.

The Middle Ages that followed the end of the Roman Empire were as fertile an artistic period as any, but to a substantial extent within the confines of cathedrals and monastic retreats. Major public works were undertaken by successive rulers, but the arts of what could now fairly be described as antiquity were as often melted down for reuse in liturgical objects as appreciated for their original merits. Pagan art, as the art of antiquity would come to be known, was seen by many theologians in a negative light—and by many others as prefiguring the evangelization of symbolism, with classical images of the Good Shepherd appropriated for allegorical representations of Christ.[7]

While it would be oversimplifying the character of a period extending many centuries across the whole of Europe and the Eastern Empire to suggest that antiquities were as often suppressed as celebrated, it is the case that a new and vigorous commitment to creating new visual languages in celebration of Christian doctrine rendered many typologies of Greek and Roman antiquities obsolete or blasphemous.

There are notable exceptions to this generalization. An equestrian statue of Emperor Marcus Aurelius stood for

7. Michael Greehalgh, *Survival of Roman Antiquities in the Middle Ages.* 1st ed. (London: Duckworth, 1989).

centuries in the center of Rome's Piazza di Campidoglio, a sublime architectural setting designed by Michelangelo. The statue had survived the Middle Ages without being melted down because it was mistakenly identified as Constantine the Great, the first Christian emperor.[8]

Medieval architectural ensembles frequently repurposed not only the decorative ingredients of classical monuments, such as columns, vegetal friezes, and intact slabs of colored marble, but also ancient sculptures. The façade of the Basilica of San Marco in Venice incorporates four life-size gilded bronze statues of horses dating to the early Hellenistic period (4th or 3rd centuries BC). The previous setting for these horses was most likely the Hippodrome of Constantinople, in modern-day Istanbul. A reference from the eighth or ninth century AD alludes to four gilt horses displayed at the Hippodrome, or horse and chariot race track, that were moved during the reign of Theodosius II (AD 401–450) from their original display on a Hellenistic monument erected on the Greek island of Chios.[9]

The horses were looted by the Venetian Republic in 1204, during the sack of the Byzantine Empire's capital, and ultimately installed on the façade of San Marco in 1254. In 1797, during the reign of Napoleon, the horses were carted off to Paris to be placed atop the Arc de Triomphe with a modern replica of a four-horse chariot, or *quadriga*. They were returned to San Marco in 1815, where they stood until the early 1980s, when replicas replaced them to protect the originals from pollution. Today they stand inside the Cathedral in a protected microclimate.[10]

8. John Baskett, *The Horse in Art* (New Haven, CT: Yale University Press, 2006).
9. Averil Cameron and Judith Herrin, *Constantinople in the Early Eighth Century: The Parastaseis Syntomoi Chronikai: Introduction, Translation, and Commentary* (Leiden, The Netherlands: E.J. Brill, 1984), ch. 84.
10. Charles Freeman, *The Horses of St. Mark's: A Story of Triumph in Byzantium, Paris, and Venice* (New York: Overlook, 2010).

The odyssey of the Horses of San Marco from the early Middle Ages onwards confirms their continuous appreciation over the course of two millennia. Since they depict animals venerated throughout human history, rather than pagan gods, they were spared destruction.

The Italian Renaissance marked a reversal of fortune for the legacy of antiquity, eventually affecting the outlook of all of Western Europe. A renewed appreciation of the formal properties of antiquities overcame earlier misgivings about Christian doctrine, and the flowering of Italian creativity spread to nearby arts centers in Central and Northern Europe, and by means of trade routes, across the entire span of Western civilization.

Noble families in the courts of Italian city-states promulgated workshops of artists working in every medium, in many cases reusing, repurposing, copying, or evoking the character of excavated or publicly displayed Greek and Roman artistic output. French monarchs and nobility were swift to follow, along with courts in Spain, England, and Scandinavia.[11] Collections of antiquities began to move across countries to be mixed with and adapted to ambitious building and decorative programs across all of Europe. The opening of the royal art collections in the Palais du Louvre in 1681 represented a watershed in the presentation of classical art to mass audiences—and the beginning of a wholesale change in public taste embracing the classical past as the basis for a common visual language as unifying as the Latin language had been for centuries. The opening of the Uffizi Gallery in Florence in 1765 had a similar impact on the public visiting central Italy, and henceforth any educated person was expected to have made a pilgrimage to it during a Grand Tour, the prerequisite of a cultural education in nineteenth-century Europe.

11. N. Brodie, "Uncovering the Antiquities Market," in *The Oxford Handbook of Public Archaeology*, eds. R. Skeates, C. McDavid, and J. Carman, 230–252. Oxford: Oxford University Press, 2012.

Organized campaigns to explore ancient sites filled with artifacts began in the eighteenth century, and served to stimulate collecting and further exploration. These excavations yielded findings that became *de rigueur* features of royal and noble residences and homes of the well-to-do. These residences over time were shared with expanding circles of viewers, starting with invited guests—but today some of Europe's most visited cultural destinations are the palaces once accessible only to the few.

The collecting of ancient art spread from royalty and nobility to those scoring success as industrialists in the course of the nineteenth century, particularly in the western hemisphere. Runners were dispatched in search of suitable examples of ancient artworks to fill the new baronial homes of well-to-do Americans. Among these was J.P. Morgan, whose acquisitiveness was so pronounced that he was among the founders of the Metropolitan Museum of Art in 1870 once it became clear that even he could not accommodate the architectural elements, marble statues, relief sculptures, portraits, and other examples of Greek and Roman art being shipped across the Atlantic. Andrew Mellon, Henry Clay Frick, and other leading lights of New York society were soon joined by Bostonian collectors, whose enormous appetites similarly led to the founding of the Museum of Fine Arts that same year.

These two leading cities cemented a uniquely American phenomenon: individuals accumulating private collections of ancient art and simultaneously supporting the creation of major public collections. The practice spread rapidly across the United States, with the founding of multiple "encyclopedic" or general art museums with collections encompassing the whole history of art, from the Cleveland Museum of Art to the Art Institute of Chicago. In each instance the playbook was similar, with private collectors coming together to found public museums, and a market being fostered in the process. Purchasing agents like John Marshall spent their time in Europe sourcing

and securing works for private and public acquisitors. In the decades after the formation of the great encyclopedic museums came the formation of multiple museums rich in collections of antiquities, most notably the J. Paul Getty Museum in California, which opened to the public in 1974 within a recreation of ancient Herculaneum's Villa dei Papiri.

The encyclopedic model was not replicated outside the United States in the nineteenth or twentieth centuries. And the venerable European tradition of imperial, royal, and noble collecting in encyclopedic museums was unique to the Continent. Such was not the case in Asia, Africa, or South America, in which the collections built by imperial orders often dissipated upon the marking of any dynastic succession.

Notable exceptions were the founding of the National Palace Museum in Taiwan in 1925, the Palace Museum in Beijing in 1925, and the Topkapı Palace in Istanbul, Turkey, in 1924. These major repositories of ancient art each had different sources. What they had in common was an appetite to preserve the heritage handed down to them—and in each instance these remain significant institutions and collections of abiding interest to local audiences and tourists.

The Japanese relied on monastic collections making their way to public institutions such as the Tokyo National Museum. In Southeast Asia, the Bangkok National Museum devolved from the Siamese king Mongkut, while in Phnom Penh, the author and curator George Groslier (1887–1945) successfully promoted a plan for the National Museum of Cambodia, which is home to a major collection of Khmer antiquities.

In the Middle East and North Africa, we turn to larger collections that reflect interest in their indigenous cultures. Such is the case with the Egyptian Museum in Cairo, established in 1835. To this day it remains a core repository of the ancient heritage of Egypt, appreciated both by Egyptians and foreigners alike. Napoleon's earlier conquest of Egypt and the resulting deposit of his spoils in the Louvre was one of many examples of

the appropriation of collections by European powers through-
out the nineteenth century, which warrant discussion later
in this book. These displaced artifacts are today the subjects
of intense interest, both in what they can tell us about life in
antiquity, and in how much has changed in the norms of col-
lecting. Regardless of how massive the Louvre's collections
of Egyptian art may be, even Napoleon barely scratched the
surface of Egypt's vast legacy, much of which remains undis-
covered in the vicinity of the 4,258-mile-long Nile River and its
Delta on the Mediterranean coast.

How did artifacts move across cultures in the ancient world?

Conquest and trade were the twin forces leading to the wide-
spread circulation of artifacts in antiquity and beyond. The
intermingling of artistic traditions as a result of both phe-
nomena is among the most fascinating features of the history
of art. To cite only a few, the heritage of the Ancient Near East
greatly influenced Greek civilization; the Roman tradition
was beholden to Greek antecedents; the Gandharan monu-
ments of India owed much to exposure to late Hellenistic
and Roman sculptural traditions; and the arts of China,
Japan, and Korea were intertwined through typological and
stylistic precedents. Much later, art in the South American
colonies of Spain and Portugal reflected the dominance of the
Catholic faith comingled with indigenous traditions, and
the nineteenth-century arts of sub-Saharan Africa adopted
the iconography of European popular culture, from top hats
to carbines. In almost every one of these instances, collec-
tions of imported artworks and artifacts coexisted with local
artistic traditions.

A large factor in the challenges attendant to sorting out the
ownership of cultural heritage in our very porous world is the
time-honored absorption and appropriation of artistic tradi-
tions across cultural 'boundaries.' Today's political definitions

of nationhood, tied not to dynastic authority and inheritance but to parliamentary or democratic conventions, will be the subject of analysis later in this book.

When did ancient cultures turn into modern ones?

Each cultural tradition has its own story in this regard. There was rarely a clean demarcation between antiquity and modernity. As reviewed in chapter 1, even the end of antiquity in each civilization can be endlessly debated. As to the emergence of a *modern* culture, there is a broad understanding among the member countries in the United Nations that the watershed of self-determination as a free-standing political entity is a convenient dividing line. Even in those nations that continue to recognize imperial authority, most notably nations in the British Commonwealth, the provision of autonomous political functions, self-government, and a separation of nominal authority from actual political independence make for a hybrid existence. Honoring the heritage of the past while affirming freedoms attendant to modern self-determination requires a constant juggling of past and present values. For those newer state parties eschewing an imperial or colonial past, the example of Commonwealth nations ringing the globe from Australia to Gibraltar to Canada may be seen as archaic. But for the citizens of modern nations still connected with the British Crown, there is a healthy division of opinion about both the virtues and the practical value of honoring past traditions.[12] The pursuit of new solutions to tugs-of-war between those claiming cultural artifacts and those defending their possession must be built on an acknowledgment of the

12. A recent example has been the debate as to whether Scotland, if it votes for independence from the United Kingdom, would still recognize the British Royal Family. See Webber, "Scottish Independence: What Will Happen to the Queen?" *BBC News*, September 11, 2014.

modern right to self-determination balanced with a quest for the free circulation of heritage for educational purposes.

Who gets to decide whether an artwork has 'repose'— or a permanent claim to stay in its current place?

The concept of repose—or the cessation of a legitimate claim to cultural heritage after a long period of possession—is fraught with challenges. Many modern nations today reject the premise that simply because a monument, collection, or artifact left its country of modern discovery long ago, the current possessor should be entitled to hold onto it.[13]

The body of legal literature addressing repose is vast—and contradictory.[14] And in the end, while there are court cases that have addressed and in the future will confront claims, the fair adjudication of what is a legitimate claim to cultural heritage will always be particular to the body of work in question. When, in 1984, the British Museum provisionally agreed to a permanent loan of part of the beard of the Great Sphinx to Egypt, many observers questioned why this fragment was more deserving of return than the Museum's Rosetta Stone, the bust of Nefertiti in Berlin, or any number of other more noteworthy artifacts of ancient Egypt still embedded in public collections across the Western world.[15] There is no simple answer to the question of what objects should be exempt from claims of repose. But in time each instance of claims and counter claims will continue to be evaluated on its own particular merits.

13. For a detailed discussion of the proposed—and ultimately rejected— Cultural Property Repose Act, see James A. R. Nafziger, "Repose Legislation: A Threat to the Protection of the World." *California Western International Law Journal* 17, no. 1 (1987): 250–265.
14. Ellen Herscher, "The Antiquities Market." *Journal of Field Archaeology* 14, no. 2 (1987): 213–223.
15. However, this portion of the Sphinx of Giza's beard is still on display at the British Museum.

What happens to cultural ownership when governments or regimes change?

In general international treaties discourage efforts to impose retroactive changes to ownership laws. It is broadly accepted that a 'bright line' once drawn and subsequently erased in favor of an earlier one cannot compel the return of artifacts already exported from the country of origin. That said, multiple countries have moved the goalposts back in recent years, citing ever-earlier proscriptions against the export of cultural goods.[16] Controversy typically arises only when such retroactive changes are invoked to pursue objects that have already crossed the modern boundaries of countries. Changing the rules in the middle of a game is rarely accepted. And while the fate of antiquities is no game, most courts will find it unreasonable to run roughshod over legal precedent in a way that would compromise the integrity of modern national collections. There is little prospect of emptying the world's great encyclopedic museums in order to return imperial spoils to countries that may not have existed when such works arrived abroad. That said, as with the case of the Sphinx's beard fragment, restitutions may be made that are indexed not to a legal claim, but to an ethical one made in the interest of adding to the art historical and scholarly record. And it is impossible to predict when and where such moral impulses will next reveal themselves, as debates about ownership show no signs of abating.

Why does a modern nation have a claim to an ancient culture?

For most modern nations, the nationalization of cultural heritage is an assumed right, much like the nationalization of other material or natural assets, from mineral rights to oil fields to bodies of fresh water. The United States is an outlier in this respect. It is virtually alone in eschewing patrimony

16. For example, Italy requires an export license for the export of any cultural property more than fifty years old.

laws protecting cultural heritage on its soil, with the notable exception of the heritage of indigenous cultures. Apart from the cultural inheritance of Native Americans, the United States has steadfastly avoided creating any expectation that cultural goods discovered or made on US soil should enjoy any protection. [17] The American tradition of honoring the values espoused by its eighteenth-century Founding Fathers is at the core of this avoidance. It is understandable that a scrappy new nation, antiaristocratic and forged in conflict with Great Britain, might not have assigned any priority to protecting its own fledgling heritage. But nearly two and a half centuries later, the nearly complete reliance on private philanthropy to safeguard American heritage has shown itself to be an imperfect model.

No less importantly, America's abnegation of responsibility for its own heritage contributed to a long-standing dispute of the right of other states parties to codify protection of their heritage. The struggle among representative interests in the President's Cultural Property Advisory Committee (CPAC) epitomizes the anomalous nature of US attitudes about cultural heritage. CPAC is obligated to include representatives

17. Although Congress passed the American Antiquities Act of 1906 (16 U.S.C. §§ 431–433), which penalized with fines or incarceration the unauthorized excavation, destruction, or damage of American antiquities found on federally owned or federally controlled lands, the Act proved to be an unsuccessful attempt to combat looting on those lands. Attempts to improve the Act eventually led to a new statute, the Archaeological Resources Protection Act of 1979, which attempted to clarify the penalties and the types of prohibited activities included under the Act. See Francis P. McManamon, "The Archaeological Resources Protection Act of 1979 (ARPA)," in *Archaeological Method and Theory: An Encyclopedia*, eds. Linda Ellis. New York and London: Garland, 2000.

The Native American Graves Protection and Repatriation Act (Public Law 101-601; 25 U.S.C. §§ 3001–3013) outlines the treatment, repatriation, and disposition procedures of Native American human remains, funerary objects, sacred objects, and objects of cultural patrimony to statutorily defined lineal descendants, Indian tribes, and Native Hawaiian organizations.

of inherently disunited factions: members of the collecting community and the art trade, alongside representatives of the archaeological and museum communities. In the recent past, the museum community was more closely aligned with collectors and dealers. Since 2008, when the Association of Art Museum Directors recognized the 1970 UNESCO Convention on the Means of Prohibiting and Preventing the Illicit Import, Export and Transfer of Ownership of Cultural Property as a bright line, museum representatives have dissociated themselves from advocates of unrestrained collecting, and tread a more nuanced line, recognizing the right of nations to protect their heritage while seeking to promote both the protection of works on US soil and the prospect of a legal international art market in antiquities.[18]

Federal policy shaping import restrictions of archaeological and ethnographic material in the United States is therefore forged by an anomalous combination of public and private interests. Almost all art museums in the United States are private institutions, notwithstanding their public mission. Having art collectors and dealers serving on a federal panel weighing claims by countries that are loathe to cede any moral or legal authority to private concerns is, nevertheless, a recipe for intractable debates. The inherent contradiction between private property owners and those representing the scientific interests of cultural heritage makes for episodic standoffs. The time-honored American tradition of fealty to private property is not likely to change in the near- or medium-term.

18. Notably, Marion True, one-time curator of antiquities at the Getty, who was herself indicted in Italy for her alleged participation in illegal trafficking of antiquities, was an early proponent of more restrictions on museum collecting. The Getty would eventually adopt a much stricter acquisitions policy.

3

FRAMING TODAY'S DEBATE

What are the key issues in debate on this matter?

Having considered how antiquities were first assembled into collections, how objects have historically moved from one place to another, and some of the ways in which claims arise, we will now consider the key issues fueling the debate about who owns antiquities and what should befall those yet to find a home.

On the face of it, there should be few grounds for debate: the schoolyard taunt "finders, keepers" summons a time-honored tenet of property law. Yet the circumstances of how ancient objects come to light are usually more complicated than is the case in a schoolyard.

Key Issue 1: How Much Does Context Matter?

Take the example of a Greek vase made in sixth century BC Athens. Thrown on the wheel of a potter in the section of the city known as the Kerameikos, it was painted and made available for sale. Often such a highly decorative vessel ended up being purchased by Etruscan households in central Italy, where it was displayed and enjoyed as a key part of the rituals of daily life. Upon the death of the head of the household, the vase was buried in an underground tomb, along with other prized possessions, including jewelry.

In antiquity, such a vase thus had at least three contexts in what are today two sovereign nations. Which of these contexts is the most significant with regard to our understanding of the vase? A reasonable answer would be neither the small shop in which it was made, nor the earth-filled tomb in which it rested for centuries—but instead the Etruscan house in which it was displayed and used. But we have yet to discover a Greek vase in a fully preserved Etruscan house.[1] Vases that come to light from the ancient world are normally those found in tombs, removed from their place (and country) of manufacture, and no longer part of the setting in which they were appreciated, displayed, talked about, and in the case of a vase, used for storing, pouring, or drinking wine.

It's obvious that even though such a vase recovered from a tomb carries with it information about the life of its owner—by means of the other artifacts with which it was buried—that information is not as rich and illuminating as what could be derived from the missing household in which it figured.

Most Greek vases that are today on display in archaeological museums around the world are not accompanied by any information from antiquity, since they came to light prior to the advent of rigorous scientific excavation techniques. In the case of art museums that purchased them from the secondary art market (meaning not directly from the primary market—i.e., that Greek workshop in sixth century BC Athens), they appeared without any information about their origins. To an archaeologist, any information gleaned about the circumstances of that vase in antiquity is of primary importance. By contrast, to an art historian, collector, or dealer, the formal properties of the vase tell us most of what we need to know

1. Etruscan domestic architecture has been the subject of study but intact examples are rare. See Paul Miller, "Continuity and Change in Etruscan Domestic Architecture: A Study of Building Techniques and Materials from 800–500 BC." Edinburgh Research Archive. University of Edinburgh, 2015. https://www.era.lib.ed.ac.uk/handle/1842/11708.

about it. The facts surrounding its burial in a tomb would be interesting to know, but would not significantly enhance their understanding of how it was appreciated in that Etruscan household, or which other vases made by the same workshop ended up in other tombs, or indeed what value and significance it might hold to a contemporary viewer. Debates over the value of archaeological context are thus the first key issue we face.[2]

Key Issue 2: How Much Does a Buyer Need to Know?

A second key issue in the antiquities field is centered on whether there is proof that an ancient object available for purchase has or has not been looted. Until a few years ago, it was commonplace for collectors and museum curators to purchase antiquities unless there had been clear evidence of looting or theft. The problem with that approach is that looters and middlemen 'fencing' or illegally facilitating the circulation of stolen goods do their best to mask the illicit origins of their wares. And unscrupulous dealers are not above inventing provenance, or ownership history, in order to smooth the passage and sale of looted and stolen goods. Forged documents and false declarations have been commonplace in misrepresenting the history of an artifact, resulting in the illegal export, import, and sale of objects fresh from the facades of monuments, museum inventories, or below ground or underwater. To complicate matters, looting eradicates both the circumstances of an object's modern removal

2. For the archaeological perspective, see, for example, Derek Fincham, "The Fundamental Importance of Archaeological Context," in *Art and Crime: Exploring the Dark Side of the Art World*, ed. Noah Charney, 3–13. Santa Barbara, CA: Praeger, 2009. For a counterargument, see James C.Y. Watt, "Antiquities and the Importance—and Limitations—of Archaeological Contexts," in *Whose Culture? The Promise of Museums and the Debate over Antiquities*, ed. James B. Cuno, 89–106. Princeton, NJ: Princeton University Press, 2012.

and the ancient context of the kind described above. For archaeologists, source country authorities, and most museum professionals, the purchase of a work without certainty that it is not looted is likely to fuel further looting and the illicit trade, and should be avoided.

For some collectors, dealers, and museum professionals, the purchase of a work detached from its most recent archaeological context represents not an illegitimate act, but an act of rescue. The logic is that unless a well-intentioned purchaser removes a potentially looted work from the art market, it may be subject to damage, loss, or destruction. And, the reasoning goes, since a private owner is likely to keep the work off the market, or even donate it eventually to a museum, it is better off in private hands than remaining in a dealer's inventory. According to this perspective, even if a purchaser does not know for certain that work was not looted, the removal of a work from the trade is a benevolent act.

These two views are irreconcilable and have led to paralysis in the quest for an international solution to reduce looting and the illicit trade. Unless something forces one camp to bend toward the other, those espousing either point of view will inevitably find the other to be unreasonable, or even unscrupulous.

Key Issue 3: What Should Become of Unprovenanced Antiquities?

A third key issue in the field of antiquities is what should happen to objects that arrive in the art market without information about their original archaeological context or their provenance.

For the archaeological community, the work is tainted, lacking as it does the paperwork necessary to demonstrate that it was not looted. As a result, it cannot in good conscience be provided a reputable home outside its country of probable modern discovery. While the impulse to see a work restituted to its place of origin is understandable, the act of

restitution is not so simple as might first be assumed. Source countries have museums with bulging storerooms, and works restituted without accurate archaeological context are often unwelcome. Overworked administrators, curators, and conservators have enough to cope with from the objects in their care along with others that are scientifically excavated and find their way to storerooms once they are examined, photographed, and documented. While they may be the subjects of a temporary exhibition, upon its close they are often as not returned to storage.

It is increasingly the case that unprovenanced antiquities cannot find a home in any museum. European and American museum officials are today cautious about purchasing or accepting donations of unprovenanced antiquities, given successful prosecutions in the recent past. In 2003 Dr. Marion True, a curator at the Getty Museum, was indicted by the Italian government for conspiring to traffic in illicit antiquities. Her subsequent trial had a profound impact on the practices of US museums with respect to unprovenanced antiquities. Although the case was ultimately dismissed in 2010, the chilling effect of her indictment remains uppermost in the minds of potential buyers of unprovenanced antiquities.

Collectors, too, have been on notice that the purchase of unprovenanced antiquities can lead to civil liability. A raid on the Fifth Avenue home of the collector Michael Steinhardt on November 9, 1995, led to the seizure of a Greek gold phiale, or offering dish, which had been illegally imported by its vendor into the United States after a false customs declaration.[3]

Thus the three conventional destinations for unprovenanced antiquities in the United States—restitution to the assumed source country, purchase by or donation to a museum, or purchase by a private collector—can no longer be counted

3. United States v. An Antique Platter of Gold, 991 F. Supp. 222 (S.D.N.Y. 1997), *aff'd*, 184 F.3d 131 (2d Cir. 1999), *cert. denied*, 528 U.S. 1136 (2000).

upon as safe havens. The result is that future discoveries are even likelier to be driven into the black market, invisible to scholars and the public. An already flourishing black market needs little encouragement. But as the devastation of archaeological sites by looters continues unabated, there is nowhere else that these works can go. With most of our collective ancient inheritance yet to be unearthed or discovered underwater, this situation is untenable, and demands new solutions. We will consider some of these in chapter 8.

What are the fault lines between archaeologists and those defending collecting?

The three key issues above—the value of context, the degree of information required about a prospective purchase, and the destination of unprovenanced objects—are hotly debated. And within each of the two opposing camps, loosely identifiable as those privileging archaeological information versus those privileging object-centered appreciation, there is as yet little effort to find common ground. Both camps are well-intentioned, but both carry with them embedded inflexibility.

For many archaeologists, the loss of information about an object's circumstances of discovery deprives the object of value, perhaps even to the point of its being of minimal relevance for further inquiry. Their perspective is that the loss of information is tantamount to a person who has suffered complete amnesia.[4] A person without memory or identity may be able to subsist, but she or he lacks the fundamental attributes that mark the person's significance in the world. Other archaeologists are more forgiving in the absence of known context; they see the value of placing the amnesiac antiquity in an orphanage of other such objects, even if little can be surmised about the work in its diminished state. At both ends of the archaeological

4. Gavin Lucas, *The Archaeology of Time* (New York: Routledge, 2005), 132–134.

spectrum, the unprovenanced antiquity is at best a proxy for but not in and of itself as meaningful as a comparable example accompanied by the comprehensive archaeological record of its precise findspot, associated finds, soil conditions, and other features of its last context in antiquity.

Many collectors and dealers find this perspective to be irrational. The object enjoyed some kind of currency in antiquity prior to its burial, the thinking goes. And the burial provides little or none of the information about the ways in which the object was used and appreciated in daily life.

We can distill these two conflicting points of view into one privileging the extrinsic value of an antiquity, and those privileging its intrinsic value. While there may be matters of degree within each position, which find their roots in debates dating back to the Enlightenment, they are difficult to bridge, since the point of departure for each is so fundamental.[5] An archaeological viewpoint recognizes that an object may be a thing of beauty, rarity, or decorative interest. But it also looks at these attributes as largely irrelevant to the work's importance as a potential source of information about the ancient world.

The collector's point of view in no way dismisses the utility of additional information surrounding an object's origins or the circumstances of its modern discovery, but sees that information as ancillary to the intrinsic interest of the artifact, derived from the choices made by the artisan in shaping and decorating it. The collector considers his or her interest in the work closer to the kind of interest that the original owner would have lavished on it, even if the loss of information about the object subsequent to its utility in daily life and its likely appreciation is noted.[6]

5. Georg Wilhelm Friedrich Hegel and Heinrich Gustav Hotho, *Vorlesungen über die Aesthetik* (Berlin: Duncker U. Humblot, 1838).
6. James Cuno, ed., *Whose Culture? The Promise of Museums and the Debate over Antiquities* (Princeton, NJ: Princeton University Press, 2012).

What is at stake in the debate?

The debate summarized above—and the paralysis in forming internationally acceptable policy to solve it—results in an uncertain future. Unless a solution is found, the only path is continued looting, the disappearance of our collective heritage into the recesses of the black market, and the incremental extinction of the material record of mankind's past. Like a growing hole in the ozone layer and melting ice caps, the prospective loss of yet-undiscovered traces of our past is an irreversible phenomenon. There is hope that a radical reduction in carbon emissions might give nature a fighting chance to slow or eliminate the threat to our environment. But there is no going back once an archaeological site is razed for a highway, detonated by extremists, or looted. What is at stake is the legacy of our ancestors. Unless we find common cause with those seeking to address the loss of our past, we set in motion the inevitable erasure of every trace of what is meaningful about human history.

Who gets to decide the outcomes of claims and counterclaims?

The courts are the place of last resort in sorting out ownership issues. But before claims reach a judge or jury, the self-policing of well-intentioned stakeholders offers only a small window to address the fate of antiquities. Were individual collectors to decline to purchase works, part of the global demand might slow—but only the very top end. The vast majority of works making their way from looted sites to criminal syndicates will never see the light of day, but will instead remain trapped in a cycle of laundering, barter for arms and drugs, and likely damage or destruction. These works will never be the subject of claims or counterclaims, since they will not become known to authorities.

When a looted work does make its way to the awareness of the authorities, evidence is hard to come by to consider the best course of action. In subsequent chapters we will review

the evolving attitudes, international accords, and national legislation that are leading to new options ahead in resolving the debates.

How has the debate changed over the last few years?

An awakened interest in protecting cultural heritage beginning in the mid-twentieth century is chronicled in chapter 6. More recently, museums have taken it upon themselves to address challenges connected with collecting. In November 2002, a gathering of some fifty of the world's leading museum directors, known as the Bizot Group, met in Munich for its annual international convening. The newly appointed director of the British Museum, Neil MacGregor, made the assembled aware of new energy in the assertive campaign by Greek authorities to seek the return of the Parthenon marbles. In response, in the month following the Munich meeting of the Bizot group, a small group of member directors drafted a manifesto, which would become known as the "Statement on the Value of the Universal Museum," which was sent by the British Museum to the BBC in an email on December 9th. Of the fifty members of the Bizot Group, only eighteen signed it, and of that group, ten were US museum directors. The BM's director explained to the BBC that it supported the statement but had not signed it. The text was headlined as a *"Declaration on the importance and value of universal museums."* Although it began in Munich as a simple affirmation of the legitimacy of the British Museum's ownership of the Parthenon marbles, the script changed to take on a posture defending the repose of antiquities in collections in general. While not every signatory relished the new rhetoric, solidarity with the British Museum's position trumped misgivings about tone-deaf language eschewing claims in general.

My own reservations grew in step with criticism of the Declaration by the archaeological community. On December 20, 2002, as president of the Association of Art Museum Directors, I formed an inaugural fifteen-member Cultural Property Task

Force, including the directors of the leading antiquities collections across the United States. Our avowed purpose was to grapple with the ethical limits of collecting.

The Task Force met every few weeks for a year and a half. In May 2003, a draft version of evolving guidelines was circulated to the Task Force members, which had not resolved deep differences of opinion about whether and how to propose restrictions on prospective acquisitions. On June 25, 2003, the conviction of antiquities dealer Frederick Schultz was announced. What had until that point been a philosophical debate about ethics was suddenly in the shadow of legal precedent that could lead to the indictment of Task Force members.

In the fall of 2003, under the directorship of Wolf-Dieter Heilmeyer, the Berlin State Museums announced a self-imposed end of acquisitions lacking provenance before 1970. By the spring of 2004, AAMD's Task Force had run out of time to further refine its report, which was due to be presented at the annual meeting. The 2004 Report on the Acquisition of Archaeological Materials and Ancient Art was sent from the Task Force to AAMD's board, and issued on June 4th, over the objections of several Task Force members to the last-minute inclusion of a "ten-year rolling rule," which in effect sanctioned acquisitions of unprovenanced material that had been in circulation for at least ten years.

The May 2005 indictment of Getty Museum curator Marion True, and her resignation from the Getty that October, led the Los Angeles museum, spearheaded by then director Michael Brand, to enter into negotiations with Italian authorities to pursue long-term loans in exchange for restitutions of illegally exported antiquities. The Getty's overtures to Italy were soon followed by negotiations on the part of Princeton University, the Metropolitan Museum of Art, the Boston Museum of Fine Arts, and the Cleveland Museum of Art. Susan Taylor of the Princeton University Art Museum was among the first to negotiate an amicable outcome, and to set the tone for future

discussions with Italian authorities, relying on fluent Italian and an ethical compass.

In March 2006 the Archaeological Institute of America issued a statement condemning AAMD's 2004 Guidelines, stating that "The acquisition of antiquities has too often taken place in a twilight zone of uncertain legality and ambiguous policies and procedures. Greater transparency and openness are needed."[7]

At the Portland, Oregon, annual meeting of AAMD in June 2006, some of us raised the need to return to our Report and reframe and tighten it. On October 26, 2006, the Getty was the first US museum to announce a strict new acquisitions policy intended to clear its name and move forward. It noted the new requirement, among other tenets, of ". . . documentation or substantial evidence that the item was out of its country of origin before November 17, 1970 and that it has been or will be legally imported into the United States."[8] Princeton followed shortly thereafter. On April 4, 2007, the British Museum followed the Getty in adopting a similarly stringent policy, leaving an exception for "minor items."[9]

The Getty's salvo had effectively altered the museum landscape. AAMD's standing approach, which urged museums not to "knowingly" acquire an illicitly obtained work, was now in serious question.

In November 2006 AAMD program chair and Clark Art Institute director Michael Conforti began planning a panel on cultural property for the midwinter meeting in order to brief members on the evolving negotiations about the return of objects, and kept the Association engaged with evolving thinking

7. Professional Responsibilities Committee, "Principles for Museum Acquisitions of Antiquities," Archaeological Institute of America, March 2006.
8. Press Release. The Getty. "J. Paul Getty Museum Announces Revised Acquisitions Policy," October 26, 2006.
9. The British Museum. "British Museum Policy Acquisitions," April 24, 2007. http://www.britishmuseum.org/pdf/Acquisitions.pdf.

about the antiquities dilemma during his subsequent tenure as president.

AAMD's midwinter Atlanta meeting included a January 24, 2007, presentation titled "Cultural Property: A Report from the Field," with presentations by directors Michael Brand (Getty Museum), Timothy Rub (Philadelphia Museum of Art), and Susan Taylor (Princeton University Museum). There was ample discussion about the Getty's new policy, enacted since our previous AAMD meeting, and a new willingness to take up the matter again.

On April 9, 2007, Art Issues Chair and Peabody Essex Museum Director Dan Monroe issued an invitation to several members to join a new Task Force. On April 30 the Indianapolis Museum of Art followed the Getty's, Princeton's, and London's lead with a new policy on the acquisition of antiquities, published in *The Art Newspaper*. Monroe led the Task Force with grace and candor, and over months of deliberations was successful in moving the dialogue forward considerably. The new Report, published on June 4, 2008, included language that toughened our stance on the acquisition of unprovenanced antiquities, provided for a new online AAMD Object Registry, and rethought the general position of the Association. It removed the ten-year rolling rule, substituting an obligation to obtain clear title before 1970, and left AAMD's membership with a newly framed position that the Archaeological Institute of America acknowledged to provide a major step forward.

In September 2009, AAMD launched its Object Registry, an online resource created by the IMA Lab web team helmed by Rob Stein at the Indianapolis Museum of Art, for listing unprovenanced works acquired by AAMD museums. It was conceived and devised to include explanations of why exceptions to the 2008 policy were invoked in each instance. While an imperfect solution to the need for transparency, it became the portal through which antiquities lacking a complete history were required to be documented.

The criminal and civil prosecution of individuals beginning in 2003 altered the debate significantly. When previously sparring factions of archaeologists and the collecting community argued over specific instances of collecting, there was rarely a threat beyond public embarrassment that could tighten the demand side of the market. With jail sentences for dealers like Frederick Schultz, Gianfranco Becchina, an indictment for the dealer Edoardo Almagià, and civil proceedings against a museum curator like Marion True, the museum establishment was moved to action, altering collecting policies.[10] The Steinhardt case had a sudden chilling effect on the collecting of unprovenanced antiquities. In the art market, the prices for works with established provenance has surged in recent years, and the research being undertaken by auction houses on the history of works offered for sale has become more rigorous.

Meanwhile, looting has never been so rampant; the intentional destruction of monuments and antiquities by the Islamic State has been like wind shear in an otherwise predictable and mercenary black market, and public works resulting in the demolition of urban settings for buildings and underground systems continues to take a heavy toll on as-yet unexcavated sites and contexts.

Many recent legal developments have reduced the acrimony in the debate over cultural heritage. But as we will consider in chapter 13, even with lessened demand by wealthy collectors and institutions, the spoliation of the past continues unabated, and deserves our full attention.

10. Institutions that changed their policies include: the Getty Museum (2006), the Indianapolis Museum of Art (2007), and the Metropolitan Museum of Art (2008).

4

THE COSMOPOLITAN ARGUMENT

What does the contextual argument leave unanswered?

As discussed in chapter 3, the archaeological community looks upon objects with and without accompanying information about context as two altogether different classes of material. Objects that have been scientifically excavated often enjoy a wealth of accompanying information about the precise date of their burial, along with other evidence about the history of the site, and the circumstances surrounding their deposit. Those about which no archaeological record is known are seen as legacies of the past, but lacking essential information to decode their meaning and extrinsic value.

For archaeologists, the primary reason to remove artifacts from below ground or underwater is not to reveal them in order to lavish appreciation on them—it is to establish what we can about the facts and circumstances surrounding their last known usage in antiquity. To most observers not steeped in archaeological training and parlance, the distinction may seem arbitrary or willfully ideological. The external appearance of an ancient object, after all, conveys much of what a nonspecialist assumes to be its true value. Ancient objects that have come to light over the course of the last few centuries are so abundant that their typologies are reasonably straightforward. When we see a newly revealed and documented Greek

hydria, or water jug, of the late sixth century BC, it closely resembles other comparable jugs, and even a nonspecialist can see the similarities and distinctive features that warrant close attention. It therefore seems counterintuitive to nonspecialists to see the object as of lesser importance simply because it lacks evidence of its last setting in antiquity.

What is the cosmopolitan argument?

Those in favor of the so-called cosmopolitan argument contest the proposition that unprovenanced antiquities merit any less study than those that have emerged with context attached. The word cosmopolitan is invoked to imply that objects have universal value that rises above the particular circumstances of their manufacture and burial.[1]

This perspective rests on the assumption that the object is blameless, and that it should not be penalized for existing out of the ground without information about the circumstances of its burial. Its proponents further note that an enormous amount of information about objects can be surmised with no contextual information. The subject matter illustrated on that Greek hydria cited above is normally straightforward enough, drawn as it is from a familiar repertoire of mythological narratives or scenes from daily life. The subject did not change from the day it was fired and glazed to the day it ended up in an Etruscan's tomb. Similarly, the shape and features of the vessel are easy enough to interpret based on similar examples known from other sources, and are unaffected too by the circumstances of its burial. We can identify its intended function from the shape of a vase, and can classify it with respect to other existing and known examples.

1. Pauline Kleingeld and Eric Brown, "Cosmopolitanism," in *The Stanford Encyclopedia of Philosophy*, ed. Edward N. Zalta. Stanford, CA: Stanford University, 2013. http://plato.stanford.edu/archives/fall2014/entries/cosmopolitanism/.

Therefore, the holder of a cosmopolitan viewpoint might extrapolate, the fact that a vase ended up in a burial site is not connected to its original intended purpose. Its final resting place as one of many grave goods provides only one context for it. As discussed above, since entombed objects are inherently separated from their place of manufacture and the setting in which they functioned during the owner's lifetime, it would be arbitrary and narrow-minded to limit their interpretation to the circumstances of their burial.

Misgivings over the purist archaeological viewpoint are therefore not without merit. Among the most outspoken advocates of a cosmopolitan view is James Cuno, currently the CEO of the Getty Trust. His publications on the subject include *Who Owns Antiquity? Museums and the Battle over Our Ancient Heritage.* He goes further than simply questioning the utility of knowing about a work's burial conditions, and notes that antiquities were made in civilizations that normally bear no direct connection to the modern country governing the territory under which such artifacts have been and will be extracted.[2] He espouses a point of view that cultural property laws of countries of modern discovery are purely political constructs that exploit nationalistic sentiment to prevent ancient artifacts from circulating.[3]

Adherents to the cosmopolitan view additionally believe that objects out of the ground benefit from being seen in comparison with cultural artifacts from other civilizations. The premise of so-called universal museums, dating back to the founding of the British Museum in 1753, is that the intertwined histories of world civilizations are best understood when displayed under one roof. Proponents of the cosmopolitan view postulate that the best outcome we could hope for is the modern-day spawning of new universal museums, whereby residents in the developing world might have the

2. Cuno, *Who Owns Antiquity?* 20.
3. Ibid., 9–11.

opportunities afforded residents and visitors to the European and American 'universal' museums that have emerged since the mid-18th century. Many adherents of this perspective also maintain that modern western museums are better equipped than nonwestern museums to safeguard antiquities, citing recent looting, wanton destruction, and theft of antiquities in museums in Central Asia and the Middle East.

To recap: There are three assumptions informing the cosmopolitan opposition to restraints on collecting: 1) antiquities have an intrinsic value as ciphers of world history outweighing their value in the archaeological record; 2) antiquities cannot reasonably be claimed by countries that have no role or responsibility in their ancient manufacture; and 3) instead of seeking to restitute antiquities that have left their source countries under various circumstances, these countries should turn over new finds to an international body to facilitate their circulation.

The cosmopolitan view claims that there exists a battle between what the late legal eminence John Henry Merryman described as "retentionist" impulses in source nations, and an "internationalist" vantage point embraced by collecting interests in importing nations, including the United States and select European nations.[4] Cuno notes that the emergence of nationalist appropriation of cultural heritage beginning in the nineteenth century did not prevent the practice of *partage*, whereby expeditions by European and American archaeologists yielded discoveries shared among source nations and museum collections represented by visiting scholars. This practice contributed to the formation of significant public collections in archaeologically rich countries, alongside the growth of universal collections in art-importing countries. The practice of partage came to an end by the middle of the twentieth century, as nation after nation imposed restrictions on art

4. John Henry Merryman, "The Nation and the Object," *International Journal of Cultural Property* 3, no. 1 (1994): 61–76.

exports, and effectively clamped down on the circulation of ancient heritage that had bolstered the formation of spectacular encyclopedic institutions ranging from the Hermitage in St. Petersburg to the Pergamon Museum in Berlin to the Louvre in Paris to the British Museum in London to the Metropolitan Museum of Art in New York City.

The end of partage was the result of a wholesale rethinking of our collective responsibilities in safeguarding the past. In 1970, a meeting in Paris of the United Nations Educational and Scientific and Cultural Organization (UNESCO) yielded a convention intended to curtail the illicit market and about which more detail is provided in chapter 6. Known as the Convention on the Means of Prohibiting and Preventing the Illicit Import, Export and Transfer of Ownership of Cultural Property, it marked the beginning of the end of unfettered collecting, and was followed by decades of incremental tightening of laws and statutes governing the antiquities market, bolstered both by changes in attitude and by successful claims for restitution. The relatively recent self-policing of collecting practices by leading European and US museums has narrowed the path of unprovenanced antiquities out of their nations of modern discovery, as well as the 2008 decision by the Association of Art Museum Directors to adopt 1970 as a bright line in making acquisitions of antiquities,[5] after which acquisitions of ancient art should be avoided unless there is reason to believe that they were not looted.

The cosmopolitan argument, and its rejection of need for a bright line, is derived from an understandable point of departure: that the political manipulation of cultural heritage for nationalistic gain is intellectually dishonest. Modern nations like the Republic of Turkey have inherited the bounty of

5. Association of Art Museum Directors, "New Report on Acquisition of Archaeological Materials and Ancient Art Issued by Association of Art Museum Directors," June 4, 2008. https://aamd.org/sites/default/files/document/Antiquities%20Guidelines%20with%20Intro%2006.08.pdf.

a sprawling Ottoman Empire, which controlled territory and heritage completely unrelated to the political and religious identity of modern Turkey. Its own encyclopedic museum in Istanbul, Topkapı Palace, was founded by Mehmed II. Construction began in 1459, and includes collections assembled up to the present with no more careful attention to export restrictions than most Western museums.

In the case of modern China, a cosmopolitan point of view laments the inconsistency of the central government's position. Instead of requiring restitution of stolen, looted, or illegally exported antiquities to China's government-controlled museums, the Ministry of Culture encourages the purchase of artifacts by any party provided that they end upon Chinese soil.[6] And tellingly, the Ministry of Culture does not require proof that such objects were legally exported from China in the first place.

These two examples serve, for adherents of the cosmopolitan view, to call the bluff of "nationalist-retentionist" nations, which pursue Western collections but shine no such light on their own. They are correct that the restitution of stolen or looted artifacts from Western museums is a wrenching experience for prior owners who may have bought them in good faith, and that there is no guarantee of consistency in the conduct of source countries. Cultural and juridical authorities in source countries receiving restituted objects can resemble schoolyard bullies, issuing victorious proclamations that privilege the act of return as of greater value than the scientific import of the objects themselves. And in at least one instance, restituted objects have been stolen after their return.[7]

But while posturing and crowing about returned artifacts may be distasteful, the act it celebrates normally rests on solid

6. Cuno, *Who Owns Antiquity*, 166–167.
7. Sebnem Arsu, "Thefts Focus Attention on Lax Security at Turkey's Museums." *The New York Times*, Arts, June 13, 2006. http://www.nytimes.com/2006/06/13/arts/13muse.html.

legal ground. The belief that "nation-states"—a nineteenth-century locution—have no business invoking sovereign authority over archaeological material found under their soil is the Achilles heel of the cosmopolitan argument. It has long been established that sovereign nations can and do lay claim to certain assets within their borders, whether oil, money, or heritage. The sense that this is in some way an underhanded scheme betrays a uniquely American worldview. The United States, as mentioned, is one of very few nations in the world that lacks any export controls on its cultural heritage (apart from Native American material).[8] While invoking a long-lost culture in service of modern political aims may be patently manipulative, such manipulation is irrelevant to the legitimacy of an actual claim. The cosmopolitan dismissal of the right of modern nations to legislate practices relevant to their patrimony puts its adherents outside the company of legal observers schooled in the realities of international law.

How is it rooted in history?

Cuno's lengthy exposition of the vagaries of national property laws makes for interesting reading. He thoroughly catalogues some of the ways in which ancient realities, colonial-era practices, and contemporary realities collide. The resulting picture is a complex one, studded with irreconcilable points of view, conflicting solutions, and unreasonable appeals to past practices.

While there is no disputing that a search for consistency or abiding logic among nations and across time in the ownership of antiquities would be fruitless, the same could be said of many other arenas in the law. Accounts detailing how oil

8. Archaeological Resources Protection Act of 1979. 16 U.S.C. §§ 470aa–470mm. Section 470ee restricts the trafficking of archaeological resources illegally excavated on "public or Indian lands" in interstate and foreign commerce.

fields and mineral reserves have been treated as private property or annexed as national resources and have been the subject of contesting factions or armed conflict makes for interesting reading too. But no one can sensibly argue that shifting perspectives throughout history should result in an abandonment of current practice. Changes in laws and statutes are today a negotiated affair, dependent on mutual interest and legal precedent. Reminiscences and wishful thinking offer no path forward.

What practical steps are implied in the cosmopolitan argument?

Having offered multiple reasons why collecting should proceed apace without regard to laws in the country of modern discovery, Cuno proceeds to advocate that yet-to-be-discovered artifacts end up not in national museums but in an as-yet non-existent "international trusteeship under the auspices of a nongovernmental agency."[9] Thus the country would cede any grounds for claims of unprovenanced works abroad—and cede grounds for claims of works found on their soil.

It is hard to imagine that either recommendation could be adopted. The first suggestion, that individuals and museums should collect antiquities without regard to national laws, is an open invitation to continuing legal challenges, ranging from seizure of artifacts by authorities to prosecution in the courts, accompanied in either case by a loss of revenue from any purchases and a guarantee of controversial press. It is an unappetizing menu for any private or public would-be purchaser, and amounts to an encouragement to flout the law.

The second entreaty, that nations voluntarily abandon their national patrimony statutes in favor of a yet to be identified

9. Cuno also explains that UNESCO would be an inappropriate authority because of UNESCO's non-enforcement powers and its respect of member states' authority. See James Cuno, *Who Owns Antiquity?*, 147.

nongovernmental agency, offers nothing in return. There is no reason that a sovereign nation would voluntarily cede ownership of goods that are not only valuable, but conventionally understood as an integral part of national patrimony and identity.

The heart of the problem with the cosmopolitan argument is thus twofold: it is both impractical and unreasonable. From its anachronistic endorsement of practices that are no longer feasible, like partage, to its abnegation of the right to national self-determination, the cosmopolitan argument offers no plausible prescription for what ails the field of antiquities.

How has the cosmopolitan argument been received?

James Cuno is an influential figure in the cultural establishment by virtue of the positions he has occupied, recently as director of the Art Institute of Chicago, and currently the Chief Executive Office of the Getty Trust. Notwithstanding his notoriety, the irony is that the very organization he helms has long had a policy at variance with his own views. In 2006 the Getty adopted a 1970 bright line, preventing it from acquiring antiquities without a decades-old provenance.[10] Thus notwithstanding the opinions of its chief executive, the institution was an early leader in changing its policies and practices to acknowledge a changing world. His manifesto has been warmly received among some art dealers and collectors of antiquities. But for the vast majority of stakeholders connected with the fate of antiquities, the cosmopolitan argument is dismissed as the relic of a bygone era, one during which the West was in charge, the antiquities market was free of restraints, and responsibility for the loss of cultural heritage was seen as the result of incompetent policing.

10. "Policy Statement: Acquisitions by the J. Paul Getty Museum," October 23, 2006.

Those days are well behind us. We live today in an interconnected world, where shared responsibility for cultural heritage demands tolerance of conflicting viewpoints as well as an appreciation of the right of nations to make their own laws. There is no doubt that a market without restraint contributes mightily to incentivizing looting. While many observers believe that a legal international antiquities market might serve to dampen the demand for illicitly obtained works, that goal would require fundamental changes in attitude internationally.

5

DIVINING ORIGINALS, PASTICHES, AND FORGERIES

What are the origins of copying and forging antiquities?

The copying of works of art is a predictable phenomenon that reaches back to remote antiquity. Today's "sampling" in the music industry is but the latest example of a deeply rooted impulse to borrow from others' creative achievements, sometimes out of necessity to insert repeating elements in colossal projects, sometimes out of admiration for earlier works, sometimes for personal gain, and sometimes simply to show off technical prowess that ends up confounding experts in a field.

The earliest architectural programs on a large scale in Egypt and the Near East involved sanctioned copying. Such is the case when sculptors adorning massive palace and temple complexes in ancient civilizations required consistent style and subject matter across hundreds of meters of carved and painted surfaces, along with consistently rendered free-standing statuary. Workshops of artists in ancient Egypt strove to mask individual hands when sculpting narrative accounts of Pharaonic triumphs in battle. Pattern books by lead artists were likely employed to provide other artisans in large-scale workshops with necessary blueprints for visual consistency.

The same was true in every ancient civilization, and as a result we have scant information about the identity of individual artists at work on large-scale commissions and their

components. Close examination of tool marks can often show technical variations in how an artisan rendered a statue or relief sculpture, just as tomb paintings in Egypt offer clues about the large number of hands at work through differing brushstrokes and facial details. And subtle variations among depictions of physiognomy can lead us to attribute portions of large-scale commissions to individual hands. But it was rare in antiquity for artists to sign or incise works out of pride of authorship—art making in antiquity was no less virtuosic than at any other time in the history of art, but recognition by others of one's individual talent was not typical across all cultures.

Up until the present day, with 3D printing as the latest technique to duplicate the creative innovations of one or more hands, there has always been an almost infinite supply of replicated art spawned not from an intent to deceive, but from a businesslike determination to use one or more person's creative innovations for a wide variety of approved purposes.

But antiquities made in near simultaneity by multiple hands in the past in furtherance of a shared artistic goal are not the subject of this chapter. Our inquiry is instead about how experts go about recognizing fakes, making distinctions between copies and originals, and noting interventions to works as a result of factors including damage and changes in taste. We will seek to clarify the distinctions among six sometimes overlapping categories of antiquities: originals, restorations, interventions, replicas, pastiches, and outright forgeries. These six categories represent a spectrum, from the true intent of an object's author to the fraudulent simulation of an original.

How is an original antiquity recognized as such?

Countless original examples of creativity endure from the ancient world. These range from works that have stood above ground since their creation, to works subsequently unearthed, to a growing number of works salvaged from underwater.

Monuments that have never been buried, such as the Pyramids of Giza, Greek temples, the Colosseum in Rome, the mountaintop sprawl of Machu Picchu, and the jungle temples of Angkor Wat, often bear decorative programs that have been visible since the day they were completed. These living monuments have long held fascination for local chroniclers and international travelers alike. They have been routinely altered over the centuries in one way or another—with changes ranging from cleaning, to consolidation of damaged or missing elements, to outright replacement of features, to the removal of part or all of the decorative program. Free-standing ancient monuments have for centuries informed our collective knowledge of the past, and serve as touchstones of the civilizations that birthed them.

Objects and contexts retrieved in the aftermath of antiquity pose an entirely different set of challenges for experts. To begin with, the chance discovery of objects often reveals only partial information about material evidence of the past. Degradation through exposure to soil, water, or pollutants can radically alter the appearance of objects, not only through loss of original surface elements such as color, but also through the accretion of disfiguring deposits like calcium carbonate. Archaeologists and art historians often have to surmise the original condition of damaged artifacts based on other comparable works in better condition.

Objects first encountered already out of the ground normally betray nothing about their original functional circumstances, and experts can be easily confounded by sophisticated forgeries. Original objects are recognized as such based on their conformity to known typologies—such as materials, scale, shape, and proportion—in keeping with already authenticated examples. Statues from classic Khmer temples have attributes and features that vary little from one example to another.[1] Newly discovered examples, if original, depart from

1. "Gods of Angkor: Bronzes from the National Museum of Cambodia," The J. Paul Getty Museum, August 22, 2011. http://www.getty.edu/art/exhibitions/gods_angkor/.

known typologies only in detail, and if a Khmer statue is not made of a sandstone typical of quarries supplying workshops in antiquity, few explanations other than its being forged present themselves.

Advances in scientific testing make the authentication of supposedly ancient works a more reliable process. Easiest of all to be tested are works made of baked clay, or terracotta. These can be studied under thermoluminescence, which reveals an approximate date. The test effectively measures the infinitesimal cooling of a work since it was fired, and when carefully administered, the results are accurate to within 150 years before or after the work's manufacture.[2]

Testing of metal objects reveals the chemical composition of the work, such as the percentage of tin and copper in a bronze work, which has varied little within defined periods in the ancient world. But experts have been misled by forgers melting down other antiquities, such as coins, only to cast them in the shapes of more valuable objects such as statuettes or portrait heads.

Other tests on metal objects can distinguish natural accumulations—formed by protracted burial in the ground or exposure to sea water—from intentionally applied accretions, such as cement to simulate calcium carbonate.

Most difficult of all media to authenticate are sculptures made of stone, ranging from soft alabaster to harder limestone to harder marble to granite, one of the hardest stones of all. Their surface modeling reveals little or nothing about how or when they were carved—unless there is the dead giveaway of a modern pneumatic drill, a trap some forgers have set for themselves.

And just as the sculptural techniques used in stone carving are difficult to decode, so is certainty about whether the

2. Elias H. Bakaraji, Nada Boutros, and Rana Abboud, "Thermoluminescence (TL) Dating of Ancient Syrian Pottery from Six Different Archaeological Sites," *Geochronometria* 41, no. 1 (2014): 24–29.

particular stone in use is consistent with what artists of a given place and time would likely have used. Our ability to identify quarries in use in antiquity remains relatively primitive. One clue that can be of help is the presence of inclusions and impurities in the stone, which is a kind of fingerprint revealing the soil composition of the relevant area, as in the case of a particularly iron-rich deposit. But for the time being, even these clues are not adequately mapped to connect particular stone objects with particular stone quarries. Thus forgers today gravitate to materials that are harder to analyze, such as stone or metal, rather than organic or more easily tested works made of bone, ivory, or terracotta.

Museum curators, art historians, dealers, and collectors maintain that they can usually identify originals based on close examination of an object's condition, typology, and style.[3] Archaeologists are skeptical about relying on stylistic grounds, since clever forgers have tripped up many a museum curator making acquisitions over the last century and a half. The problem is self-perpetuating: the more that forgers' workshops are aware of demand from select clients or the general collecting community, be they institutional or individual, the more inclined they are to manufacture fakes to meet market demand.

What reveals that an antiquity has been restored?

It is always surprising when an antiquity comes to light in its original condition. Exposure to the elements normally takes a toll on any object that is more than a few years old. Such was the case in antiquity as well. Many objects were displayed

3. For a criticism of these methodologies and a list of allegedly forged artifacts housed in major museums, see Oscar White Muscarella, "The Veracity of 'Scientific' Testing by Conservators," in *Archaeology, Artifacts and Antiquities of the Ancient Near East*, ed. Oscar Muscarella, 931–952, Leiden, The Netherlands: Brill, 2013.

outdoors, or in confined spaces with burnt offerings expos-
ing works to smoke, or through repeated touching by those
venerating a monument. Therefore restorations were common
throughout the lifespan of an object from the time of its manu-
facture onward. We can recognize ancient restorations in a few
ways. The recutting of stone works to sharpen details softened
by rain or wind was routine, and can yield an inconsistent
surface treatment. Outright damages, such as broken limbs on
statues, required the insertion of dowels, which change little
in technique throughout antiquity. Missing elements, such as
added glass or metal to simulate eyes, or hair, often needed
to be replaced. Painted works might be refreshed. And gilded
statues displayed outdoors were often regilded over the course
of decades.

What is meant by an intervention?

By restoration we intend efforts to return a work to its origi-
nal appearance, rather than to alter it. In ancient Rome, it was
customary not only to restore works but also to intervene and
update them, such as by altering the hairstyles of sculpted por-
traits to stay in fashion. We have seen this impulse throughout
the history of art, as when limner portrait artists in eighteenth-
century America would update the clothing of sitters in com-
missioned works that stayed in a family. In the ancient world,
it may have been considered natural enough to update the
commemoration of a departed relative. In the modern era we
might bring flowers to a graveside. In an ancient tomb it might
be considered no less natural to refresh the appearance of a
departed relative's portrait.

How are replicas defined?

Replicas original to a period were made to serve in place of
a lost original, or to duplicate a given object. Objects cast
from molds fit into this category, as is the case with bronze

sculptures. Such works were abundant throughout antiquity. A favored technique in early Egyptian metallurgy was sand-casting, and later the lost-wax technique, which was favored in classical and Asian civilizations. Both would yield forms approximating the reverse of the mold and its surface conditions, and objects were subsequently retouched following the casting, with instruments used to model the surface and burnish imperfections, and with other elements in other material such as glass paste, copper, silver, or gold, added to enliven features.

Baked clay sculptures, called terracottas, were similarly made from molds, but after their firing they could be painted in bright colors, which have typically faded since antiquity. Some colors are more durable than others, based on the materials used from mineral or vegetal extractions.

Stone replicas were sometimes made in antiquity without molds, but at times with the aid of a pointing device, or means of measuring features of a sculpted work with a form of calipers. But casts of portrait heads or other figurative sculptures allowed for more copies to be made for multiple settings.

Replicas were a common feature of ancient settings. Our modern veneration of originals would likely have mystified an ancient observer. Today's art market privileges rarity, while in the past, the virtue of an image resided not in its uniqueness but in its symbolism.

What is meant by pastiches?

Works of art that survived from antiquity and made their way into the hands of medieval collections were often in less than perfect condition. These so-called pastiches may appear to be faithful to the object's original appearance, or may be fanciful inventions, and require close viewing to establish the chronology of their post-ancient life. It was considered altogether reasonable in most circles to convert an object into a new purpose, by altering it and adding features. In the Renaissance and

through the eighteenth and nineteenth centuries, antiquities in European collections were routinely reworked, or reimagined altogether. Damaged statues underwent complete makeovers, with new heads and limbs, not to mention new identities. Roman sarcophagi with mythological scenes were recarved to associate their subject matter with Biblical themes. In virtually every culture around the world, antiquities that survived into the medieval and modern eras were routinely repurposed and altered significantly.

How do experts identify forgeries?

Faked or forged works of art made in the modern era are the subject of routine media coverage, since they are often connected with artists whose original works command high six- and seven-figure sums. But forgeries of ancient art are often harder to detect, given the anonymity of artists, the absence of any written or illustrated inventories, and the passage of time that erases evidence of all kinds.

Forgers of antiquities resort to tricks of the trade that can throw experts off their trail. The surface is often soaked in organic compounds to simulate protracted burial. Fine lines of cement mixed with stone powder are applied to resemble root marks, or traces of accretion from plant life underground. Objects might be subjected to intentional defacing, by means of a blow knocking off the nose in the case of a sculpture, or scratching and scraping.

Moving from the surface to the style and subject matter of forgeries, an old trick is to take a familiar subject in one medium and adapt it to another medium. A painted scene might find its way onto a sculpted relief, or vice-versa. Another technique is to copy the form of an original in a larger or smaller version, so it is not instantly recognizable as dependent on another work.

The sophistication of forgers should never be underestimated. Workshops of forgers in Asia and Southern Europe are well aware of the collecting interests of major museums,

and have been known to make works to address gaps in col-
lections, as was the case when the J. Paul Getty Museum was
spending millions of dollars annually on purchases in the
1980s and 1990s.

Forgeries of pre-Columbian art have often reused authentic
works in terracotta, and applied new painted surfaces—made
to appear slightly weathered—so as to dramatically increase
their value. South Asian sculptures have had molds made of
them, with reproduced versions masquerading as originals.
Egyptian workshops over the last century have kept pace with
tourism, providing an inexhaustible supply of 'antiquities' for
the hapless tourist, who is warned to hide these works care-
fully from authorities. The art dealer Frederick Schultz was
jailed for a variant of this tradition: his middleman covered an
ancient sculpture with a new surface to make it appear to be a
modern reproduction, and thus able to be exported out of the
country.

How long have there been forgeries?

There is no clear evidence about when the first forgers' work-
shops began—but it is known that the insatiable quest of
Roman collectors led to fakes making their way in collections
from the first and second centuries AD[4] Forging, when success-
ful, can be a lucrative practice. But it is fraught with danger,
demands painstaking research and technical sophistication,
and requires trustworthy intermediaries who can bring works
to market.

As the demand in the art market has surged, so has the
output of forgers' workshops. During the Victorian era, the
taste for fourth-century BC Greek 'Tanagra' figurines was con-
siderable. These elegant statuettes made of terracotta revealed
the forms of bodies under what was known as 'wet drapery,'

4. D. Emanuele, "'Aes Corinthium': Fact, Fiction, and Fake," *Phoenix*
43, no. 4 (1989): 347–358.

and elicited the appreciation of male collectors of the time. As a result, a significant number of forged Tanagra figurines found their way into private and public collections during the last decades of the nineteenth century and first decades of the twentieth century. To a contemporary observer, such forgeries look downright Victorian, rather than ancient. Yet at the time, they were perfectly persuasive.[5] Thus forgeries can be said to have a shelf life. As their date of modern manufacture recedes, their overall appearance becomes incrementally time-stamped to that period. At first it is only subliminally evident to experts that a work is not authentic, but in time the stylistic quirks become more manifest, and contemporary viewers may be astonished that anyone in the past was deceived.

Are fakes and fraudulently restored artifacts a big part of the market?

Given that there is no simple test to authenticate objects, there are likely large numbers of fakes lurking in private and public collections. They may only be revealed once examined freshly in preparation for a publication or exhibition. If left undisturbed for years on a pedestal, in a vitrine, on a wall, or on a shelf, forgeries can quietly coexist with authentic works. It is often only with a fresh pair of eyes and new technical examination that a fake may be revealed.

The art market today is filled with forgeries, and as prices have increased in recent years, so has the output of forgers' workshops. Other fields of art history have collaborative scholarly efforts to authenticate artworks, most notably the Rembrandt Research Project in the Netherlands. The RRP routinely considers the attribution both of known works and of works new to the market. And while it has been known to change its position

5. It was later estimated that 90 percent of the popular Tanagra figurines were forgeries. See " 'The Times' on Forgeries," *The Burlington Magazine for Connoisseurs* 42, no. 239 (1923): 61–62.

regarding the attribution of several paintings, it has provided a consistent voice of multiple scholars working together to agree on the oeuvre of one of history's most influential artists.

Since the field of antiquities is unfathomably large, spanning five millennia and multiple continents, it would be impossible to constitute a comparable body of experts committed to authentication across cultures. Instead we rely on the revelations of individual scholars within discrete fields of expertise for an ongoing review of our ancient inheritance.

How do experts insure that works are authentic?

Certificates of authenticity are hard to come by in the field of antiquities. Instead, a "buyer beware" culture endures, passing the risk on from owner to buyer. Experts in the field are loath to express their opinions given the risks of doing so. Litigation in recent years has targeted those denigrating the quality of or disputing the authenticity of objects. As a result it is harder than ever to come by expert opinions from other than those in the market. Academics are rarely drawn into disputes about dates, and on the whole steer clear of the antiquities market to begin with. Furthermore, a generation of younger scholars has been reared with minimal experience in studying original objects, and are instead schooled through digital images that reveal little of the tangible physical attributes of objects.[6] Added to that, academics in the humanities have for over more than a generation favored theoretical inquiry over training in the physical characteristics of antiquities, further diminishing the likelihood that a scholar of antiquities has much experience in the connoisseurship of actual objects.

6. Anna S. Agbe-Davies, Jillian E. Galle, Mark W. Hauser, and Fraser D. Neiman, "Teaching with Digital Archaeological Data: A Research Archive in the University Classroom," *Journal of Archaeological Method and Theory* 21, no. 4 (2013): 837–861.

Are there degrees of authenticity?

An authentic work is one made by the hand of an ancient artist rather than subjected to reworking. Authenticity is unrelated to condition—few works from antiquity have made their way down to us in perfect condition. An eroded surface doesn't diminish a work's authenticity—only its market value. Each act of retouching to mask damage or fill in missing elements represents a diminution of authenticity. Even well-intentioned restorations are in effect incremental erasures of the original artist's touch. And therefore complete authenticity is a rarity, apart from works discovered in recent times that have not suffered the ravages of burial, excessive wear, or exposure to the elements. In that sense, there are degrees of authenticity. But the measurement of authenticity can be an unscientific exercise, like discerning the elements of a prepared dish upon tasting it.[7] With the passage of time, what might have been a glaring alteration made centuries ago can be misinterpreted as original to the object's manufacture.

To an art dealer, the degree to which an object has been handed down in mint condition is pivotal to that work's market value, which is to him perhaps valued over its degree of authenticity. To an art historian, it is essential to situating the work within a period or even workshop of ancient artisans. To an archaeologist, any changes made to a work since antiquity compromise its utility as a source of reliable information about the past. For the general public, the precise calibration of which elements are original and which are restored may be of less interest. Our admiration of the Great Sphinx is undiminished by the ravages of sandstorms and amateurish restoration campaigns.

7. An additional challenge is posed by different cultural interpretations of what objects are considered "authentic." For example, in some African groups old and new ritual objects are treated as equally authentic. See Nahel N. Asfour, "Art and Antiquities: Fraud," in *Encyclopedia of Transnational Crime and Justice*, eds. Margaret E. Beare. Thousand Oaks, CA: SAGE, 2012.

*How many forgeries make their way
into established collections?*

Since authentication is not an exact science, it is impossible to know how many forgeries have made their way into public collections. It is safe to assume, however, that few collecting institutions have not been taken in by clever fakes. The occasional revelation of such works comes as a surprise, but should not, given the ingenuity and determination of forgers over the last century alone. While scientific testing of prospective purchases and gifts is now routine, those collections dating back generations, with thousands of works in inventory, are more likely than not to have been deceived in the past.

Part II

SETTLED LAW
AND OPEN QUESTIONS

6

INTERNATIONAL CONVENTIONS AND TREATIES

What prompted a global conversation about conventions on cultural property?

In this chapter we will consider the efforts by countries to regulate the international trade in archaeological heritage. Notwithstanding the superficially reasonable language of formal treaties and laws, there remain, even within countries, conflicting views about the proper role of the state in regulating the circulation and commercialization of cultural objects. The late Professor John Henry Merryman offered a cogent essay reflecting on the misgivings of market nations about inflexible restrictions on the export and import of cultural property.[1] A generation later Professor Patty Gerstenblith, a legal expert in the field and the chair of the U.S. Cultural Property Advisory Committee, offered a competing and thoroughly argued viewpoint in defense of laws restricting the trade.[2] These two perspectives were leavened over the course of half a century of debate about public responsibility for the protection of, or in Merryman's language, retention of, cultural heritage.

1. John Henry Merryman, "Two Ways of Thinking about Cultural Property," *American Journal of International Law* 80, no. 4 (1986): 831.
2. Patty Gerstenblith. "International Art and Cultural Heritage," *The International Lawyer* 45, no. 1 (2011): 395–408.

In the aftermath of World War II came a torrent of claims and counterclaims for cultural heritage in general, along with the emergence of global consciousness about the extent to which archaeological material was in jeopardy. As described above, there remain divergent opinions about the effectiveness and appropriateness of market regulations in stemming the tide of intentional and accidental destruction of ancient objects and their archaeological contexts. Attempts to clamp down on archaeological exports have, in the opinion of many, had the unintended consequence of creating a black market and further incentivizing looting.[3]

Is there a generally accepted understanding of which antiquities are legal to export and import?

The larger legal framework in which the antiquities trade operates is extremely complex and ever-changing. Within a tangle of international treaties and conventions are distinct and mutable national laws, statutes, regulations, policies, and practices. And within each country—whether a source country or a market country—are often muddled results devolving from internal competition between their cultural ministries—populated by archaeologists—and their judicial, military, national, and local police authorities, populated by prosecutors and law enforcement officials.

Another complicating overlay is the spinning carousel of political parties at the head of each government, which look at cultural heritage through changing lenses. For some politicians, archaeological heritage is an expression of modern national identity. For others, it is a critical feature of their tourism industry. For still others, it is a costly nuisance. For many, it

3. Merryman, John Henry. "A Licit International Trade in Cultural Objects," in *Thinking about the Elgin Marbles: Critical Essays on Cultural Property, Art and Law*, ed. John Henry Merryman, 273–274. Austin; Alphen aan den Rijn, the Netherlands; Frederick, MD: Wolters Kluwer Law & Business; Kluwer Law International, 2009.

is two or all three of the above. And since politicians appoint ministers of both culture and of justice, these shifting perspectives are altered abruptly with almost every national election, with effects spiraling all the way down the food chain to the thousands of museum directors, law enforcement officials, and countless others who are tasked with vigilant protection of monuments, museums, and archaeological sites visible to every citizen and visitor to their country.

Lastly, there is the populace within each country, with its constellation of individual temperaments and outlooks. Between those for whom archaeological heritage is a source of pride, and those who exploit it for personal gain, are millions of individuals who quietly or noisily defend or flout the laws of the land, making what is codified by governments only as valuable as the comportment of their citizenry.

Recognizing the challenges of reducing this global stew of competing views and factors into an intelligible summary, we will seek to summarize some of the settled and open questions facing those involved in and exploring the world of antiquities.

What are the international treaties governing what is legal?

The first major attempt at an international treaty to deal with dislodged antiquities was the Protocol to the Convention for the Protection of Cultural Property in the Event of Armed Conflict (the Hague Convention) of 1954. It sought to address the removal and illegal export of cultural property from occupied territory, and was intended to solve problems left over from World War II as well as conflicts arising in its aftermath. But the Hague Convention was conceived to control only those works of heritage displaced by war, revolution, and rebellion, which left open the question of illegally circulating artifacts in general.

A subsequent international convention to address displaced cultural heritage is UNESCO's Convention on the Means of Prohibiting and Preventing the Illicit Import, Export and Transfer of Ownership of Cultural Property, which was

adopted by UNESCO's General Conference at its sixteenth session in Paris on November 14, 1970. The Convention sought to control property stolen from a museum or a religious or secular public monument or similar institutions provided that such property is documented as appertaining to the inventory of that institution.

A treaty rather than a law, it primarily addresses documented thefts from public entities. It requires signatory nations to enact enabling legislation, one country at a time. Ghana is the most recent nation—the 131st—to join it, on January 20, 2016.[4] Notwithstanding its limited purview, the Convention set in motion a wholesale reconsideration of the responsibilities of nations that could be described as source nations and market nations. The former—those normally in the global south, with significant and valuable archaeological heritage—were exhorted to do a better job of policing and protecting their heritage, while the latter—typically those in the north, with more resources but normally less ample archaeological heritage—were encouraged to clamp down on the import of materials from the former.

UNESCO sought three broad outcomes from the 1970 Convention. The first was to pressure art-rich nations to undertake or insure the accuracy of inventories of public collections, adopt a protocol allowing for export certificates, monitor the art trade, put in place sanctions for those acting in contravention of national laws, and educate their public about their heritage. The second desired outcome was to compel state parties in possession of cultural property imported following the Convention's enactment to restitute that property to a requesting nation—with the proviso that innocent purchasers should

4. A full, updated list of signatories to the 1970 UNESCO Convention is available on UNESCO's website, "Convention on the Means of Prohibiting and Preventing the Illicit Import, Export and Transfer of Ownership of Cultural Property." Paris, 14 November 1970. http://portal.unesco.org/en/ev.php-URL_ID=42330&URL_DO=DO_TOPIC&URL_SECTION=201.html.

be paid "just compensation." The third and most sweeping goal was to incentivize bilateral and multilateral agreements regarding cultural property between and among nations, focusing where necessary on heritage at particular risk from looting.

Well-intentioned and an influential first step, the UNESCO Convention expressly protects museum inventories and monuments, but does not provide a mechanism to address the most difficult challenge related to the circulation of antiquities: the fate of objects either looted or discovered by chance that end up on the legal or illicit market. These omissions were unavoidable, given that UNESCO could not seek to alter the national private laws of state parties regarding stolen property.

The 1970 UNESCO Convention required negotiations among multiple nations with divergent interpretations of the appropriate scope of its concerns. Representatives of those nations in which private law protects the so-called 'good faith' purchases resisted what they considered potential overreach by UNESCO in demanding restitution of works in existing collections. Those from nations with the assumption that good title cannot pass from a thief to a buyer saw the 'good faith' exception as an unreasonable loophole.

Since its adoption, the UNESCO Convention has spawned multiple agreements between countries, most of which include restrictions on what cultural artifacts may be imported. Some countries have, with mixed success, enacted legislation derived from the language of the Convention to put in place oversight of imported cultural heritage. Source nations and market nations have taken predictably differing paths.

How have market nations dealt with the UNESCO Convention?

To illustrate the response of market nations, we can cite **Canada**'s 1985 enactment of its Cultural Property Export and Import Act. **Australia**'s Protection of Movable Cultural Heritage Act was passed in 1986. Both laws address national and international heritage, and are sweeping in their acknowledgment

of foreign export laws. In 2003, **Switzerland**, with one of the world's largest markets for antiquities, ratified the Convention and passed the Federal Act on the International Transfer of Cultural Property (CPTA), which went into force in 2005. The Swiss law is in some ways more comprehensive than in many other market nations, requiring sellers to join a trade registry, triggering a set of measures to ensure that objects for sale are not stolen. Swiss courts have nevertheless contested foreign ownership laws, and the full force of their 2003 Act has yet to be understood.

The European Union passed Directive 2014/60/EU in May 2014, broadening the definition of protected cultural objects and providing for new methods for member states to cooperate with each other and return illegally removed cultural property.

Germany had, in 2007, adopted a federal act addressing cultural property from within Germany, across Europe, and globally, accepting the premise that "cultural property shall be deemed to have been unlawfully removed from the territory of another State if its export was in breach of the rules of that State on the protection of cultural property."[5] Under the leadership of Culture Minister Monika Grütters, Germany took an additional step to advance the goals of Directive 2014/60/EU by further restricting the import and export of artworks.[6] The effect of the new law, which has proved highly controversial, has yet to be fully understood.[7]

5. Act Implementing the UNESCO Convention of 14 November 1970 on the Means of Prohibiting and Preventing the Illicit Import, Export, and Transfer of Ownership of Cultural Property, G. 5702, 2007. See http://www.eui.eu/Projects/InternationalArtHeritageLaw/Documents/NationalLegislation/Germany/germanyactconv19702007engtof.pdf.
6. Neuendorf, "German Cabinet Approves Controversial Cultural Heritage Protection Law," *Artnet News*, November 6, 2015. https://news.artnet.com/art-world/german-cabinet-approves-cultural-protection-law-356912.
7. Galerie Günter Puhze and Michael Henker, "Is the German Cultural Property Protection Act to Be Welcomed?" *Apollo Magazine*, December 21, 2015. http://www.apollo-magazine.com/is-the-german-cultural-property-protection-act-to-be-welcomed/.

The **United States** remains a cornerstone of the antiquities market, and its approach to the UNESCO Convention entails a unique effort to balance the public interest and the interests of private entities and individuals. The Convention on Cultural Property Implementation Act (CCPIA) (19 U.S.C. §§ 2601 *et seq.*) became United States law in 1983, and allows the President to restrict the import of cultural patrimony from a petitioning State Party if it is "in jeopardy from the pillage of archaeological or ethnological materials." The law thereby affords less blanket protection than the examples of Canada, Australia, Germany, and Switzerland, requiring evidence of jeopardy, rather than the simple contravention of export laws. It requires each nation seeking US import restrictions to apply to the State Department for a time-limited restriction, after establishing that they are active in preventing looting.

As of today there are some fifteen nations, from **Mali** to **Italy**, that have bilateral agreements with the United States under the CCPIA. These state parties apply through the Department of State for import restrictions, and the State Department's Cultural Property Advisory Committee (CPAC) reviews and refers applications it deems suitable to the President for signature. Integral to a successful application is evidence that the State Party applying "has taken measures consistent with the Convention to protect its cultural patrimony" and, among other determinants, "that remedies less drastic than the application of the restrictions set forth in such section are not available."

In recent years, CPAC has shown a willingness to accept most applications from source nations, even under circumstances suggesting that the state party in question is providing minimal resources to protect archaeological sites. The result is series of import restrictions incrementally more akin to other market nations than the CCPIA likely intended.

The application process for CPAC review is cumbersome, and the resulting memoranda of understanding with source

nations are subject to review and renewal after only a few years, which explains why so few nations have availed themselves of this path to restitution. The other recourse to restitute antiquities is through the US court system, which is today the prevailing mechanism favored by countries, and will be considered below.

How have source nations dealt with the UNESCO Convention?

Source nations have put an emphasis on restricting the export of antiquities. In 2003, **Argentina** passed Act. No. 25742, Protection of the Archaeological and Paleontological Heritage. The Act requires all private owners of archaeological and paleontological objects to report their ownership of such objects to an official registry. If the private owner of a registered archaeological object wishes to transfer the object, the owner is required to first offer the object to the Argentine government, which has the right to accept the object for a fair price.

Since 1993, **Peru** has amended its laws and implemented regulations prohibiting the export of any cultural heritage property, except temporarily for exhibition, specialized study, restoration, or travel of accredited diplomats. Any person who plunders, excavates, or moves any archaeological objects without authorization is subject to at least three years in prison.

Adoption of the 1970 Convention was particularly important in **China** because antiquities were believed to be the largest class of items smuggled out of the country. In 1982, China adopted and later amended the Law of the People's Republic of China on the Preservation of Cultural Relics, mandating state ownership of all cultural heritage and prohibiting the export of any relics unless examined by the State Council. Nevertheless, China has faced numerous enforcement challenges of the Cultural Relics Law, especially at the local government level.

Cambodia passed its Law on the Protection of Cultural Heritage in 1996, requiring a special export license for any cultural property. Article 54 of the Act requires the consideration of three factors before an export license may be granted: (i) whether the export will impoverish the national cultural heritage; (ii) whether public collections contain cultural objects similar to the object in question and (iii) whether the cultural object in question is of irreplaceable importance to a particular branch of study.

South Africa signed the 1970 Convention in 2003, but had already passed the National Heritage Resources Act 25 of 1999. The Act created the South African Heritage Resources Agency (SAHRA), which controls the identification, registry, and export of all South African cultural objects.

Libya adopted the Law Concerning Archaeological Monuments, Museums, and Documents in 1983, prohibiting the export of moveable antiquities without an export permit. The law also requires the Libyan Archaeological Authority to inventory any newly discovered antiquities as public property.

Iraq had an antiquities law in place since 1936, but amended the law after it joined the 1970 UNESCO Convention in 1973. The law deems all antiquities to be state property and prohibits the export of any antiquity outside of Iraq. With the political upheavals in the last few decades, foreign legislation has supplemented protection of Iraqi antiquities. For instance, the United States' Emergency Protection for Iraqi Cultural Heritage Act of 2004 and related regulations created strict import restrictions for looted archeological and ethnological materials arriving from Iraq.

Afghanistan signed the 1970 Convention in 2005, but had adopted the Law on the Preservation of the Historical and Cultural Heritage in 2004, creating a registry of cultural objects and prohibiting the sale of any registered cultural properties to foreigners. Furthermore, the export of any registered objects is prohibited, except if the state sends the property

abroad for international exhibition, research, or maintenance, or in exchange for historical and cultural properties conserved in foreign museums. A unique example of this procedure presented itself recently: between 2009 and 2012, Britain returned more than 2,300 smuggled Afghani cultural objects, which had been seized by British Customs and temporarily deposited in the British Museum until the objects were to be returned to Kabul.

In 2016, Khyber Pakhtunkhwa, one of the four main provinces in **Pakistan,** introduced a new bill intended to increase protection of antiquities in the region. The bill is intended to incorporate provisions from both the Khyber Pakhtunkhwa Antiquities Act, 1997 as well as Pakistan's Federal Antiquities Act of 1975. Pakistan ratified the UNESCO 1970 Convention in 1981.

Israel has not signed the 1970 Convention, but has nevertheless implemented legislation in 1978, which nationalized ownership of Israeli antiquities and in 1989 which created the Israel Antiquities Authority (IAA). Unlike other source nations, however, the trade of antiquities is still permitted in Israel. But the effectiveness of Israel's regulations on the trade of antiquities within its borders has been questioned, with the IAA reporting that of 14,000 registered archaeological sites, more than 11,000 have been looted since 1967 and there is widespread looting in numerous unregistered locations.

What treaties have come in the wake of the UNESCO Convention?

Although the 1970 Convention has continued to sign up nations at a steady rate, the private-public law divide was recognized from the outset as an unresolved challenge, and UNESCO undertook a parallel research effort beginning in 1982 to arrive at solutions for the illicit trade that could bridge the gap. It approached UNIDROIT (the *Institut international pour l'unification du droit privé,* or International Institute for

the Unification of Private Law) to draft new rules. UNIDROIT was first formed in 1926 as an affiliate of the League of Nations. After the League collapsed, UNIDROIT was reestablished in 1940 as an intergovernmental organization, which seeks to harmonize private international law, and is headquartered in Rome. Even before the 1970 UNESCO Convention, UNIDROIT had published a *Draft Uniform Law on the Protection of the Bona Fide Purchaser of Corporeal Movables* in 1968, which sought to implement many nations' protection of good faith purchasers of stolen goods in international trade. After the Draft was met by strong objections by member countries including the United States, the law was revised in 1975 to specifically exclude a good faith defense (Art. 11).

After almost a dozen years of deliberations, the Italian government hosted a conference in June 1995, during which the text of a new intergovernmental agreement, the Convention on the International Return of Stolen or Illegally Exported Cultural Objects, was signed. To date, only thirty-seven nations are signatories. But many of the leading art-collecting nations are not, including the **United States**, **Great Britain**, **Germany**, **Switzerland**, and **Japan**. The objections of some of the art-importing nations center around the relevance of the 'good faith' exception when making purchases as an exception to works subject to restitution.

What is meant by "good faith"?

Good faith is a legal construct dating back to ancient Rome, when "bona fide" was used to denote implied trust in transactions. The premise that the buyer of a stolen object acted in good faith—in other words was unaware of its illicit status—serves as a form of protection in most nations. The distinction between legal systems boils down to how entitlement to possession is viewed. In the United States and Great Britain, the current possessor may not have legal title, while civil law nations focus on whether the party acquiring an object, stolen or

not, did so in good faith.[8] In multiple nations from Sweden to Chile, the law requires that a good faith buyer be entitled to reimbursement in the event that the work is returned to another party. Both the UNESCO and UNIDROIT conventions protect the good faith purchaser as well. The requirement that owners should compensate good-faith buyers when restituting examples of what they deem to be stolen cultural heritage is a deal-breaker for the United States and Britain, which insist that the specific facts and circumstances of each case should be resolved through individual court actions rather than the blanket solutions favored by civil law nations.

Like UNESCO's 1970 Convention, UNIDROIT's 1995 Convention cannot reasonably be said to have cured the challenges attendant to looted works or chance finds ending up in the international art trade. The divergent points of view between market nations and source nations have rendered international treaties ineffectual. In their place, source nations have increasingly chosen the courts in other nations to pursue restitution, with a predictable patchwork of results.

8. For a more in-depth examination of the meaning of "good faith" in the purchase of antiquities, see Derek Fincham, "Towards a Rigorous Standard for the Good Faith Acquisition of Antiquities," *Syracuse Journal of International Law and Commerce* 37, no. 1 (August 14, 2009): 145–206.

7

NATIONAL LAWS AND STATUTES

How do national laws intersect with foreign legal systems?

The relative ineffectiveness of international treaties has led source countries to pursue looted works through national courts. Turkey enacted a law in 1983 titled the Law on Protection of Cultural and Natural Antiquities, which strengthened earlier legal instruments dating back to 1906 and 1973.

Four years after its enactment, in 1987, Turkey sued the Metropolitan Museum of Art in Manhattan federal court under US law for the return of its famed "Lydian Hoard," consisting of 363 examples of sixth-century BC gold, silver, and bronze vessels and implements, along with jewelry, wall paintings, and sculpted sphinxes. Although the case was brought in the United States, Turkey relied upon its 1983 Law on Protection of Cultural and Natural Antiquities to establish that the collection was exported illegally from Turkey, and was therefore stolen property when the Metropolitan acquired the collection. The Metropolitan had acquired the collection in separate purchases beginning in 1966 and ending in 1970. It filed a motion for dismissal on the basis of the statute of limitations, and the allegation that its purchase had

been "in good faith" under New York's unique demand and refusal rule.[1]

But when Judge Vincent L. Broderick acceded to the Turkish request for an inspection of the relevant holdings, damning evidence of the original looting in early 1966 came to light. After six years of legal wrangling, the Metropolitan agreed in September 1993 to return the Lydian Hoard, together with an admission of likely wrongdoing by some of its staff upon making the initial purchase.[2]

Turkey was emboldened by this victory and set about pursuing other objects it believed to be looted, approaching Sotheby's auction house and multiple museums in the United States and Europe, and retrieving multiple antiquities in the process. But corruption and incompetence led to the disappearance of key examples of the Lydian Hoard once back on Turkish soil, and legal efforts slowed in the later 1990s, only to resume in 2012.

Like Turkey, Italy has successfully used the US legal system to retrieve stolen artifacts. In September 1995, the raid of a storage facility in the Geneva Freeport brought to light thousands of looted artifacts in the possession of Giacomo Medici, who was convicted in Italy a decade later of trafficking in stolen antiquities.[3] The trove of objects and accompanying documentation laid bare how

1. The "good faith" purchaser under the New York demand and refusal rule is slightly different from civil law's "good faith" exception. Under the New York rule, an innocent purchaser of stolen goods lawfully possesses those goods until the purchaser refuses the legal owner's demand for the goods. The New York rule is arguably more favorable to the legal owner because it allows claims to be brought years after the initial misappropriation of the work. For a full discussion of the New York rule, see Judith Wallace, "New York's Distinctive Rule Regarding Recovery of Misappropriated Art After the Court of Appeals' Decision in Mirvish v. Mott," *Spencer's Art Law Journal* 3, no. 1 (June 2012).
2. *Republic of Turkey v. Metropolitan Museum of Art*, 762 F. Supp. 44 (S.D.N.Y. 1990).
3. Corte App., Roma, Sez. II Pen., 15 luglio 2009, n.5359; Cass. Pen., Sez. II, Sent., (ud. 07-12-2011) 22 dicembre 2011, n. 47918.

extensive and sophisticated the looting of antiquities from Italian soil had been for the previous decades. The evidence retrieved in 1995 continues to be used for investigations and indictments up until the present day, at the altogether deliberate speed of the Italian justice system. Successful claims for works implicated in Medici's archive—which includes some 5,000 snapshots of works immediately after being unearthed—have emptied multiple public and private collections of objects over the last twenty years.

The Italian justification for pursuing illegally exported antiquities rests on a 1939 law Concerning the Protection of Objects of Artistic and Historic Interest. The law, enacted under fascist leader Benito Mussolini, nationalized antiquities and required export licenses of any such works before being eligible for sale. Additional legislation was enacted in 2002 and 2004, which further tightened export restrictions.[4]

The Greek strategy indicates both a desire to compromise and a strengthening of internal legislation to return illegally exported art works. For instance, in 2008, the Greek government passed the Measures for the Protection of Cultural Goods, to enhance enforcement of its legislative cultural property protection.[5] One modification included application of the Greek statute of limitations period for criminal offenses rather than the limitations period of the jurisdiction where the crime occurred. This potentially extended the time

4. Legislative Decree No. 42 of 22 January 2004—Code of the Cultural and Landscape Heritage (It.), http:// www.unesco.org/ culture/ natlaws/ media/ pdf/ italy/ it_ cult_ landscapeheritge2004_ engtof. pdf.

5. On Measures for the Protection of Cultural Goods, Law No. 3658/ 2008 of Apr. 22, 2008 (Greece). The Greek government revised and updated its laws on antiquities in 2002 with the passage of Law 3028/2002 "On Protection of Antiquities and Cultural Heritage," which generally prohibits the export of cultural objects from Greece. See Greece, Law No. 3028/2002 of June 28, 2002 (On the Protection of Antiquities and of the Cultural Heritage in General). However, qualified antiquities merchants and dealers may obtain a two-year export license for legally acquired objects (Art. 32). Further, if an

period for Greek authorities to pursue criminal prosecutions in Greece.[6]

However, Greece's most famous attempt to recover Greek antiquities in foreign court systems concluded quietly. In May 2015, the Greek Government announced it would not pursue legal action against the British Government for the return of the Parthenon Marbles, turning instead to diplomatic and political channels in seeking the marbles' return. We will consider the Parthenon marbles in greater detail in chapter 14.

The Greek efforts have also resulted in mutually beneficial settlement agreements. In 1994, the Greek government filed suit against New York antiquities dealer Michael Ward, after Greece was alerted that Ward, notably a member of CPAC, intended to sell a collection of Mycenaean jewelry that had been identified as looted. Before the case went to trial, the parties settled, with Ward agreeing to donate the works to a charity, the Society for the Preservation of the Greek Heritage, which in turn returned the works to Greece. While Greece ultimately obtained ownership of the works, the donation also allowed Ward to obtain a healthy tax break. Thomas Hoving noted that the resolution was "one of the most creative, and potentially the single most effective, schemes to regain smuggled works in the history of the game."[7]

Cambodia has also been active in recent years in pursuing examples of its heritage in foreign museums. Recent claims have led to the successful restitution of temple sculptures from

object has been illegally exported, then the claim is assumed by the State. See Ira Kaliampetsos, "Combating Looting and Illicit Trafficking of Cultural Objects in Greece—Administrative Structure and New Legislation." Paper presented at the Ninth Mediterranean Research Programme—European University Institute Florence 12–13 March 2008. Edited by Robert Schuman Centre for Advanced Studies. Florence: Hellenic Society for Law and Archaeology, 2008.

6. Law No. 3658 (art. 13) (Greece).
7. Mary Walsh, "A Grecian Treasure: Back From the Grave?" *Los Angeles Times*, August 12, 1996. http://articles.latimes.com/1996-08-12/news/mn-33617_1_aidonia-treasure.

US museums ranging from the Metropolitan Museum of Art to the Norton Simon Museum in Pasadena, California.

Nigeria is among those sub-Saharan African nations that have suffered most from looting. Its 1989 *Déclaration des États ACP sur le retour ou la restitution des biens culturels* is a less than airtight instrument in protecting national heritage, focusing on the need for documentation and inventories of works in member states of the ACP (African, Caribbean, and Pacific Group of States). This was followed by a declaration in 2000 called the *Accord de Cotonou*, which offers a single sentence exhorting ACP member states to restitute works when legitimate claims are filed. Nigeria's lack of reliance on binding laws regarding cultural property is in part a function of skepticism about their efficacy, according to Folarin Shyllon.[8]

What are the differing laws among so-called 'source' countries protecting ancient artifacts?

Returning to the United States, aggrieved state parties have recourse to the courts through the relatively recent application of a 1934 law, the National Stolen Property Act (18 U.S.C. § 2314). The NSPA expressly prohibits the movement of stolen, converted, or fraudulently acquired goods valued at $5,000 or more, and is applicable in both interstate and foreign commerce.

The NSPA was first invoked for a cultural property case in 1974, in United States v. Hollinshead.[9] This was a clear-cut

8. Folarin Shyllon, "Looting and Illicit Traffic in Antiquities in Africa," in *Crime in the Art and Antiquities World: Illegal Trafficking in Cultural Property*, eds. Stefano Manacorda and Duncan Chappell, 135–142. New York: Springer Science & Business Media, 2011; Folarin Shyllon, "The Nigerian and African Experience on Looting and Trafficking in Cultural Objects," in *Art and Cultural Heritage: Law, Policy and Practice*, ed. Barbara T. Hoffman, 137–145. Cambridge, MA: Cambridge University Press, 2006.
9. U.S. v. Hollinshead, 495 F.2d 1154 (Court of Appeals, 9th Circuit 1974).

instance of criminal intent, involving a Mayan stele stolen and imported from Guatemala to the United States. Five years later, a more complicated case, United States v. McClain, involved artifacts stolen from Mexico. The court concluded that declaration of national ownership of all cultural objects, but not physical possession, is necessary for the illegal exportation of an article to be considered theft within the meaning of the NSPA.

However, the Fifth Circuit also concluded that the Mexican law in force when the artifacts were illegally imported did not adequately declare absolute ownership of the pre-Columbian objects at issue. As a result, some of McClain's convictions were reversed, but the legal precedent of honoring a foreign cultural patrimony statute was upheld.[10]

The ensuing effect of the Fifth Circuit's rulings was seismic, signifying that when an antiquity enters the United States after being illegally exported, it can be categorized as a stolen good imported in violation of the NSPA, if the source country has declared unambiguous ownership of such property.

The most clear-cut and successful application of the NSPA to build on the legal precedent of the McClain case was United

10. United States v. McClain (McClain 1), 545 F.2d 988 (5th Cir. 1977), *reh'g denied*, 551F.2d 52 (Court of Appeals, 5th Circuit 1977); United States v. McClain (McClain II), 593 F.2d 658 (Court of Appeals, 5th Circuit 1979), *reh'g denied* 444 U.S. 918 (1979). The Fifth Circuit found that five Mexican statutes dated between 1897 and 1972 declaring state ownership of pre-Columbian objects were cumulatively insufficient to establish the Mexican Government's ownership of the disputed imported objects because it was unclear when the defendants had imported the goods. It was not until 1972 that Mexico unequivocally declared ownership of *all* pre-Columbian objects. Such ambiguity was found to potentially violate the defendants' due process rights, thus reversing the substantive violations of the NSPA. But the court nevertheless convicted the defendants for conspiracy under the NSPA. The Fifth Circuit also concluded that objects imported after June 5, 1972 (the date of the statute's enactment), would be deemed "stolen" from the Mexican Government.

States v. Frederick Schultz, beginning in 2001. Schultz was accused of falsely representing a looted Egyptian antiquity as a replica on its import documents into the United States. His defense was that he was unaware of a 1983 Egyptian law vesting title in Egypt and banning exports of cultural property without a license. His conviction and imprisonment sent shockwaves throughout the United States, since it indicated renewed US interest in prosecuting cases on behalf of other countries.[11]

What are the export restrictions of art-rich nations?

Over the last generation there has been an awakening of interest in export restrictions internationally. A 255-page digest of such export laws and statutes was published by UNESCO in 1988, reciting chapter and verse the statutes of 162 nations, from Afghanistan to Zimbabwe. There is predictably much variety among national regulations, ranging from complete prohibition of circulation to requirements of documentation of exports. The consequences of illegal export range from confiscation and fines to imprisonment. And the definition of cultural property believed to be under state control varies, from archaeological material to a more broader interpretation.

More up-to-date resources are on the Internet, most notably UNESCO's national laws database. In addition, the International Cultural Property Ownership and Export Legislation (ICPOEL) is a useful, highly detailed resource, but is behind the pay wall of the International Foundation for Art Research.[12]

11. United States v. Schultz, 178 F.Supp. 2d 445 (S.D.N.Y. 2002), *aff'd*, 333 F.3d (2d Cir. 2003), *cert. denied*, 540 U.S. 1106 (2004).
12. UNESCO, "UNESCO Database of National Cultural Heritage Laws." http://www.unesco.org/culture/natlaws/.

What are the import restrictions of nations where collecting is robust?

Those nations that are signatories to the 1970 UNESCO Convention have for the most part enacted laws that cover both export from source countries and import into their respective nations. A variety of positions following the Convention's adoption is summarized on UNESCO's website.[13]

How and where are stolen works seized by government authorities?

Customs officials at ports of entry are in some instances being trained to recognize antiquities, although as the Schultz case demonstrated, thieves and smugglers can be sophisticated at masking or altering the appearance of ancient objects so that they appear to be modern replicas. And many small antiquities in precious metals can be easily hidden in large shipments of other goods, or even in checked luggage. Accompanying documentation to prove legal export can be forged, and customs officials have to be alert to this possibility as well.[14]

Notwithstanding the efforts by some countries to train their border police to recognize looted works, there is no integrated system to alert authorities to recent plunder or specific thefts.

13. The relevant material can be found under the "Monitoring" section of UNESCO Convention on the Means of Prohibiting and Preventing the Illicit Import, Export and Transfer of Ownership of Cultural Property.
14. Customs officials may sometimes target events in the art market. For instance, in March of 2016, United States Customs officials raided several South Asian antiquities dealers during Asia Week New York, an annual celebration of Asian art that often results in a spike in sales of Asian antiquities. See Tom Mashberg, "Federal Agents Seize What They Called an Illicit Antiquity Headed for Asia Week," *The New York Times*, NyTimes.com, March 15, 2016. http://www.nytimes.com/2016/03/16/arts/design/federal-agents-seize-what-they-called-an-illicit-antiquity-headed-for-asia-week.html?nytmobile=0.

The nearly twenty-year old "Object ID" program launched by the Getty Information Institute and supported by the International Council of Museums (ICOM), was born in the proto-digital age, and provided scant information reliant on documentation of known works.

In the absence of a sophisticated international information-gathering protocol, some state authorities turn to databases maintained by private concerns, such as the Art Loss Register. But the weakness of any illustrated database is that objects spirited out of the ground at night are not documented—and so cannot be traced. This leaves border officials with no choice but to make judgment calls. And often as not, that judgment may extend to corruption, with the acceptance of bribes to look the other way, as shipments of innocuous goods may include a single crate with stolen artifacts.

In May 2015 the signatories to the 1970 UNESCO Convention took the step of adopting, by consensus, the 1970 Operational Guidelines for the Implementation of the Convention on the Means of Prohibiting and Preventing the Illicit Import, Export and Transfer of Ownership of Cultural Properties (hereinafter OGs). Within the OGs, Guideline 58 reads as follows: "State Parties should prohibit the entering into their territory of cultural property, to which the Convention applies, that are not accompanied by such export certificate . . . [The absence of] the export certificate should make illicit the import of that cultural property into another State Party, as the cultural property has not been exported legally from the country affected."[15] Just as application of the NSPA within the United States codifies the need for an export license, the OGs offer a compelling instrument for any aggrieved source country.

15. Operational Guidelines for the Implementation of the Convention on the Means of Prohibiting and Preventing the Illicit Import, Export and Transfer of Ownership of Cultural Property (UNESCO, Paris, 1970), 2015. http://www.unesco.org/new/en/culture/themes/illicit-trafficking-of-cultural-property/operational-guidelines/.

The picture that emerges from attempts to harmonize and legislate international and national treaties, laws, and statutes, is one of mixed success. Perhaps as significant as the codification of state ownership is an emerging public consciousness that the theft of antiquities is linked to organized crime, and to terrorist organizations. The stigma attached to purchasing an unprovenanced antiquity from Syria in the age of ISIS may prove as powerful a deterrent as any law.[16] And the awakening of national pride among source nations, together with the revulsion in market nations at how exploitation of cultural resources is destroying an irreplaceable past and fueling criminal activity, may be the most potent result of the diplomatic and legal debate that began in earnest with the 1970 UNESCO Convention.

16. One such legislative deterrent in the United States currently awaits the signature of the President. By April 2016, both the United States House of Representatives and Senate had passed H.R. 1493, a bill intended to restrict the import and sale of looted antiquities from the Islamic State of Iraq and Syria. The #CultureUnderThreat Task Force concurrently supplied a list of recommendations that would not only increase governmental involvement in the antiquities market, but also create a trade organization for art dealers that would monitor which art dealers abide by prescribed ethical codes and best practices.

8

MODERN NATIONAL IDENTITIES

What modern nations first codified the concept of cultural patrimony or state ownership?

Proprietary instincts to protect archaeological heritage as a function of national, rather than religious or cultural identity, originated by definition with the rise of nation-states. Throughout European history, the aggregation of defined populations into modern nation-states has taken many forms. The Dutch, aligned in Protestantism and a belief that their Republic could be correlated with ancient antecedents, forged a national identity as far back as the late sixteenth century, united in their defense against Catholic Spain. By the eighteenth century, Britain rose up as another great Protestant power, bonded by a common language, commercial strength, and the need for unification to defend itself against Catholic France. For most of its history, Italy was composed of a series of independent states sharing a common heritage in ancient Rome, and a common language, but effectively isolated one from another. Papal influence dominated and precluded a sense of nationalism that would ultimately challenge the hegemony of the Catholic Church. In Spain to this day, most identify with their region, describing themselves as Catalans or Castilians ahead of being Spaniards. For Germans, the common bond of a language did not guarantee that multiple principalities would eventually

coalesce under a national identity, split as they were between Protestants and Catholics. It was the monarchy that defined France, rather than a developed concept of a nation, right up until its population was represented by a central government within a defined geographical territory with the creation of the French Republic in 1792, following the monarchy's demise during the French Revolution.

The American Revolution spawned a new concept—a nation-state built not on the strength of a unifying religion, language, or ethnic identity, but on the foundation of a representative political system. It may be inevitable that as a function of the deracinated origins of its citizenry, the United States is largely indifferent to the protection of its cultural heritage, with the exception of indigenous traditions predating the invention of the modern state.

The great civilizations of South, East, and Southeast Asia took various paths to modern national identities, but were typically aligned as a function of linguistic traditions. In China, religious devotion, rather than any concept of statehood, ensured the protection of historic monuments, temples, tombs, and antiquities.

How much does state ownership depend on national identities?

Claims to state ownership of antiquities were a natural outgrowth of the rise of national identities. With the emergence of statehood came pride in ancestral origins, even if embroidered to the point of invented memories. Pride in the cultural heritage of a nation naturally yields a protective instinct, which is ultimately translated into proscriptions against the loss of or damage to that heritage.

A complicating factor in such proscriptions is that national boundaries rarely correspond precisely with the extent of artistic influences in antiquity. For much of ancient history, southern Italy was an extension of Greece, called Magna Graecia. Beginning in the 8th century BC, colonies of Greek city-states

were founded not only in what are modern-day Calabria, Puglia, and Sicily, but also as far afield as the Black Sea, North Africa, and the southern coast of France. The Greek heritage in each of the many modern states that overlay the relevant terrain is claimed, understandably, to be part and parcel of their national identity.

Before a state goes to the trouble of asserting ownership rights to a natural or manmade resource or commodity, it has to care about it. But in some instances the overlay can make for unnatural bedfellows based on religious or political viewpoints. As we touched on in chapter 1, the Western appreciation of antiquity dates as far back as ancient Rome, when the Greeks were considered ancient, and their cultural achievements were protected and appropriated throughout the Roman Republic and Empire. Within the stylistic choices made by Roman artists toward the end of the empire, an anticlassical style gained favor, leading to large-scale projects in which competing styles of sculptural reliefs coexist. This style was evident on public monuments dating as far back as the early third century AD, when the Libyan emperor Septimius Severus (reigned 198–211) seems to have encouraged Rome's embrace of a 'provincial' artistic style from North Africa as an act of political advocacy.[1]

Many Egyptian monuments too survived for millennia, given that religious practices remained relatively constant across multiple dynasties. But appreciation of the past was not universal in Egypt. Iconoclasm, or the intentional destruction of monuments or relics based on politics or religion dates back to the Amarna Period, within the last half of the 18th dynasty, in the mid-1300s BC. At that time, the rulers Apophis and Akhenaten looked with disfavor upon the traditional gods of Egypt, and imposed monotheism and the worship of Aten.

1. François Baratte, *Die Römer in Tunesien und Libyen: Nordafrika in Römischer Zeit* (Darmstadt/Mainz, Germany: Verlag Philipp von Zabern, 2012), 86, 144.

With that edict, countless examples of Egyptian heritage were defaced or destroyed, a reign of terror that only ended when Tutankhamun was crowned Pharaoh in 1332 BC.

Such bouts of iconoclasm have recurred throughout history, right up to the present. During the Cultural Revolution in China in the late 1960s and early 1970s, incalculable damage was inflicted on Chinese heritage by the Red Guard, who were tasked in 1966 with the elimination of the "Four Olds" (old customs, old culture, old habits, and old ideas). The wholesale destruction of entire sites, temples, monuments, and material evidence of the past in every imaginable form was understood to be essential to building a modern China. And the loss to cultural heritage can only be guessed at, since unlike the devastation wrought by the Nazis in the Second World War, there was no detailed documentation of the ravages at the hands of the Red Guard.

In Central Asia, the Taliban in Afghanistan looked askance at remnants of Buddhism in a majority Muslim nation, leading to the horrific destruction of the Bamiyan Buddhas in the spring of 2001. In more recent times, the detonation of monuments in Syria and Iraq at the hands of ISIS is believed to be a purifying act, ridding the erstwhile Caliphate of the remains of civilizations predating Islam.

Indifference to or antagonism toward the cultural inheritance of past civilizations is exacerbated when modern political or religious extremism is given state approval. But a nation's identity can be bound up with any number of intellectual justifications. Italian dictator Benito Mussolini came to power in 1922 and looked to ancient Rome for inspiration, festooning his propaganda efforts with direct appropriations of classical symbolism. The very word fascism derives from the ancient Roman *fasces*, or wooden rods tied together by a red band, with ax head protruding.[2] Mussolini sought to portray his ascension

2. *Fasces* symbolized the authority of a Consul, and were carried by Lictors to herald his arrival of a Consul.

to power as the rebirth of the ancient Roman Empire, and in so doing ordered the emulation of ancient sculptural and architectural symbolism in state-commissioned public spaces and buildings.

Have there been successful challenges to state ownership?

Acts of war can lead to disequilibrium in ownership rights long after the cessation of hostilities. Priam's Treasure offers an example of how disinterred antiquities can find themselves entangled in state party tug-of-wars almost two centuries later. Excavated in Hissarlik in northwestern Anatolia (modern-day Turkey) by Heinrich Schliemann in 1837, the hoard of gold and copper works were carried off to Berlin, where they were mistakenly heralded as treasures of ancient Troy.[3]

During the Soviet Union's invasion of Berlin at the end of the Second World War, the looted works, collectively identified as Priam's Treasure, were seized and dispatched to Russia. Although rumored to be in Russian hands over the intervening decades, it was not until a 1996 exhibition at Moscow's Pushkin Museum that the location of the hoard was confirmed.

Relations between the Federal Republic of Germany and the Russian Federation have been strained to this day in no small part over disagreement about which nation should possess these works. Vladimir Putin's rationale for retaining Priam's Treasure is that it is reparation for German aggression against Russia. But Chancellor Angela Merkel notes that a treaty signed in 1990 obligates Russia to restitute the cultural property seized during the course of World War II.

3. Whether this misnomer was a mistake or intentional has been the subject of debate, given Heinrich Schliemann's apparent propensity for misrepresentation. See David A. Traill, "Schliemann's Discovery of 'Priam's Treasure': A Reexamination of the Evidence," *The Journal of Hellenic Studies* 104 (1984): 96–115.

To date there has been no progress in resolving the fate of Priam's Treasure. The complexity of the situation is further compounded by Turkey's potential claim to this hoard, which was excavated during Ottoman rule, almost a century prior to the founding of the modern Republic of Turkey under Mustafa Kemal in 1923. Over two decades ago, Patty Gerstenblith argued that Turkey had a solid claim to the hoard as the natural successor state to the Ottoman Empire; her opinion is highly relevant since she today chairs the U.S. State Department's Cultural Property Advisory Committee.[4]

All three modern states look upon the artifacts as rightly theirs, and the basis to agree on a final resting place remains impossible to reach. The modern identities of each state party are bound up in retrospective thinking. While the law might favor Germany's claim simply on the merits of repose—its century-long possession of the treasure beginning as far back as the early nineteenth century—the emotional claims of both Turkey and Russia can be understood just as clearly.[5] So often these entanglements rely not on the law, but on politics and a sense of entitlement spawned from associating cultural goods with national identity.

4. Patty Gerstenblith, "Turkey Has Good Claim to Gold of Troy," *The New York Times*, October 9, 1993. http://www.nytimes.com/1993/10/09/opinion/l-turkey-has-good-claim-to-gold-of-troy-242493.html.
5. The legal concept of repose means that the status quo should remain, unless there is a compelling legal reason that prompts a change. But the principles of repose could also be argued in favor of Russia since the artifacts have remained safely in Russia for more than seventy years. However, Germany maintains that under international law, the taking of cultural property is always illegal, even during wartime. Furthermore, Russia's assertion of valid title by prescription could also fail because the artifacts were hidden for more than fifty years. For a full discussion of the merits of each nation's legal arguments see S. Shawn Stephens, "The Hermitage and Pushkin Exhibits: An Analysis of the Ownership Rights to Cultural Properties Removed from Occupied Germany," *Houston Journal of International Law* 18, no. 1 (1995): 59–112.

What if the evidence of state ownership is unclear?

The late Roman Sevso Treasure illustrates a different challenge in adjudicating the potential restitution of artifacts based on national identity. In this case, the alternatives are not as clear-cut as the choices facing Priam's Treasure. The first example of the Sevso Treasure, from what would later be revealed to be a magnificent hoard of fifteen silver vessels, appeared together with a copper cauldron on the London art market in 1980. Vienna-based Serbian dealer Anton Tkalec offered documentation alleging that the ensemble had been discovered in Lebanon's Tyre and Sidon regions, and the Getty Museum in Los Angeles was eventually approached as a possible buyer. By 1990, the treasure remained unsold, and was put on display at Sotheby's in New York, with an ostensible provenance of Phoenicia in the Eastern Roman Empire. The first showing of the hoard was marked by disputes over the provenance, leading to claims by no fewer than four governments: Lebanon, Yugoslavia, its successor state Croatia, and Hungary. Multiple twists and turns ensued in the press and in courts internationally.

In the spring of 2014 the Treasure was broken up, when the Hungarian government announced its purchase of the copper cauldron and seven examples of the Treasure. This outcome is akin to removing sheets from a manuscript for purchase; the vessels were linked in both style and subject matter. The hoard was in all likelihood buried together in antiquity, even if individual examples may have had somewhat different dates of manufacture. It is thus a less than ideal result to have a single treasure dispersed in this way, since the items acquired by Budapest leave orphaned single works behind.

This more than generation-long squabble over one group of artifacts underlines the fact that ancient cultures spanned landmasses that today bear national identities grafted onto past cultures under their soil. Thus while solidly documented claims of cultural ownership are legitimate in the eyes of international law, those claims with sketchy or nonexistent

documentation lay bare how challenging it can be to couple national identity with remains of the remote past. Modern entrants on the art market have only rarely yielded multiple national claimants, but other examples exist and certainly await us in the future.

Are there legitimate claims of state ownership decoupled from national identity?

The Mahdia shipwreck illustrates how fate can deposit cultural heritage in unforeseen hands. A group of Greek sponge-divers were off the Tunisian coastline in 1907, when they happened upon the remains of a sailing vessel which sank as early as 80 BC. Named for the neighboring town of Mahdia, the ship was likely blown off course while attempting to sail from Athens to Italy. The ship's contents, today in the Musée national du Bardo in Tunis, included a significant number of bronze and marble sculptures, furniture elements, and decorative objects, along with marble columns and military equipment. Among the finds was a bronze herm of Dionysus, inscribed with the signature of Boethos of Chalkedon, a sculptor of the first-century BC. As an ensemble, the cargo was almost certainly en route to one or more Roman collectors. The appetite for Greek art among well-to-do Roman Republicans was noteworthy, and led to the formation of major collections in Italy.

Tunisia was the fortunate beneficiary of this accident during transit. That these Hellenistic artworks recovered at the beginning of the twentieth century are by any legal interpretation clearly Tunisian cultural heritage is beyond dispute. But the objects themselves ended up far from home purely by chance, driven perhaps by the *scirocco*, the unpredictable winds from the Sahara blowing into the Mediterranean. Their resting place on the bottom of the sea off the eastern coast of Tunisia is in no way connected with their origins or their intended destination. But no other modern nation could make a plausible claim for them, given the fact that they were in transit in antiquity.

This third instance of displaced antiquities is the most provocative for our purposes. While Priam's Treasure was clearly indigenous to ancient territory known today as Turkey, and circumstantial evidence linked the Sevso Treasure to modern Hungary, the pertinence of the Mahdia shipwreck to the national identity of Tunisia is literally accidental. That makes it no less deserving of possession. But the spectrum of relevance of ancient art to modern nationhood is vast, reinforcing the need to evaluate each claim and counterclaim on the basis of its individual merits.

Are there recently formed nations with looser claims to state ownership?

The newest state parties in the United Nations—such as South Sudan (2011), Kosovo (2008), Montenegro (2006), Serbia (2006), East Timor (2006), Palau (1994), Eritrea (1993), the Czech Republic (1993), and Slovakia (2003) have varying degrees of archaeological heritage. Montenegro has been subjected to organized looting of shipwrecks since before its independence from what was the Federal Republic of Yugoslavia. In some ways, the fiercest advocates of coupling archaeological heritage with modern identity are likely to be the newest nations. Any international body would honor claims made by any legitimately formed nation, regardless of when it obtained independence.

9

CHANCE FINDS, EXCAVATION, AND LOOTING

What are the differences among chance finds, excavation, and looting?

The circumstances of any discovery invariably set in motion presumptions about its eventual fate. A *chance find* denotes a work's accidental discovery in the course of activities such as the demolition or renovation of an existing structure, or earth removal in preparation for a public works project such as a tunnel, subway, road, or bridge. Almost any human activity involving disturbance of the soil, or informal exploration off a coastline, can result in a chance find.[1]

An *excavation* usually refers to the state-sanctioned exploration of an archaeological site, often in the aftermath of a chance find. Excavations can last for generations, such as the ongoing excavation of Pompeii, or they can be rescue archaeology, when a major public works or development project will not be held up but allow a window of time to remove archaeological evidence before it is covered up or lost to destructive digging.

1. In March 2016, a Chinese man was arrested on suspicion of illegally planning to sell ancient pieces of pottery and a sword that he excavated from a tomb on his property in the Shaanxi province in China. The tomb was discovered by workmen who were digging a well on his property. See Catherine Wong, "Chinese Man Arrested on Suspicion of Planning to Sell Ancient Artefacts He Found in Tomb Buried in Backyard," *South China Morning Post*, March 25, 2016.

Looting is the illegal removal of archaeological material, sometimes the result of chance finds, or increasingly the result of sophisticated scavenging by means of electronic tools—everything from remote sensing to radar or sonar, to metal detectors, all the way to strip mining with moving equipment.

How do different nations treat chance finds?

As so often in matters of law, the intention of an individual involved in a given situation may color evaluations of their act. A landowner who accidentally discovers an ancient tomb under his or her private property will face different remedies in different nations, sometimes based on how promptly public authorities were notified. A tourist on a boat who hauls up a net containing a 2,000-year-old wine amphora off the coast of Turkey may face imprisonment, while the same tourist might be able to sell it if retrieved off the coast of Israel. In general, an antiquity brought to light by a private individual is considered state property.[2] If the land on which an object is recovered is the private property of an individual, she or he is often entitled to retain physical possession, provided that it is never sold to a party outside the nation of modern discovery, and never leaves the borders of that state party.

What kinds of shipwrecks have been discovered to date?

UNESCO estimates that there are over three million shipwrecks around the world.[3]

2. Countries declaring state ownership include Brunei, Bulgaria, China, Cyprus, Dominican Republic, Greece, Haiti, Hong Kong, Hungary, Iceland, Iraq, Israel, Italy, Kenya, Kuwait, Libya, Malaysia, Mexico, New Zealand, Peru, Romania, Sri Lanka, Sudan, Taiwan, Tanzania, Tunisia, Turkey, Venezuela, and the People's Democratic Republic of Yemen. Lisa J. Borodkin "The Economics of Antiquities Looting and a Proposed Legal Alternative," *Columbia Law Review* 95, no. 2 (1995): note 103–104.
3. UNESCO News Service, "Underwater Cultural Heritage Convention on the Protection of the Underwater Cultural Heritage Will Enter into Force in January 2009," October 14, 2008.

Over more than three thousand years of seafaring, that would equate to an average of one thousand lost vessels every year since the Bronze Age. But only a tiny fraction of them have been explored. By way of example, the Archaeological Institute of America lists just three fieldwork opportunities in Italy which entail underwater archaeology. And this in the nation estimated to have among the highest concentrations of archaeological sites in the world.[4]

Shipwrecks offer a tantalizing opportunity for archaeologists, since these are in effect time capsules, which, if discovered relatively undisturbed, can yield remarkably detailed information about both the cargo on board and the presumed origins and destination of the vessel. They can also provide extraordinary insight into the geopolitics, economies, and artistic inclinations of any given period of the ancient world.

What separates shipwrecks from terrestrial excavations is the probability, rather than the possibility, that the cargo lost at sea was of considerable value, warranting the expense and risk of a voyage across the Black Sea, Mediterranean, Red Sea, Atlantic, or Pacific Oceans, or countless other bodies of water. As a result, shipwrecks are likelier to yield objects of high market value and collecting interest than typical terrestrial excavations. Often as not, ships bound for other ports were carrying cargo of great economic interest, and frequently included precious objects either destined for sale in foreign markets or the booty of conquest, salvaged from a defeated enemy and bound for appreciation back home.

What are the ownership laws governing shipwrecks?

International waters begin 13.8 miles (22.2 kilometers or twelve nautical miles) from the low-water mark of a given

4. "Archaeological Fieldwork Opportunities Bulletin," Archaeological Institute of America. https://www.archaeological.org/fieldwork/afob.

coastal state party, as defined by the 1982 United Nations Convention on the Law of the Sea.[5] Thus any shipwreck found more than twelve nautical miles from shore is subject to the Law of the Sea, and not the laws of the neighboring state party.[6] UNESCO's 2001 Convention on the Protection of the Underwater Cultural Heritage, which seeks to offer protection for shipwrecks, has not been ratified by many countries with longstanding seafaring heritage nor by the majority of those countries with significant art markets.

A cottage industry of private exploration companies has emerged in recent decades, engendered by the allure of gold bullion and coins on board trading vessels from the sixteenth century onwards. Discoveries of such shipwrecks are clustered along the eastern coastlines of North and South America. Such expeditions are rarer in bodies of water frequented in antiquity, given the lack of documentation attesting to lost treasure. But along with incremental improvements in the ability to detect and evaluate the contents of sunken vessels will doubtless come an increase in the pursuit of ancient shipwrecks. And the loss of information attendant to commercial exploitation of ocean floor remains will be incalculable.

The commercial salvage-like activities disturbing underwater sites are already reaching crisis proportions. A highly romanticized enterprise, it is wreaking havoc on the ocean floor, disrupting contexts in a single-minded quest for precious objects. This type of trophy-hunting is comparable to the ivory trade, given that a finite and irreplaceable commodity—in this case not elephants but information—is being sacrificed as speculators sift through the fragile remains of a seafaring vessel once bearing not only cargo but the sailors entrusted with its safe passage.

5. "United Nations Convention on the Law of the Sea," December 10, 1982, Part II, sec. 2, art. 3.
6. As of June 2016, the Convention has been adopted by 168 countries.

The recent discovery of the San José, a sunken vessel off the coast of Colombia, is estimated to contain as much as $17 billion of gold, and is understandably the subject of a court battle.[7] British warships fired on it in 1708, as it ventured from the New World, destined for Spain. It sank following an explosion, only to be discovered in late 2015 by the Colombian navy and the Instituto Colombiano de Antropología e Historia, a division of the Ministry of Culture. Ownership of at least a share of the ship's contents are claimed by Colombia, by the salvage company Sea Search Armada, and potentially by the Kingdom of Spain.[8]

The travails of the fourth century BC Getty Bronze illustrate how a single underwater find can become the subject of international struggles for ownership. Discovered in international waters off the Adriatic Coast in 1964 in an Italian fishing vessel's nets, it was eventually purchased by the Getty Museum in 1977. Likely en route to Italy at the time it was lost at sea, it would be hard to consider it loot in the modern sense, but instead a chance find. And since it is of Greek manufacture, Italy's case is further complicated. The fate of the statue remains unclear. The most recent development in the battle occurred in December 2015, when an Italian high court held that the Getty had been deprived of its constitutional right to a public hearing in a Pesaro court's 2012 ruling that ordered the Getty to return the statue to Italy.

7. Sea Search Armada v. Republic of Colombia, 821 F. Supp. 2d 268 (D.C. Dist. Ct. 2011).
8. The Sea Search Armada and Colombia have battled for ownership of the treasure since the 1980s. The Sea Search Armada claimed to have located the ship in 1981 and signed a deal agreeing to give 35 percent of the finds to the Colombian government. However, the Colombian parliament subsequently overturned the deal, leading to a decades-long court battle between the two parties. Johnathan Watts and Stephen Burgen, "Holy Grail of Shipwrecks Caught in Three-Way Court Battle," *The Guardian*, December 6, 2015. http://www.theguardian.com/world/2015/dec/06/holy-grail-of-shipwrecks-in-three-way-court-battle.

What will become of as-yet unexcavated antiquities underwater?

Existing treaties and conventions addressing the so-called High Seas—or territory not governed by a state party—offer inadequate assured protection for shipwrecks, explaining why claims and counter claims are addressed in the courts of relevant nations. Given the vast quantity of presumed shipwrecks in international waters, we face nothing short of a calamity if strip-mining by commercial salvage operations is allowed to go forward unabated. Those shipwrecks within the waters of a state party are not as likely to be excavated given the prohibitive costs of thorough expeditions. And thus some countries have elected to enter into partnerships with commercial concerns, which raises vexing questions about the ultimate claims of ownership of finds.

An example of such joint ventures involved the Indonesian government and a company known as Seabed Explorations. In 1998 a group of Indonesian fishermen came across traces of what would become known as the Belitung shipwreck of an Arabian *dhow*. The ship was presumably en route home to the Middle East from China in the middle of the ninth century AD. The ship's contents included a massive trove of some 60,000 artifacts dating to the Tang dynasty, ranging from gold, silver, and ceramic vessels to luxury and funerary objects. The Tang Treasures were subsequently excavated by the commercial treasure hunting entity after reaching an agreement that it would split any discovered artifacts with the Indonesian government. Protests from archaeologists hinged on the allegation that the commercial recovery had failed to meet best practices in excavation techniques, resulting in a serious loss of the facts and context of the artifacts. The Smithsonian's Sackler Gallery canceled a Spring 2011 exhibition of the so-called Tang Treasures after a deluge of opposition. The decision to cancel the display also resulted in reexcavation of the Belitung shipwreck.

One lesson learned from the Belitung shipwreck is that even in the case of state-sanctioned excavations, the ever-more stringent documentation standards of the archaeological profession will make it unlikely that profit-making enterprises will prove acceptable to the scientific establishment. The presumption is that such commercial enterprises will inevitably privilege profit over comprehensive research objectives, thereby tarnishing the credibility of the entire undertaking. The argument on the other side is that few governments are prepared to invest the resources necessary to undertake such a complicated operation, and that the perfect should not become the enemy of the good.

What will become of unexcavated antiquities underground?

The terrestrial frontier is more urgent and immediate, given the low technological threshold required to detect and disrupt ancient sites. The chance finds and looted works that are revealed every day around the world almost instantly disappear into the black market, preventing even the most rudimentary documentation of finds.

What is the best way to care for freshly excavated works today?

Technical knowledge of how to care for works freshly exposed to the atmosphere increases every year. In essence, the goal is to insulate works from rapid fluctuations in temperature and humidity, which may trigger changes in the stability of various materials. Professional archaeologists are typically able to transfer excavated works of extreme fragility to climate-controlled storerooms or microclimates, whereas chance finds and looted works would only rarely be accorded such careful handling.

How does someone become a looter and what do they earn?

Organized criminal gangs are the principal force in looting, since they are normally equipped with the technology and systems to both identify the location of precious works and to remove them clandestinely without attracting notice. The "tombaroli" (tomb robbers) in Mediterranean countries are poorly compensated, but they remand their finds to middlemen who can launder the objects both literally and with respect to falsified documentation of their origins.

How are source countries working to counteract looting?

The preparation of source countries to safeguard archaeological sites varies widely, even within national borders. In Italy, the policing efforts of the national police force known as the Carabinieri are most evident in Rome and points north. The relative lack of organization in Southern Italy and Sicily reflects a larger challenge of organization in the *Mezzogiorno*, and explains why looting is more prevalent in the South. But no nation in the world has set up a cultural heritage policing structure as sophisticated as the Carabinieri.[9] Other nations offer less organized protection but may threaten harsher penalties, up to the death penalty, as is the case in various developing nations, including Iraq, and very recently in China.[10]

9. Laurie W. Rush, "Illicit Trade in Antiquities: A View 'From the Ground,'" in *Enforcing International Cultural Heritage Law*, eds. Francesco Francioni and James Gordley, 71–73. Oxford: Oxford University Press, 2013.
10. In 2016, the leader of a tomb-raiding gang was sentenced to death with a two-year reprieve after he was found guilty of offenses including tomb raiding, looting, and selling stolen antiquities. "Tomb-Raiding Gang Leader Faces Death," ShanghaiDaily.com, April 15, 2016. http://www.shanghaidaily.com/national/Tombraiding-gang-leader-faces-death/shdaily.shtml.

Mexico's state archaeological authority, INAH (Instituto Nacional de Antropología e Historia), was taken to task in 2009 and 2012 audits by the Auditoría Superior de la Federación (ASF) for failing to meet even the most fundamental responsibilities to protect archaeological sites. Few other report cards of this type have been made public, but the situation in many source nations would receive no better assessment.[11]

How do looted objects get 'laundered' so as to minimize scrutiny and suspicion?

Objects can be 'laundered' by the removal of surface dirt and accretions, and by the provision of falsified documentation alleging the work's legal provenance. A cottage industry of forgers has existed in tandem with the middlemen whose provision of credible evidence or prior ownership is normally indispensable to move a work from the black market into the mainstream market. In Switzerland in the 1980s, it was well known that unscrupulous dealers would review obituaries, ring up newly widowed women, and offer payment in exchange for affidavits alleging ownership of works fresh to the market.

How do looted works end up on the legal art market?

Dealers with minimal scruples throughout the world have traditionally been prepared to accept incomplete or falsified provenance in order to take possession of looted works. These objects have then been put on display or kept in back rooms to show clients with a similarly relaxed attitude toward proof

11. Nayeli Roldán, "El INAH Olvida Conservar Las Zonas Arqueológicas Del País: Auditoría." Animal Politico, March 9, 2016. http://www.animalpolitico.com/2016/03/el-inah-olvida-conservar-las-zonas-arqueologica-del-pais-auditoria/.

of legal title. In recent years, the plundering of sites in Syria and Iraq has led to works smuggled overseas and ending up in galleries in the United Kingdom, Switzerland, Germany, and elsewhere in Europe. The dealers offering them typically seek to throw off the scent with accounts of provenance from long-standing collections or from regions not in the headlines as hotbeds of current hostilities.

What protections are there to lessen looting by those charged with protecting archaeological sites?

Corruption is rampant throughout the developed and developing world, and tales of participation in the illicit market by the very forces tasked with protecting cultural heritage are legion, from Italy to Israel to Asia.

As is the case with police forces handling large quantities of cash or drugs, the temptation facing those responsible for protecting heritage is considerable, since no parties are better informed about the means by which antiquities can be spirited undetected from their care to the middlemen they are meant to interdict. The only remedy at hand is more efficiency and transparency in how their work is conducted.

10

ACQUIRING ANTIQUITIES
IN THE MARKETPLACE

What are the primary channels through which antiquities are sold?

There are two markets for antiquities: the licit, or legal market, and the illicit, or black market. In this chapter we will consider how each market operates today, and seek to clarify the ways in which objects move from one setting to another.

How big is the licit art market?

Sales figures are hard to come by, in part because the legal art market is assumed to be the largest unregulated market in the world, after arms and drugs. Auction houses are a reliable source of information for that fraction of the trade that passes through semi-public activity. In 2015, sales of Asian art and antiquities totaled $276.6 million, a 17 percent increase from 2014.[1]

Auction houses often begin their quest as a result of one of the "three D's"—death, divorce, or debt. There are visits to prospective sellers, who may be motivated by the death of a family member with the resulting need to address a collection

1. James Tarmy, "How Is the Art Market Really Doing?" *Bloomberg*, February 29, 2016. http://www.bloomberg.com/news/articles/2016-02-29/how-is-the-art-market-really-doing.

in probate, a divorce requiring the division of property, or
the simple realization that a timely sale of an antiquity with
ownership history is more valuable than ever, and can help
erase other financial obligations. In each of these three cir-
cumstances, auction house specialists will find a motivated
"consignor," who may consent to offering the work at the
next sale with a reserve price, or a base price, guaranteed.
Works emanating from these three circumstances are at times
accompanied by evidence of long ownership, which today
greatly increases their attractiveness to potential buyers
practicing "due diligence," or the exercise of sound judg-
ment in researching the legitimacy of a prospective purchase.
When an antiquity is accompanied by strong evidence that
the seller has legal title, insulating seller and buyer from po-
tential claims by source nations, it often rises to the top of
the heap for auction house experts, is favored with auction
catalogue cover status, and outperforms its estimate, if one
is published.[2]

Works lacking compelling evidence of legal title are in the
same sales as those with such evidence, muddying the waters
for prospective buyers who might mistakenly assume that the
legitimacy of the few lots with good provenance somehow
makes up for the unknown past of the majority of works on
offer.[3] State parties today watch such auctions with great in-
terest. A Sotheby's Paris auction of the Barbier-Mueller fam-
ily's pre-Columbian collection made headlines when it was
revealed, shortly before the March 2013 sale, that four nations—
Mexico, Peru, Guatemala, and Costa Rica—contested the title

2. Silvia Beltrametti and James V. Marrone, "Market Responses to
 Changing Legal Standards: Evidence from Antiquities Auctions,"
 SSRN Social Science Research Network. Rochester, NY, January 31,
 2016.
3. A recent study found that only one-third of antiquities offered at
 Sotheby's and Christie's between 1996 and 2014 in an examination of
 22,700 items had verifiable provenances. Ibid.

of works in the sale, claiming them as part of their national heritage. As a result, about half of the lots in the sale went unsold, and claims for works both sold and unsold may yet be made in the future. The chilling effect of the scrutiny of the sale appears to have led to anemic bidding and participation by museums and major collectors, and may serve to discourage other long-standing collectors from allowing their works to be sold at public auction.[4]

And for such recalcitrant potential sellers, there are alternatives. Alongside their primary business, auction houses have for some years acted as dealers, selling privately to individuals. This part of the auction business is less visible to observers, and it offers a sales channel for unprovenanced works that is reasonably insulated from press and public scrutiny. Records of private sales are hard to come by—being private—but may account for an increasing portion of the antiquities passing through the top auction houses.[5]

Commercial art galleries offering antiquities are numerous, and are found in cities around the world. For the most part unregulated, these enterprises range from modest storefronts in towns and small cities to elegant showrooms with ample backrooms and storerooms in large cities. Their inventory is virtually impossible to document or track, since works on public view may only represent a fraction of the gallery's holdings. Single sales in such galleries can reach the low millions of dollars for a single object.

The combined commercial value of antiquities moving through these three legal sources—public auctions, private

4. Tom Mashberg, "Sale of Pre-Columbian Art Falls Short of Expectations," *The New York Times*, March 25, 2013. http://artsbeat.blogs.nytimes.com/2013/03/25/sale-of-pre-columbian-art-falls-short-of-expectations/.
5. Neil Brodie, "Auction Houses and the Antiquities Trade," in *3rd International Conference of Experts on the Return of Cultural Property*, ed. S. Choulia-Kapeloni, 71–82. Athens: Archaeological Receipts Fund, 2014.

sales through auctions, and dealer inventory—can only be guessed at, but is certainly at least in the hundreds of millions of dollars annually. The historical value is incalculable.

How is the legal art market faring?

Over the last half century, the market has been in an increasingly defensive posture as various conventions and landmark rulings have incrementally shifted the burden of responsibility for protecting cultural heritage. Not long after the 1970 UNESCO Convention was adopted, it became a widely held assumption that buyers were creating demand and thereby incentivizing organized looting of archaeological sites.

The legal market is one in which the offer of sale is not clandestine, but takes place in full public view, and normally involves a gallery with artifacts on display, advertising to promote inventory for sale, and prices available for consideration by interested buyers. Established dealers and auction houses are under pressure to undertake costly research and provide provenance about works for sale that will reassure buyers when contemplating a purchase. They are also today routinely encumbered with costly claims made as soon as the titles of works offered for sale are called into question.

And how about the illicit market?

The illicit trade is by definition opaque, being a black market. Speculation is rampant that it could reach billions of dollars annually, but there are few ways of evaluating its size apart from extrapolation based on the interdiction of looted items by customs officials, Interpol, and national law enforcement agencies.[6] The illicit market is likely far larger than the legal

6. In 2011, Interpol had estimated the illicit trade in cultural property at $4 to $5 billion annually. The International Scientific and Professional Advisory Council of the United Nations Crime Prevention and

market, and is growing, notwithstanding increasing public awareness of the devastation wrought by looting.[7]

How big of a problem are chance finds?

The market's expansion is not simply fueled by demand. Corruption among those overseeing public works is widespread internationally. The European Commission estimates that some €120 billion (about US$163 billion) disappears annually through corruption in procurement.[8]

A shadow economy accordingly exists at the top end of the illicit trade from chance finds revealed during public works projects. Investment in public works is accelerating globally, but nowhere more than in the developing world, where the richest troves of archaeological material have yet to be revealed.

When excavating to prepare for the pouring of foundations of massive infrastructure projects, demolition and construction crews almost invariably turn up evidence of the past. In each

Criminal Justice Programme (ISPAC) estimates the market has an annual value of $6 to $8 billion. Jeremy Haken, "Transnational Crime in the Developing World," Global Financial Integrity, February 2011. http://www.gfintegrity.org/wp-content/uploads/2014/05/gfi_transnational_crime_high-res.pdf.

7. And the policing agencies that monitor the illicit market can succumb to routine budgetary cuts. This was recently the case in Belgium, where it was announced in April of 2016 that the Belgian Federal police would be eliminating its specialized art and antiques police unit because of budgetary constraints. "Belgian Federal Police Eliminating Its Art Crime Police Squad Due to Reported Budgetary Constraints," ARCA Blog, April 16, 2016. http://art-crime.blogspot.com/2016/04/belgian-federal-police-eliminating-its.html.

8. Commission to the Council and the EU Parliament, "EU Anti-Corruption Report," February 3, 2014. http://ec.europa.eu/dgs/home-affairs/e-library/documents/policies/organized-crime-and-human-trafficking/corruption/docs/acr_2014_en.pdf.

region of every antiquities-rich nation globally there are differing circumstances awaiting such evidence. In an ideal situation, a worker would alert a foreman who would contact local authorities connected with a Ministry of Culture. Following this, further excavation would cease pending a spot check by archaeologists. Only when given the green light would work resume, provided that Ministry officials determine that the excavated area is not of sufficient significance to withdraw the work permit.

That ideal situation is rare. The interests that compete to prevent the interruption of construction projects are legion—from the government or corporate funding sources behind a project, to the contracted firms whose revenue forecasts rely on the work proceeding as planned, to those with line responsibility who earn paychecks tied to the project's realization. The only person standing in the way of the project might be a local enforcement official, whose head could be turned by bribery, and the temptation to look the other way is unfathomably great: the potential inducement to fail to report chance finds can go further, in the form of shared income from the sale of accidentally discovered antiquities.

Given these obstacles to safeguarding any ancient contexts that are revealed through public works, it is almost inconceivable that a person in a position of authority in a developing country would automatically resist the rewards from the simple act of not reporting a find. In archaeologically rich areas where discoveries are routine, the assumption on the part of a foreman might reasonably be that since there is so much else in the ground, little harm would be inflicted by allowing a project to proceed—typically a project providing much-needed jobs to his family, friends, and acquaintances. As a result, a tomb, statue, vessel, or other artifact discovered under these circumstances would be quietly passed over to a middleman accustomed to erasing evidence of its discovery, and efficient at hiding it among truckloads of commodities destined for major markets, where unscrupulous dealers would be waiting

to receive it.[9] A snapshot on a cellphone accompanied by a text normally provides all that is necessary for such an illicit transaction, meaning that the quaint days of discoverable paper trails are far behind us.

How do intentionally looted works make their way to the market?

The intentional looting of archaeological sites is being undertaken with increasing energy. In conflict zones, such as Iraq and Syria, the problem is particularly aggravated, since no meaningful government protection of cultural heritage today exists, and any faction claiming ascendancy in governance seems prepared to tax the illicit trade as a coveted revenue source.[10] Outside of conflict zones, organized criminal factions often have long-established relationships with corrupt law enforcement officials, and illegal digging often proceeds not at nighttime but in plain day. Illicit digs are on every continent, and accelerate and decelerate based on very local conditions, ranging from disruption engendered by competing syndicates, to temporary vigilance by law enforcement or NGOs, to the weather.

9. In March 2016, a New York Japanese antiquities dealer was arrested for possession of stolen property after a rival art dealer informed on his activities to authorities. The dealer had allegedly purchased a rare Buddhapada sculpture that had been stolen in 1982 from the Swat Region of Pakistan and had engaged in multiple international transactions for the sculpture through the years. The dealer admitted to authorities that he "knew it was illegal to buy or possess such material." Jamie Schram, "Antique Dealer Arrested for Smuggling Ancient Sculpture," *New York Post*, March 22, 2016. http://nypost.com/2016/03/22/antique-dealer-arrested-for-smuggling-ancient-sculpture/.
10. The Islamic State requires sellers of looted artifacts in Syria and Iraq to pay to the Islamic State one-fifth of any profits under the Quran's "war booty" provision.

Once out of the ground, objects are stashed in warehouses where they can be sorted, cleaned, and photographed. The Becchina warehouse discovered in Switzerland is a textbook example of how such caches of illegally exported materials were managed.[11] After this initial organization of looted material, it is free to be offered up on the black market, much in the way that chance finds migrate to vendors internationally.

Who buys looted artworks?

No individual with concerns about their reputation would knowingly purchase a looted object. But as recent restitutions have shown, a buyer may not be certain that an object isn't looted if its provenance has gaps in it. Up until court actions of the last decade, there was little to discourage collectors from purchasing unprovenanced antiquities. All that has changed in Western markets since the Schultz case and the invocation of the National Stolen Property Act (NSPA), which opens even "good faith" buyers to prosecution. Works lacking provenance are not necessarily looted, but they are under suspicion of being obtained without an export license from the country of modern discovery. As a result, collectors with even a slight regard for their reputation or the possibility that a work purchased may become a work seized are less likely to pursue unprovenanced objects than at any time in the past. Which is not to say that reputable people don't buy unprovenanced

11. In January 2015, police uncovered an estimated 5,361 vases, bronze statues, and frescoes from the Swiss warehouse of Sicilian art dealer Gianfranco Becchina and his wife. Becchina had previously been accused of participating in an intricate global antiquities trafficking network. The Associated Press, "Record €50m Hoard of Looted Italian Antiquities Unveiled by Police," *The Guardian*, January 21, 2015. http://www.theguardian.com/world/2015/jan/21/looted-italian-antiquities-museums-switzerland. Becchina later filed a defamation lawsuit against the publications accusing him of illicit trafficking. " 'Contro Di Me Articolo Farneticante.' Gianfranco Becchina Querela 'La Repubblica,' " May 7, 2015. http://castelvetranonews.it/notizie/?r=8TM.

works—they do. But increasingly, they do so in an environment in which the potential downside of such purchases is far greater than the enjoyment they might have in possessing an artifact from a distant time and place.

What is a good faith purchase under civil law?

Years ago, when a buyer could demonstrate "good faith" when making a purchase—meaning they were unaware that an object was illegally exported—the buyer was offered a significant measure of protection from legal jeopardy. In recent years, with the increasingly militant stance of nations, together with the stiff penalties accruing even to those who protest their ignorance of wrongdoing, the premise of good faith has worn thinner. It no longer offers a plausible defense against legal action, and civil law nations—typically those outside the British Commonwealth or the United States—are increasingly tightening their national laws affecting collecting practices. The burden has therefore been shifting from the need to demonstrate that one was unaware a work was looted, to the need to demonstrate that a work in fact left its nation of modern discovery legally. The gap between these two is considerable, and the circumstances insulating a looted artifact's buyer from financial or reputational harm are diminishing.

How were private collections formed in the modern era?

Prior to recent developments such as successful claims and very public prosecutions, it was normal for collectors, largely in Europe and the United States, to form collections from the secondary market—from galleries worldwide that procured antiquities from a source at least once removed from an object's discovery. For much of the late nineteenth and twentieth centuries, collections came to be built by private individuals reviewing works for sale in galleries or auction houses. Concerns about the origins of a given object were rare, and

unless accompanied by a stellar provenance, the topic of provenance was typically left alone. If the buyer knew nothing to suggest that a work was stolen, both vendor and purchaser could maintain the convenient veil of 'good faith'—meaning that the purchaser had no reason to suspect that a work was stolen or illegally imported into the country in which the transaction was to be made. Few potential buyers would think to "poke the bear"—to discover a sketchy past to a work under consideration.

What information about purchases accompany a bill of sale?

Buyers of antiquities have in the past been able to obtain a warranty of authenticity, but not a guarantee that the object the are acquiring has good title. Both dealers and auction houses have resisted providing such a warranty, since in many cases they lack sufficient information about an object's provenance to do so. Christie's auction house is explicit in this regard, stating in its Conditions of Sale: "In no event shall Christie's or the consignor be responsible for the correctness of, or be deemed to have made, any representation or warranty of . . . provenance . . . and no statement set forth in this catalogue or made at the sale or in the bill of sale or invoice or elsewhere, whether oral or written, shall be deemed such a warranty or representation or an assumption of liability."[12] Thus the caveat "buyer beware" is implicit in agreements accompanying a bill of sale.

Are collectors complicit or innocent in fostering the illicit trade?

Given ample press coverage of the consequences of the illicit trade—from the incentivizing of looting to the involvement of

12. Christie's Auction & Private Sale, "Conditions of Sale," Accessed February 2, 2016. https://www.christies.com/LotFinder/ AbsenteeBidding/ImportantInfo.aspx?docCode=COB&sal eid=24758.

organized criminal factions—it is no longer possible for a private collector or collecting institution to allege complete innocence of wrongdoing if a stolen work is so identified.

The act of buying an antiquity without provenance is inherently different from buying a nonarchaeological work of art. While both categories of object demand due diligence in researching their ownership history, an artwork later found to have been stolen from its rightful owner could notionally be returned to its owner or her heirs or assigns. No one could rebury a stolen antiquity and reverse the disruption of its original findspot.

Part III
SCENARIOS AND SOLUTIONS

11

REALITIES OF STORAGE, DISPERSAL, AND DISPLAY

What happens once antiquities are excavated?

Once removed from an excavated trench or the ocean bottom, legally obtained antiquities are today typically dispatched to a storage facility, either at the excavation site or in a neighboring city museum. The speed with which they are transferred from findspot to storage varies based on available personnel and resources, the fragility or instability of specific finds, and competing priorities related to the excavation. Objects are especially vulnerable once excavated or brought to the ocean surface, since they are not fully documented, and are subject to deterioration because of fluctuations in humidity, temperature, and exposure to airborne pollutants. They are also subject to theft.

After being recorded, photographed, and placed in storage, objects may be set aside and languish for months or years unless they are deemed significant enough for further examination. If their storage location is already filled to capacity, which is not an uncommon situation, they may be subjected to less than ideal circumstances, sometimes being stacked, placed deep in shelves, or even on floor surfaces. Better equipped facilities will accord them ample space and security and ensure that they are thoroughly examined and documented.

Illegally obtained antiquities are rarely provided the care and consideration typical of legally excavated examples. They are often packed hurriedly and carelessly, resulting in damage to their surface or to their structural integrity, and may be lost or destroyed during their transport to a location beyond the reach of the authorities.[1] The disregard for their findspot or context results in the loss of the kind of information that routinely accompanies legally excavated antiquities.

What are the contents and state of modern museum storerooms?

The museum world's storerooms have conditions as variable as those found in any other kind of real estate. They range from the most modest of unsecured spaces lacking climate control, to state-of-the-art vaults and facilities including interior cabinets with microclimates for objects made of organic materials. Museums containing archaeological finds from nearby excavations are normally under great pressure to accommodate discoveries as they are made, which compounds the challenge of caring for and documenting unpublished objects already in their care.[2] The result is not infrequently a traffic jam of objects, with properly documented works moved aside to make room for fresh arrivals.

Collecting institutions that acquire works not through excavation but through gift and purchase are far better equipped to receive new objects. These market nation institutions are typically European or North American museums with ample resources, and their storerooms are climate-controlled, carefully supervised, and secure.

1. Stefano Manacorda and Duncan Chappell, eds. *Crime in the Art and Antiquities World: Illegal Trafficking in Cultural Property* (New York: Springer Science & Business Media, 2011).
2. Wendy Christensen, *Empire of Ancient Egypt* (New York: Infobase Publishing, 2009), 135.

How well documented are artifacts in museum galleries and storerooms?

The degree to which an object is documented also varies widely. Awarding each newly obtained artifact a reference number, or accession number, is a normal first step. That number is normally painted on the least obtrusive part of its surface, on top of a reversible (removable) sealant. From that point on the work is typically photographed, measured, and identified, with these details recorded in a museum's database. For most objects in museum collections, that may be the full extent of the digital record. For others considered more noteworthy, documentation may include a detailed description; information about its provenance, publication, and exhibition history, if known; and a full accounting of any conservation treatment, such as chemical analysis, and x-ray or infrared examination.

Works on display have typically undergone more extensive review and documentation than those that have never been exhibited, the latter category accounting for the vast majority of the holdings of museums.[3] The tedious work of documentation may demand dozens of person-hours per object, which explains why so little of the cultural heritage in museums is accessible in print publications, let alone in online digital databases. The typical prompt to create a more complete record is as a result of a request from a peer institution or renowned scholar to examine, exhibit, or publish a given work. If undocumented objects remain in storerooms, the passage of time can contribute to neglect of their condition as well as their origins,

3. For example, in 2009, the Metropolitan Museum of Art New York was estimated to own two million objects, but displays only tens of thousands at a time. At the Museum of Fine Arts in Boston, 18,000 objects were on display at any one time, but the Museum has an inventory of 450,000 objects. Geraldine Fabrikant, "The Good Stuff In The Back Room," *The New York Times*, March 12, 2009. http://www.nytimes.com/2009/03/19/arts/artsspecial/19TROVE.html.

which is when they become vulnerable to theft or careless handling and resulting damage.[4]

What will happen to stored works in the long term?

As noted above, once in storage, the path out of the basement is far from assured. With most of the world's cultural heritage still unexcavated, the fate of objects in storage is far from certain. Within particular categories of antiquities, certain museums may have dozens or even hundreds of similar examples, resulting in their likely permanence in storage.

This is hardly cause for alarm. Drawing an analogy to libraries, no one should be penalized if a given book stays on a shelf unconsulted for decades. The purpose of a library is not to ensure that every book circulates frequently—it is to compile a comprehensive collection, with holdings of books, periodicals, and serials that will be available if and when a scholar, student, or member of the public seeks to consult it. The episodic hue and cry about the percentage of museum collections not on display misses the point of museums.[5] Museums are research institutions, like libraries, that exist to care for collections. The public benefit is not only realized by means of display. The costly, complex obligation to care for cultural heritage is a public good in and of itself, and should not be misunderstood

4. Even antiquities that have been documented or registered can be subject to theft once placed in a storeroom. For example, after excavation and registration in 1979, several ancient Egyptian duck-shaped vessels were stolen from a storeroom in Saqqara, Egypt. Two of the objects were returned in 2008, when the objects were offered for sale, but two vessels from the storeroom remain missing today. Also in 2008, the St. Louis Art Museum had to defend its purchase of an ancient Egyptian burial mask, after the Egyptian government claimed the mask had been stolen from a Saqqara storeroom.

5. Christopher Groskopf, "Museums Are Keeping a Ton of the World's Most Famous Art Locked Away in Storage," *Quartz*, January 20, 2016. http://qz.com/583354/why-is-so-much-of-the-worlds-great-art-in-storage/.

to stem from an impulse to hoard or from the inability to de-
cline donations of excavated or market-sourced materials. If
not destined for museums, these works would likely end up
on the legal or illicit market, likely yielding neither a scholarly
record nor a public benefit.

How easily do artifacts circulate for exhibitions, long-term loans, and collection sharing?

Many art world observers exhort museums to liberate art-
works from storage. While the circulation of antiquities can
have positive results, it is also expensive, time-consuming, and
distracting from the other multiple obligations of museum per-
sonnel. Which is not to say that circulating works is not a good
idea, simply that each potential loan has to be reviewed on
a case-by-case basis. Museum directors overseeing significant
collections find themselves forced to decline the majority of
loan requests, for various reasons. The intellectual premise of a
loan exhibition may be felt to be of negligible research value, or
the presumed display conditions might invite outright physi-
cal risk to the object and its lending institution. The works re-
quested for loan may be judged too integral to the museum's
identity and current displays to be away from view for several
months. Or the would-be lender lacks the resources necessary
to prepare the works for display, travel, and publication.

In my experience, objects are no more likely to be damaged
when in circulation than when back home at their museum.
Michelangelo's marble statue group the *Pietà* famously trav-
eled to the 1964 New York World's Fair without incident,
only to be vandalized back at the Vatican eight years later.[6]
Antiquities slated for display are routinely accorded spe-
cial treatment in advance, and that can include the possible

6. Philip Pullella, "Vatican Marks Anniversary of 1972 Attack on
 Michelangelo's Pieta," *Reuters*, May 21, 2013. http://www.reuters
 .com/article/us-vatican-pieta-idUSBRE94K0KU20130521.

discovery of 'inherent vice' such as infestation or bronze disease that can be interrupted and addressed. Other potential benefits can result from reintegration of old damages, consolidation of the object's surface, and new mounts that are more stable and trustworthy than their original mounts. The careful handling of works slated for display rarely results in damage while packing, and the technology of crating and shipping artworks has greatly improved over the last generation, to the point that the chances of misfortune are minimal.

By contrast, objects that are not accorded the attention of works in circulation may suffer in silence, unseen on the back of a shelf, with corrosion triggered by excessive humidity, staining from leaky pipes above, animal droppings saturating their surface, or any of a number of other threats familiar to people with heirlooms long neglected in attics and basements.

How common are long-term loans or collection sharing?

Many museums with significant stored collections are amenable to extending long-term loans. These can be extensive, with dozens or more works spending several years at smaller museums. The presumed value of such loans is obvious: these tend to be objects that would otherwise remain in storage, but are instead made available to a broad public in a location or institution unable to provide access to relevant examples of cultural heritage. The costs attendant to long-term loans are absorbed over years instead of weeks, and benefits to the borrowing institution are incalculable, starting with the implied savings of not needing to purchase comparable works were they available on the legal market—an increasingly unlikely scenario in any event.

Long-term loans demand a great deal from both lending and borrowing institutions, beginning with mutual trust, a perceived benefit to both museums, and the costs of preparing, packing, shipping, installing, and offering educational programs and publications connected with them. The numbers of

such loans are accordingly finite, even for the largest of institutional lenders, and demand continuous vigilance from both lender and borrower, as well as increased insurance, security, and management costs. That said, they can be transformative for the borrowing institution, and typically yield new research on works that might otherwise remain out of circulation. There is no organized reward to encourage such loans, and therefore they tend to be arranged as a function of an entrepreneurial director at the borrowing end, and an open-minded director at the lending end. With so much of the world's cultural heritage in storage, and a sharp decline in the number of antiquities available for sale in the legal market, long-term loans could become the best way for archaeological and collecting institutions to share both the burden and the gift of caring for our collective heritage.[7]

Collection sharing offers a variant of long-term loans, implying that museums have joint ownership of works. This entails a more complicated set of concerns, since while loan agreements tend to be straightforward, shared ownership demands agreement on the exercise of intellectual property rights, and the right to conserve, display, lend, sell, and otherwise dispose of jointly owned works. Collection sharing can be an encumbrance over the long haul, since elements of an agreement that once seemed reasonable can become fraught over time, given changes in leadership, attitudes, and external circumstances.

How have displays of antiquities changed over time?

Grainy photographs of nineteenth-century museum galleries filled with antiquities reveal a consistent display technique. Long wood-framed cases with glass tops and sides allowed

7. Recent estimates for the State Hermitage Museum in St. Petersburg indicate that only 30 percent of its collection of more than three million objects is in storage. Crystal Bennes, "What's in Store at the State Hermitage Museum." *Apollo Magazine*, March 17, 2016, http:// www.apollo- magazine. com/ whats- in- store- at- the- state- hermitage- museum/.

for hundreds or thousands of objects to be lined up as if in a department store, visible by sunlight or by means of ambient light from ceiling fixtures. The taxonomy, or typological categorization of antiquities, was the focus: bronzes with bronzes, statuettes with statuettes, and vases with vases.

By the 1960s not only were such display cases thought to be old-fashioned, but they also limited the public's appreciation of the ways in which different kinds of antiquities were used together in daily life, religion, and burial. The transition to more flexible display cases was ushered on by the invention of Lucite and Plexiglas in the 1930s, variants of acrylic safety glass that offered a more forgiving display technology than glass. This new medium allowed for the easy fabrication of vitrines with varying shapes and dimensions, and yielded installations that mixed works of different media along thematic lines.

In more recent times, the introduction of recorded tours and now digital interpretive technology has meant that wall texts and labels are no longer the only way to provide information and to engage public interest. Open storage has become more common, allowing visitors to see collections otherwise away from view, and to glimpse the magnitude of a collection's representation of a given time or place.[8] And web-based information allows non-visitors both to consult illustrated databases and fly-through videos or stitched-together still images of galleries.

Archaeological displays simulating the context in which objects were unearthed are popular, as are reconstructions of settings in which antiquities may have been stored and used in residences. The variety of installations in museums enlivens our encounters with objects that may at first be difficult to interpret. For example, period rooms with furnishings alongside

8. Examples include the Metropolitan Museum of Art's Henry R. Luce Center for the Study of American Art; the ceramics gallery in the Victoria and Albert Museum in London; and the Storage Gallery of pre-Columbian art and artifacts at the Larco Museum in Lima.

statuary and frescoes are the most common kinds of simulated contexts in museums, more common in special exhibitions than in permanent displays.

Antiquities follow various paths from discovery to public display. The discovery of new antiquities will demand new storage space alongside objects excavated or acquired decades or centuries ago. The oversaturation of facilities will in many cases lead to ever-more crowded shelves, and with them attendant neglect and damage. Museums cannot continuously expand to cope with the emergence of new archaeological discoveries over decades and centuries to come, and other solutions must be found, ranging from long-term loans to collection sharing to the eventual possibility of a licit market to disseminate objects into foreign museums and private collections.

12

CAPTURING ANTIQUITY

DOCUMENTATION

What is meant by object documentation and why is it important?

While mass production as we know it is a phenomenon that began only in the industrial age, ancient artisans had, as we have noted, techniques at their disposal to create multiple versions of objects through molds. For an archaeologist or art historian studying a particular class of object or a site rich in multiples, the differentiation of one artifact from another is a basic necessity in recreating the material evidence of the past. For example, two stylistically similar ancient Chinese bronzes may bear maker's marks that provide information about their differing dates, and unless these identifying attributes are noted, there would be ample room for confusion once in the storeroom. When extracting artifacts from a complex excavation with multiple layers of historical evidence, field archaeologists could make misleading conclusions if the exact findspot of a particular example is incorrectly noted or lost.

The documentation of an object, as briefly discussed in chapter 11, entails assigning an identifying number to the work, carefully marking the object with that number, and creating a record with corresponding information about it. Archaeologists will typically assign a number that allows for cross-reference with the precise coordinates of its discovery. Museums sometimes assign a number that situates the work

in the chronology of all acquisitions, by first noting the year of its acquisition, then its place in the sequence of acquisitions that year, and then a specific identifier within that sequence. The resulting number might be 2016.11.2, which would signify that this is the second of two related objects that were acquired at the same time after ten other acquisitions had been made in the year 2016.

With the number assigned, a photographic record is made to capture not only the overall appearance of an object, but also details bearing any particularly noteworthy attributes, such as an inscription or a stamp. Noting the date of the photograph can prove important if the condition changes later on, the work sustains accidental damage from handling, or a nearly identical object is later acquired that could easily be confused with the first work.

The measurement of an object can prove complicated when a given work is three-dimensional and of irregular shape. The first integer identified in an object record is typically the object's height, then its width, and then, if three-dimensional, its depth or its circumference. Dimensions are essential when a scholar is consulting an illustration of the work rather than examining the original, so as to show the predictable degree of detail for works of a given size. Ancient workshops often strove to achieve identically shaped objects in a series, and the assignment of a stray work to a series known from other collections may hinge in part on the dimensions being consistent.

The recording of other more detailed information about a given work may include a thorough description of unusual features, damages, and repairs. This narrative portion of the object record may shed light on comparable examples known in the same or other collections.

Finally, the object record includes any past exhibitions or publications. These markers in time allow scholars to review the history of the work's acceptance by others as authentic or significant, and are frequently helpful in reconstructing

the history of collecting, or of the development of knowledge about a particular class of objects during past generations.

Moving past the object record, the documentation of antiquities normally falls into a select group of publications. A field report by archaeologists will painstakingly note the circumstances of a work's discovery. This report may be published at the end of a season of excavations or a year or two thereafter. Subsequent articles frequently address either that precise excavation or the typology of a class of works made at a particular time, tying conclusions back to what can be learned from the archaeological context in which a work was first discovered.

Art historians are just as interested in the symbolism, iconography, or style of ancient objects, and their publications may take the form of articles reviewing whole categories of objects, or themes common to objects across typologies. They may publish compendia of all known examples of a particular type of object, or entire histories of a given period, citing examples of antiquities from collections worldwide.

What are the unique challenges in documenting antiquities?

Post-ancient periods of art history are often rich in written evidence at the disposal of an art historian. Bills of sale, correspondence, contemporary written accounts, and official records may make specific reference to an object, its place of manufacture, or the artist responsible for it. In the case of paintings, the artist's signature, or evidence of ownership on the back of the picture, may aid a scholar in assigning it to an individual or giving it a fairly precise date. Sculptural commissions may have been cited in public records, or may be inscribed by the artist. Metalwork may include maker's marks, marks attesting to the purity of a particular metal, or even an inscribed signature.

Scholars of antiquities rarely have any of these kinds of evidence at their disposal. Artists in the ancient world who identified themselves were exceptions. And contemporaneous

accounts of artworks are virtually nonexistent. While there are, among some categories of works, identifying marks on portable objects, these are seldom matched with any contemporary written evidence, apart from signed sculptures by artists referred to in historical accounts, as in the Hellenistic period of ancient Greece.

As a result, the documentation of antiquities in modern times is normally the only evidence at a scholar's disposal. The paucity of contemporaneous evidence has, through the centuries, often yielded incorrect or incomplete assertions about the chronology and symbolic meaning of ancient artworks. Greek vases excavated in Italy during the late eighteenth and nineteenth centuries were assumed to be of Italian or Etruscan manufacture. Gold artifacts, which are notoriously hard to authenticate, have been misdated by centuries. It is only through the emergence of new information that these errors have been corrected, often thanks to subsequent scientific excavations that situate comparable objects in a particular location, resulting in the reattribution of misidentified artifacts located in far-flung collections.[1]

Sometimes reidentification of the origins of antiquities starts with a hunch. Over the course of six years as assistant curator of Greek and Roman Art at the Metropolitan Museum of Art, I devoted ample time to 'excavating' objects in deep storage. On occasion this detective work was repaid with fresh discoveries, as when I hazarded a guess that previously anonymous sections of architectural ornament decorated nothing less than the throne room (Aula Regia) of the Palace of the Emperors in Rome. The palace was constructed by the architect Rabirius on the Palatine Hill by the emperor Domitian between AD 81 and 92. The five elements in the Metropolitan Museum had been

1. One such example is the Met's "Terracotta Statue of a Young Woman," as described in Maxwell L Anderson, *The Quality Instinct: Seeing Art Through a Museum Director's Eye* (Washington, DC: American Alliance of Museums Press, 2013), 115–120.

donated to the Museum in 1906 by J. Pierpont Morgan, but had never been attributed to any particular structure.

During a trip to Rome in the mid 1980s I measured, with calipers, distinctive features of portions of architectural ornament from the Palace that had been securely identified, which are to this day in the French Embassy compound in the Palazzo Farnese.[2] The features in common between the Farnese and Metropolitan sections matched precisely, and the museum's elements are today on prominent display. Once part of dazzling decorative friezes and entablatures some one hundred feet above the three-story throne room where the Roman emperor received official visitors, these previously unidentified elements now boast a noteworthy provenance.[3]

How have antiquities been documented until recently?

In addition to the publication of excavation reports of varying detail and accuracy since the nineteenth century, scholars have long sought to classify the scattered examples of past civilizations that have ended up in collections across the world through trade. Among the most ambitious early twentieth-century achievements was that of Sir John Davidson Beazley, who set about identifying the artists responsible for every known Greek vase in the world. His lifetime quest resulted in the attribution of tens of thousands of vases to thousands of artists, most of whom did not sign their work, and a classification system that remains relevant to contemporary scholars. His volumes on black-figured and red-figured vases stand to this day as among the most extraordinary feats of art scholarship in history.[4]

2. "SANbox." DecArch, September 21, 2014. http:// www.decarch.it/ wiki/ index.php?title=Sanbox#Roma.2C_ palazzo_ di_ Domiziano_ sul_ Palatino.2C_ 81- 92_ d.C.
3. "Five Marble Architectural Fragments," The Metropolitan Museum of Art. Accessed May 1, 2016. http://www.metmuseum.org/art/collection/search/247174.
4. "Sir John Beazley," The Classical Art Research Centre. University of Oxford. http://www.beazley.ox.ac.uk/index.htm.

The advent of photography radically improved the usefulness of publications, which had previously depended on line drawings. With the possibility of rapidly documenting classes of objects, some scholars sought to map the inheritance of entire bodies of work, as an international association of scholars, the Union Académique Internationale, did when founding the Corpus Vasorum Antiquorum, or CVA. This multinational effort began in 1922, seeking to document all known Greek and Italian ceramics made between the seventh millennium BC and the fifth century AD. A herculean effort ending in 2004, it yielded almost four hundred illustrated publications of more than 120 collections in twenty-six nations, with each black-and-white sheet including a small number of illustrations, accompanied by highly detailed object records. In the predigital world, the resulting compendium of some 100,000 vases was the best available tool for a scholar, allowing her or him to compare a newly revealed vase with those already figuring in the CVA.

As looting and the illicit trade became more visible to cultural and civic leaders, solutions involving documentation were devised to stem the tide. In 1993 the Getty Trust unveiled what it called the Object ID program, which encouraged museum officials worldwide to assign shared types of identifiers to their holdings, so as to record all artifacts by means of a common methodology. Launched a decade after the United States passed enabling legislation for the 1970 UNESCO convention, Object ID was a laudable effort to achieve consistent documentation of inventories, intended to professionalize the care of antiquities globally, and to aid in the recovery of stolen artworks. The advent of digital photography and the Web meant that competing means to document collections were at the disposal of cultural administrators, but the Object ID program is still in use, promoted by ICOM and UNESCO.[5]

5. ICOM, "Fighting Illicit Traffic: Object ID." http://icom.museum/ programmes/fighting-illicit-traffic/object-id/.

What is the best way to identify ancient objects in the digital age?

While digital cameras and illustrated databases offer scholars an updated version of Sir J.D. Beazley's quest for the universal classification of one category of antiquity, the mere advent of these tools has not resulted in the kinds of advances one might expect. The labor cost of photographing and documenting an individual artifact remains high, and harried museum administrators rarely have supplementary budgets to allow for the time- and labor-intensive campaign of digitizing their collections. Furthermore, the journey from taking a photograph to obtaining expert opinion on the date, classification, and interpretation of an antiquity is no shorter than it has ever been. The fact that the photographic and written record of an artifact can be available for consultation worldwide, twenty-four hours a day, offers little incentive for a museum staff short on research capacity to reveal their lack of knowledge. If anything, the instantaneity of information access has made many museum professionals leery to hazard identification and attribution of artifacts out of a fear of revealing research shortcomings.

Many well-funded institutions and NGOs have made rapid progress in digital documentation of excavations and of museum collections.[6] Their online collections provide a wealth of searchable information, and allow individual scholars to make comparisons, identifications, and attributions of comparable works under review. That said, it is regrettable that there is no common language of documentation among archaeological collections worldwide. Despite the capacity of the Web to host integrated, relational databases, for the most part archaeological authorities and museums have built proprietary databases, which are not searchable across institutions. An early effort to build such a database, the Art

6. An overview of these resources is available at "Databases," *The Antiquities Coalition*, October 24, 2008. https://theantiquitiescoalition .org/problems-and-solutions/databases/.

Museum Image Consortium, yielded hundreds of thousands of free searchable records across three dozen museums in several countries. Its demise was not followed by a comparable platform, and as a result, an intrepid researcher is obligated to hop from one website to another—metaphorically pulling each separate collection volume off a shelf one at a time. The Object ID program started a few years too early; had the same attention been paid to building not a carbon-based but a shared web-based taxonomic structure for the identification of antiquities, the research opportunities at our disposal today would have been geometrically improved. It is not too late to work toward shared classification standards that will allow for comprehensive access to the material record of antiquity— but with the system having been built as a village of separate buildings instead of a single tower of data, it will take some time to get there.

What new methods to document archaeological objects are on the horizon?

The forty-year-old technology of barcoding revolutionized the retail world, and could do the same for the world of antiquities. Many museums have resorted to barcoding artifacts as a way of keeping track of their location, which can be complicated in a large institution with multiple storage spaces and active research and exhibition programs. Some have even experimented with the application of microscopic markings to allow for real-time tracking of artifacts, offering hope in the interdiction of stolen artifacts, as well as in providing linkage to an electronic record that can be kept up to date.[7]

7. DataDot is one such marking technology. DataDot markings, each the size of a grain of sand, are laser-etched with unique identifying information, equated to DNA for the object. This information is then theoretically registered with a national law enforcement database, to assist police in retrieving stolen objects. Other technologies include

These and other documentation techniques have been slowly adopted by very few institutions. Arriving at a reward system for increased documentation is the core of the challenge ahead. With so many competing obligations in simply caring for and displaying collections, there must either be a top-down allocation of new resources to fund specialized teams required to photograph, research, and document collections online, or, in a longer path, such efforts must be fitted into an already demanding workweek. The antiquities field as a whole stands to gain exponentially if the energy devoted to handling and displaying objects is matched by energy devoted to documentation. Those governments, NGOs, foundations, corporations, and individuals that foster such research efforts are to be commended, and those museum administrators who pursue comprehensive documentation are no less deserving of support and encouragement.

RFID technology, which uses electromagnetic fields to identify and track objects within museums, and traditional GPS trackers placed on the art objects.

13

REPLICATION OF
ANCIENT OBJECTS

What is meant by replication?

With decreasing access to authentic antiquities obtainable from
the legal market, one alternative for those seeking to experi-
ence the creativity of ancient craftsmanship in their home or
workplace is through replicas. Digital images are one form of
replication, which are certainly rewarding as representations
of originals, or as research tools. But for anyone interested in
cohabitating with a three-dimensional version of an antiquity,
the potential attraction of replicas is beginning to make itself
felt, as we will consider below.

What did people in antiquity think of replication?

The veneration of artistic authenticity is tied to the emergence
of an open art market, as opposed to an ancient market fueled
by private commissions. If a work was commissioned directly
from an artist in antiquity—be it a royal or noble patron—the
identity of the artist was assured. Only when a flourishing sec-
ondary market developed in a given region would it become
important to find ways of assigning particular works to spe-
cific makers as an assurance of authenticity or quality.

In the ancient world, copies and casts were a ubiquitous fea-
ture of decorative programs. The value of objects was as likely

a function of the value of their medium—ranging from gold at the upper end to terracotta at the low end. Since the authorship of an artwork was not the determining factor in value, even a later replica in gold of a 'lost' original would have likely been appreciated without reservation. By the time that 'autograph' works by the hand of acknowledged masters became the most highly prized works of art, the question of medium took a back seat to the attribution to a particular hand. In other words, a clay bozzetto (rough study) of a bust by Gianlorenzo Bernini himself is today more highly prized than a finished bronze bust by a lesser artist. By contrast, ancient collectors were for the most part interested in the formal properties of artworks, including the preciousness of the medium, their artisanal sophistication, and the pertinence of subject matter to an intended display, and only incidentally interested in who made something. There were of course exceptions, as when in ancient Greece the reputation of renowned sculptors like Lysippos was a topic of interest. But for most of classical antiquity and throughout the rest of the ancient world across Asia, North Africa, Europe, and the Americas, the names of artists often went unmentioned or were unknown.

For that reason, replicas from molds were appreciated alongside carved versions of sculpture. The architectural decoration of palaces, temple complexes, and luxurious private residences were rife with features mechanically measured, pressed into place using plaster molds, or painted in close approximation of sketchbook patterns. The modern appreciation of "handcrafted" details did not enjoy the same currency in antiquity. The result, not the process, was celebrated in cultures that assigned value and virtue to attributes of art disconnected with the identity of the maker.

Why were Roman copies of lost Greek originals so popular?

Roman villas excavated in Pompeii and Herculaneum revealed widespread use of marble copies of Greek sculptures made in

gold, silver, bronze, or marble. Few gold and silver examples of statuary from classical antiquity survive, but they were the subjects of commentary by ancient authors including Pliny the Elder.[1] Many marble works were carved freehand, but other copies are understood to have been made with a 'pointing' system that measured the key features of the original or a cast of the original, roughed out from a marble block to match the dimensions of the original or cast, and then hand-finished with a polished the surface to reflect the appearance of the original.

Opulent villas could have been decorated exclusively with 'original' works by living Roman craftsmen in the first centuries BC and AD. But appreciation of the ancient Greek past was sufficiently strong that the allure of replicas was often greater than the veneration of contemporary talent. This impulse is eminently understandable today. From the 1920s through the 1980s, prior to the contemporary art boom, art collections formed by wealthy industrialists and financiers often favored not the art of their own time, but art of the nineteenth century. This predilection served to fuel the combative energy of the 20th century avant-garde, since artists in contemporary European ateliers found that top patrons passed over their work in favor of tried and true masters of the eras of Romanticism, Realism, neo-Classicism, Impressionism, and post-Impressionism. A comparable impulse seems to have existed in classical antiquity in the enduring preference for contemporary versions and adaptations of fifth- and fourth-century artworks. Innovation in Roman art was to be found in architectural novelties like vaulted ceilings and domes, made possible by the Roman invention of cement, along with new subjects in fresco painting and portraiture. A significant proportion of relief sculpture, free-standing statuary, and decorative arts instead relied on adaptations of the formal and stylistic conventions of classical and late classical Greece.

1. Jacob Isager, *Pliny on Art and Society: The Elder Pliny's Chapters on the History of Art* (London; New York: Routledge, 2013).

How were replicas viewed in antiquity in Asia?

A similar impulse to privilege form and subject over individual authorship was the norm in East Asia. Fingerprints and handprints impressed into ceramic objects were the conventional means by which the (literal) hand of an artist was identified, beginning in the third century BC in China, and by the 8th century AD in Japan. Alongside finger- and handprints was the use of a seal, although the primary purpose of seals was not to identify the maker, but to identify the Emperor during whose reign the work was made.

How about in pre-Columbian Art?

We have almost no evidence of individual signatures by artists in pre-Columbian cultures.[2] These works convey the identity of rulers and of aristocrats, rather than the identity of artists. This is yet further evidence that the modern focus on authenticity would have been a puzzlement in the ancient world at large.

When and why did plaster casts enjoy popularity?

Plaster casts of sculpture and architectural elements date as far back as funerary portraits in third millennium BC Egypt. Plaster casts were known in both ancient Greek and Roman contexts. After the Middle Ages, plaster casts were revived in art schools during the High Renaissance and used for sketching as they are to this day.

The use of plaster casts as substitutes for originals in displays are thought to have begun in earnest in the nineteenth century. In 1805, a shipment of casts from France arrived in the Pennsylvania Academy of the Fine Arts, marking the

2. Although generally very little is known about pre-Columbian artists, one Mayan sculptor, Chakalte' (active c. 750–800) was known to have inscribed his name onto several works throughout his career.

beginning of a cast display tradition in US museums that lasted over a century.[3]

Upon the founding of the Metropolitan Museum of Art and the Museum of Fine Arts, Boston in 1870, among the largest early acquisitions were plaster casts. Supporters and administrators of America's first two encyclopedic museums saw replicas as wholly acceptable substitutes for original Greek and Roman statuary that they assumed was largely out of reach. While subsequent strides in finding and acquiring original marble sculptures were made by purchasing agents based in Europe, the first few years of both museums were marked by halls of famous examples of classical carvings back in Athens and Rome—but not originals. The presence of these bright white substitutes in no way dimmed enthusiasm for the museums' educational enterprise.

Plaster casts were gradually retired from view in these and other museums in the course of the early twentieth century, as ambitious acquisition programs mined the noble collections of Europe, and as both state-sanctioned and illegal excavations yielded boatloads of original artworks. But these casts remained a valuable teaching tool in studios, and nineteenth century casts normally displayed outdoors are still quite useful, since they today offer a glimpse of the original surface condition of classical and Renaissance sculptures prior to the ravages of modern pollution.

For what purposes are replicas of antiquities in use today?

The Acropolis Museum in Athens, which opened in 2009, is intended as much to highlight the missing components of the Parthenon temple dispatched to London's British Museum by Lord Elgin between 1803 and 1812 as to celebrate those that remained in Athens. The new museum relies on both digital

3. Cheryl Leibold, "The Historic Cast Collection at the Pennsylvania Academy of Fine Arts," *Pennsylvania Antiques and Fine Arts*, 2010, 186–191.

reproductions and reconstructions of missing elements to call attention to the absence of much of the temple's original fifth-century decorative program.[4] In so doing it seeks to pressure the British Museum and the British Parliament to relinquish their holdings from the Acropolis.

An ironic result of the enterprise is that the appeal, which is based on moral and emotional grounds, rather than legal ones, is weakened by a very satisfying display that offers a compelling introduction to the original temple complex even without the elements today in London. The potential to present convincing patinated resin replicas of any and all missing elements, indistinguishable to the naked eye, undermines the case for restitution. Ever-improving techniques to create three-dimensional replicas is making the possession of original stonework seem like an option rather than a necessity to convey the artisanal genius of original examples of ancient sculpture. Such is the case, it could be argued, at the British Museum as well.

Will 3D printers and manmade materials make increasingly credible duplicates of originals?

The advent of three-dimensional printers has served to address scarcity in multiple industries: the possibilities seem limited only by our collective imagination. With regard to replicas of antiquities, the recreation of fine jewelry or other coveted forms of creativity is now far from an exotic quest. There remains seemingly no barrier to the routine, cost-effective, and startlingly persuasive reproductions of beguiling ancient creations, and in the coming years what was once thought to be beyond the reach of all but the fortunate few may become as available as digital images.

4. "Learning Resources," The Acropolis Museum. Accessed February 16, 2016. http://www.theacropolismuseum.gr/en/content/learning-resources.

For example, one enterprising photographer Cosmo Wenman has captured hundreds of photographs of classical sculptures in major museums and converted the photographs into high-fidelity 3D scans, making the files available to the public on 3D printing platforms.[5] Although some museums have resisted this activity, others including the Metropolitan Museum of Art, have actually encouraged visitors to photograph and share their 3D scans of museum artifacts.[6]

Can replicas substitute for originals?

The techniques of *trompe l'oeil*, or eye-tricking art forms, date back to first-century Roman mosaics purporting to show fish bones strewn on dining room floors, and elaborate geometric patterns that appear to recede or project from what is actually a flat surface. This time-honored tradition continues in the hands of sidewalk chalk illustrators who amaze passersby with illusory sinkholes.

These examples of trompe l'oeil are like sleights of hand—once explained to the onlooker their methods of artifice are laid bare. The accuracy of reproduction in the digital age takes us to an entirely new threshold. Workshops in China turn out replicas of Impressionist paintings replete with three-dimensional brushstrokes, leaving gobs of impasto on the surface of a canvas that can match centimeter-by-centimeter the topography of originals.[7] The untutored eye can easily be deceived by

5. Kecia Lynn, "3D Replicas Of Famous Sculptures, Printed At Home." Big Think, July 2, 2013, http://bigthink.com/ideafeed/3d-replicas-of-famous-sculptures-printed-at-home.
6. Don Undeen, "3D Scanning, Hacking, and Printing in Art Museums, for the Masses." The Metropolitan Museum of Art. October 15, 2013. Accessed February 16, 2016. http:// www.metmuseum.org/ about-the- museum/ museum- departments/ office- of- the- director/ digital-media- department/ digital- underground/ posts/ 2013/ 3d- printing.
7. Katherine Brooks, "Art Website Sells Cezanne Painting For $20." *The Huffington Post*. Accessed February 16, 2016, http://www.huffingtonpost.com/2012/08/02/chinese-art-reproduction-_n_1733455.html.

such machine-rendered surfaces—as may be on occasion the eye of gullible art historians.

The questions raised by this caliber of reproduction are many. If the naked eye—even of an expert—cannot distinguish a two- or three-dimensional replica from an original without turning the canvas over, why is it less effective as a conveyer of aesthetic and iconographical intention than the original on which it is based? The objection to its substitution for an original is based on moral grounds—that it's a deceitful masquerade.[8] But if the imperfect human eye can be completely won over by increasingly clever technical trickery, and the authorship is known to be modern, how is the promulgation of such replicas not a victimless crime?

These digitally mastered replicas cannot in every respect substitute for originals. But like stunt doubles, they can offer a satisfying, entertaining, and persuasive proxy for the original. They can provide visual stimulation and information indistinguishable from that provided by the originals on which they are based. And they can do so without disturbing archaeological contexts, fomenting the illicit market, or depriving the public of a masterwork relegated to a private collection.

The provision of experiential milieux emulating original contexts is already an accepted practice in cultural tourism. Prehistoric caves in France can no longer risk further damage from the breath of groups of tourists, with exhaled carbon dioxide progressively eroding the painted surface. So it is with replicated Egyptian tombs, like a full-size replica of King Tutankhamun's tomb in Luxor, Egypt, which even recreates the existing damage to the murals and walls resulting from temperature fluctuations and moisture from visitors' breath. Similarly, the Mogao Caves at Dunhuang in China have been replicated with unerring accuracy, yielding insight and enjoyment of a near-perfect translation of the original decorative program.

8. John Henry Merryman, "Note on Counterfeit Art," in *Thinking about the Elgin Marbles: Critical Essays on Cultural Property, Art and Law*, ed., J. H. Merryman, 468. The Hague; Boston: Kluwer Law International, 2009.

Cultural tourism on a mass scale proves that the appetite for experiencing ruins and partially preserved contexts and monuments is only growing—and thus the promulgation of replicated environments could be our only option to safeguard exposed and fragile archaeological settings. Over time we should expect and demand that these settings become more convincing, more educationally satisfying, and more deserving of our collective support. But exposing delicate settings to immeasurable quantities of pounding shoes, carelessly swiveled backpacks, oily hands, and damaging exhalations can only lead to their incremental disappearance.[9]

Finding innovative ways to expose new generations to the achievements of ancient artists is a worthy quest, updating the plaster cast phenomenon of the nineteenth century. Replicated objects and environments offer a sustainable substitute for the experience of the Grand Tour of the 18th century, when British voyagers would incise their names on temple columns and purchase the decorative features of exposed and excavated monuments and sites.[10] Today's version of the Grand Tour starts on a handheld device and can end with a three-dimensional simulation of an object or place abroad or at home. The biggest risk to our collective understanding of antiquity is that the aura of the original is missed in such virtual encounters. But in the weighing of rights and wrongs, the substituted experience is in many instances the only way forward. Because in the end it is a lesser deprivation to miss the aura of a site if it means that later generations won't live in a world without the site itself.

9. Yaron Steinbuch, "Tourists Are Finishing What the Volcano Started in Pompeii," *New York Post*, February 24, 2016. http://nypost.com/2016/02/24/tourists-are-finishing-what-the-volcano-started-in-pompeii/.
10. Jon Henley, "Graffitists Who Leave Their Mark on History May Have Had Their Time," *The Guardian*, March 4, 2014. http://www.theguardian.com/culture/shortcuts/2014/mar/04/graffiti-leave-mark-on-ancient-monuments.

14

RETENTION, RESTITUTION, AND REPATRIATION

What do these terms mean?

Antiquities in the permanent collection of a particular museum or monument were likely transferred from or donated by a royal, noble, state, or private collection, or purchased.

But so-called "permanent" collections are not impervious to change. Museums on occasion will sell or trade works, downgrade some to the status of forgeries, destroy irretrievably damaged objects, and on occasion lose others in ownership disputes with state parties or individuals. Multiple claims made by source countries for antiquities in foreign public collections over the last few years have been successful, although not without some skirmishes to rebut them. Those museums that have held onto works in the face of claims have done so on legal grounds—such as by invoking a statute of limitations, for example.

As we reviewed in chapter 4, some have advanced the notion that state parties are unreasonable in their stalwart **"retention"** of cultural heritage, a charged term by which they intend that these state parties claim ownership without sufficient grounds. The basis of this position is that since modern nations postdate the ancient cultures whose artifacts they seek to protect, they have no inherent right to retain them.[1] Labeling

1. "Governments can use antiquities—artifacts of cultures no longer extant and in every way different from the culture of the modern nation—to serve the government's purpose. They attach identity

source nations as 'retentionist' makes an appeal based on emotional rather than legal grounds to undo national property laws in order to allow for the circulation and sale of examples of cultural heritage. While the emotional claim is understandable, it has no basis in international law.

Restitution implies the return of an antiquity to its probable nation of modern discovery. Returning an antiquity to its source country comes about through successful legal claims, or as a result of compelling evidence that the work was stolen or illegally exported. UNESCO maintains an international committee representing twenty-two member states to review restitution claims by source countries that are not supported by treaties or conventions.[2]

Repatriation is, like retention, a politically charged term with respect to antiquities, used to mean returning an object of cultural heritage to its *patria*, or native country. The word is more conventionally used to refer to a refugee who is involuntarily sent home, which is hardly an apposite connotation in the minds of those who advocate the legitimacy of claims for antiquities by modern governments. Nevertheless, the word is widely used to signify restitution, but, by means of the same root word in *patriotism*, to justify the return of objects on moral grounds.[3]

Which term is best suited to address the Parthenon Marbles?

Among the longest-running disputes regarding the return of antiquities is that of the marble sculptures that once adorned

with an extinct culture that only happened to have shared more or less the same stretch of the earth's geography. The reason behind such claims is power." James Cuno, "Who Owns the Past?" *Yale Global Online*, April 21, 2008. http://yaleglobal.yale.edu/content/who-owns-past.

2. United Nations Educational, Scientific and Cultural Organization, "Intergovernmental Committee (ICPRCP)," *Restitution of Cultural Property*. Accessed February 26, 2016. http://www.unesco.org/new/en/culture/themes/restitution-of-cultural-property/.

3. "Patria," Oxford Dictionaries. U.S. English. Accessed February 26, 2016. http://www.oxforddictionaries.com/us/definition/american_english/patria.

the Parthenon in Athens. There are examples in the Louvre, the Vatican Museums, the National Museum in Copenhagen, Vienna's Kunsthistorisches Museum, the University Museum in Würzburg, and Munich's Glyptothek museum. But the vast majority of the elements outside of Athens were removed between 1801 and 1805 by Lord Elgin, Britain's ambassador to the Ottoman Empire, and have been on display at The British Museum since 1816.

While their removal from the temple and export to Britain were not contested at the time, in recent decades the clamor for their return to Athens has grown, starting with a very public campaign by Melina Mercouri, Greece's Minister of Culture and Sciences from 1981–1989 and from 1993–1994. Mercouri's impassioned quest continued until her death in 1994.

Any legal grounds for Greece to claim the Parthenon marbles would have lapsed almost two centuries ago. But the campaign to send them back has not faded since Mercouri's passing. So animated are the two sides debating the fate of the sculptures that books continue to be published on the topic. The administration and trustees of the British Museum have unflaggingly defended their pertinence to the Museum's collections, and have flatly rejected any possibility of restitution.

The moral or ethical case is where a crack of light shows from time to time. The British Parliament, not the British Museum itself, could decide for any number of reasons to reverse its 1983 decision to reject the Greek government's appeal for the marbles' return. For the time being there is no evidence of energy to do so. Britain's recent vote to exit the European Union will likely further diminish the possibility that Greece will prevail in this quest.

Are antiquities better off staying put or circulating?

The three words relating to the possession of antiquities represent the spectrum of opinion about ownership claims. Collectors and dealers may invoke 'retention' to signify what

they perceive to be an unreasonable aversion to allowing works to circulate in an open market. Nationalists invoke 'repatriation' to signify that antiquities belong where they began.[4] And in the middle are those who use 'restitution' to signify the return, voluntary or not, of examples of cultural heritage to their nation of modern discovery. Those espousing the two extreme views see little room for compromise.

But as far as the objects themselves imputed in property disputes are concerned, what matters most is careful handling, a stable climate, and a secure setting. It is hard to make the case that antiquities are by definition better off in one country or another. Some favor circulation of antiquities through exhibitions, long-term loans, or permanent acquisitions, as a means of sensitizing the public about their significance and about the cultures from which they emanate. Others worry that circulation puts objects at risk, and contend that motivated members of the public can travel to source countries or consult illustrated databases to develop greater understanding about a particular region's cultural heritage.

Both are right. And thus the case for possession has less to do with what is best for the material remains of our past, and more to do with personal and political aims. The fate of the Cambridge Cockerel, a brass sculpture from the Kingdom of Benin looted by the British in the 19th century, will rest on Cambridge University's decision, in light of the clamor, on whether to restitute a work to Nigeria—even without any legal obligation to do so. Recent student protests have led to the sculpture's removal from display, and the review by University leadership of its eventual fate.[5]

The private collector seeks to enjoy the company of original objects in a private setting. The cultural patriot seeks to

4. William Pearlstein, "Rethinking Antiquities: Collecting in the Time of ISIS." Panel presented at Cardozo Law School, March 1, 2016. http://www.cardozo.yu.edu/events/rethinking-antiquities-collecting-age-isis.
5. Sally Weale. "Benin Bronze Row: Cambridge College Removes Cockerel." *The Guardian*. March 8, 2016. http://www.theguardian.com/education/2016/mar/08/benin-bronze-row-cambridge-college-removes-cockerel.

enshrine those same works in a setting that acknowledges the state's rightful possession. The public museum professional seeks possession of the objects for motives of her or his own. These could be as selfless as seeking to create an educational context by which the public's understanding of an ancient culture is magnified. Or they could be as selfish as one-upmanship, to procure a precious example of the past before a competitor does. The academic seeks the outcome that best assures maximum information about the objects under consideration. If illicitly excavated and in circulation, an antiquity's ultimate destination may matter less to some archaeologists than its preservation. Others side with the cultural patriot or the public museum professional.

Every actor in the field of antiquities therefore has one or more motives that rise above—or below—the best interests of the object itself. And thus the case for retention, restitution, or repatriation is tangled up with personal predilections along with legal and ethical grounds. There is no single right answer for the destiny of antiquities; each case must be taken up on its own merits.

How have recent upheavals in the developing world affected the rationale for state ownership?

Everyone with a shovel has had the experience of inadvertently striking and damaging something under topsoil. Every hour of every day, damage is inflicted on the world's archaeological heritage somewhere, whether intentionally or not. The recent conflagrations in Afghanistan, Iraq, Syria, and Libya have brought the fate of antiquities to the public's consciousness in unprecedented ways.[6] The willful destruction of sites

6. In 2016, Arab League Chief Nabil al-Araby announced newly drafted resolutions to afford stronger protection to Arabic cultural heritage. As part of this announcement, Araby mandated a new holiday on February 27th as "a day of reviving Arab cultural heritage." The date was selected to mark the destruction of antiquities at the

and contexts by the Taliban and Islamic State have been jarring evidence that ideological and religious extremism contribute to the spoliation of evidence of the past.

These incidents have also called into question the reasonableness of restituting looted artifacts to nations with conflict zones. How, it can understandably be asked, does it make sense to return looted objects to the region where active looting and organized theft is fueling the insurrections and destructive acts to begin with?

Few contest the basis of this last question. It is for that reason that the British Museum acted to take in over 2,300 smuggled cultural objects in the wake of the Taliban's destruction of sites, monuments, and museums in Afghanistan. The British Museum has similarly sought to protect at least one artifact looted from Syria.[7]

What is "safe harbor" for ancient objects?

The British Museum's assumption of responsibility for these artifacts between 2009 and 2012 was premised on the clear need for "safe harbor," whereby the objects in question were spared intentional destruction by the Taliban, as well as their potential disappearance into the art market. The Museum made the decision to return the works when it was reasonable to assume that government officials could protect them from loss or damage.

The safekeeping of art abroad during times of conflict was a major concern during World War II, when the Allies retrieved

Mosul Museum in Iraq. Al-Masry Al-Youm, "Arab League Draft Resolution to Protect Arab Antiquities: Araby," *Egypt Independent*, April 5, 2016. http://www.egyptindependent.com/news/ arab-league-draft-resolution-protect-arab-antiquities-araby.

7. "British Museum 'Guarding' Object Looted from Syria," *BBC News*, June 5, 2015. http://www.bbc.com/news/ entertainment-arts-33020199.

tens of thousands of artifacts and dispatched them abroad, to Russia, the United States, and throughout Europe.[8] Many works remain at large, as is the case with Priam's Treasure described in chapter 8, and still others were lost by serving soldiers who brought them home.[9]

The concept of safe harbor has recently gained traction as state parties including France have announced their intention to import endangered Syrian antiquities for safekeeping.[10] Some in the collecting community have argued for loosening restrictions on the import and sale of looted works as a remedy, suggesting that the world would be better off having stolen art in Western collections than remaining in the shadows of the illicit trade. The North American professional art museum organization AAMD (Association of Art Museum Directors) worked to alter a bill in the U.S. Congress to allow museums to take in looted Iraqi and Syrian antiquities temporarily, just as the British Museum did during the time of the Afghan invasion beginning in 2009.[11]

Each of these efforts demonstrates that in times of conflict, solutions for looted and displaced art are countenanced that would not pass muster in times of peace. And the greatest challenge after the cessation of hostilities will be to insure that stolen artifacts make their way back not only to the nation of modern discovery, but as close as possible to the findspot where they emerged.

8. Michael J. Kurtz, *America and the Return of Nazi Contraband: The Recovery of Europe's Cultural Treasures* (Cambridge, MA: Cambridge University Press, 2006).

9. "Returning the Spoils of World War II, Taken by Americans," *The New York Times*, May 5, 2015. http://www.nytimes.com/2015/05/06/arts/design/returning-the-spoils-of-world-war-ii-taken-by-our-side.html.

10. Ed Adamczyk, "Hollande Proposes That Syrian Antiquities Be Brought to France for Safekeeping," UPI, November 17, 2015. http://www.upi.com/Top_News/World-News/2015/11/17/Hollande-proposes-that-Syrian-antiquities-be-brought-to-France-for-safekeeping/6501447778123/.

11. The bill was signed into law on May 9, 2016.

How do restituted objects fare once returned
to their source country?

When restituted antiquities arrive in their nation of modern discovery, the results are mixed. In some cases, the objects noted in published inventories are reinserted into the collections from which they were stolen. This is the most straightforward category of restituted works, since their place of origin is documented, and their return is explicitly prescribed by the 1970 UNESCO Convention on illicit trafficking.

More complicated are the restitutions of antiquities that were looted in the course of illicit excavation, as with Britain's 2015 restitution to Egypt of 619 artifacts seized by UK authorities. The origins of the objects were unknown, and possession of the antiquities was assumed by the Egyptian Museum in Cairo, without clarity about their ultimate destination.[12]

The 2015 restitution to India by several US museums of artifacts illegally obtained by the disgraced dealer Subhash Kapoor represents a similar challenge. The works were for the most part looted directly from temples, which will allow in some instances for Indian authorities to identify their exact original context, but in others will not.[13]

It is not unknown for restituted works to go missing once dispatched to their country of origin. Such was the case with examples of the Lydian Hoard restituted to Turkey by the Metropolitan Museum of Art (see chapter 7), and more recently a group of antiquities seized in the United States and returned to Iraq.[14]

12. AP Archive, "Stolen Antiquities Returned from Britain," July 21, 2015. https://www.youtube.com/watch?v=ePfOBB7rW5U.
13. Tom Mashberg, "Museums Begin Returning Artifacts to India in Response to Investigation," *The New York Times*, May 15, 2013. http://www.nytimes.com/2013/05/16/arts/design/cambodia-presses-us-museums-to-return-antiquities.html.
14. Included in the artifacts returned to Iraq was a group of 362 cuneiform clay tablets that had been seized by American authorities in 2001, and were being stored in the World Trade Center when it

These two examples of carelessness with restituted objects on the part of authorities in source countries are cited by the collecting community as grounds for an open market. If a source country cannot be trusted to safeguard antiquities which it considers state property, the argument goes, then such objects are better off on the open market whereby a private collector or public museum abroad could devote the necessary resources to its conservation and protection.[15] The counterargument is that even if there are examples of restituted artifacts being cared for incompetently, these are isolated instances that should not undermine the legal and moral claims of state parties. When examples of Nazi loot are returned to the heirs of a victim, and the heirs choose to sell the work, there is no outcry.[16] The overarching conclusion that a fair-minded observer might draw is that owners of antiquities, careless or not, are the owners.

What are "objects in limbo"?

The last category to be addressed in this chapter is "objects in limbo", or what some have called "orphaned" antiquities. These are works without any provenance, or with only very recent provenance that does not include an export license from its probable nation of modern discovery. Within the United

was attacked on September 11, 2001. Steven Lee Myers, "Looted Treasures Return to Iraq," *The New York Times*, September 7, 2010. http://www.nytimes.com/2010/09/08/world/middleeast/08iraq.html.

15. Peter Tompa and Kate Fitz Gibbon, "Protect and Preserve International Cultural Property Act, H.R. 1493/S.1887: Saving Syrian Antiquities or Crushing the Legitimate Art Trade?" *Committee for Cultural Policy*, November 30, 2015.

16. Alex Capon, "Restituted Works Headline Impressionist and Modern Art Auction Series," *Antiques Trade Gazette*, June 29, 2015. http://www.antiquestradegazette.com/news/2015/jun/29/restituted-works-headline-impressionist-and-modern-art-auction-series/.

States, a significant gap in provenance exposes the owner of an orphaned antiquity to a potential claim invoking the NSPA, or National Stolen Property Act. The acquisition policies of certain museums in Germany, Great Britain, the United States, and elsewhere prohibit the purchase of objects that lack proof of ownership before the 1970 UNESCO Convention. Such prohibitions also effectively prevent private collectors from donating works to these museums, although the Association of Art Museum Directors has provided for exceptions to its guidelines for normally declining such gifts. It created an Object Registry and obligates any of the over two hundred museums in its membership that choose to acquire unprovenanced works to divulge these on the Registry and explain the rationale for invoking an exception.

How much provenance is deemed sufficient to take objects out of limbo?

The AAMD's 1970 'bright line' requires ownership history of the work predating the passage of the UNESCO Convention. That said, the evidence required for an object to be considered reasonably free of the risk of a claim can be daunting. If an object was illustrated in a publication predating a given country of origin's export restrictions—such as a sales catalogue, collection publication, or exhibition catalogue—or illustrated in a published photograph of a collector's home, the owner or subsequent owner is unlikely to be exposed to the risk of a claim. But if the object lacks a record of publication or public exhibition before the date of a given nation's enactment of export laws, it's possible that a potential claimant might come forward with evidence of their own documenting the looting, theft, illicit export, or illicit import of the artifact in question.

Retrospective research on an object previously identified as unprovenanced can yield beneficial results, such as

photographic evidence in a family archive, or a bill of sale, or mention in correspondence, that would serve to bolster the case for the object's legitimate ownership.[17]

Is transparency about objects in limbo productive?

As museums undertake retrospective and prospective research and publication on under- or unprovenanced objects in their collections, some have chosen to notify source countries of gaps in provenance, in order to avoid embarrassing claims that might otherwise come without warning. Some in the collecting community have bemoaned this due diligence, considering it an overreaction to recent claims made by Mediterranean, Asian, and African nations. But given the museum community's ongoing commitment to the creation of searchable, illustrated databases, it is reasonable to assume that source nations are reviewing collections evidence online to assess the validity of ownership claims, and the provision of even incomplete ownership information by museums offers at least a starting point in their defense should a claim arise, as well as a protection against allegations that they were seeking to suppress objects which lack a complete record predating a given nation's export laws.

Have source countries claimed any objects in limbo that are not documented as stolen?

There have been instances of claims of objects in limbo even in the absence of direct evidence of theft. Such is the case with Cambodian sculptures stylistically associated with the

17. For a first-hand account of these benefits, see Gary Vikan, "A Former Director's Perspective on Provenance Research and Unprovenanced Cultural Property," *Collections: A Journal for Museums and Archives Professionals Provenance Research in American Museums*, n.d. Benjamin Cardozo School of Law. https://cardozo.yu.edu/sites/default/files/VIKAN_article.pdf.

Koh Ker temple complex that are in numerous US museums today. Stylistically similar works in museums have recently been returned even without forensic or documentary evidence that they pertained to a standing monument, largely as a result of public pressure and the threat of claims by Cambodian authorities.

What will become of antiquities in private collections that don't meet restrictive acquisition standards?

As mentioned above, some market nations such as Germany, and several US museums with restrictive acquisitions policies including the University of Pennsylvania Museum,[18] the J. Paul Getty Museum,[19] and the Indianapolis Museum of Art[20] will not acquire objects lacking pre-1970 provenance. The current guidelines of the Association of Art Museum Directors do not prevent member museums from acquiring objects in limbo, provided that these acquisitions are illustrated and documented on the Association's Object Registry, and that an explanation is provided for why the museum feels it's reasonable to invoke an exception.

Notwithstanding the exceptions provided for by AAMD, the vast majority of private collections of antiquities lack the documentation that would insulate a museum acquiring them from claims.[21] As a result, the Association has nevertheless

18. Penn Museum, "The University Museum Acquisitions Policy," *Expedition Magazine* 22, no. 3, March 1980.
19. "Policy Statement: Acquisitions by the J. Paul Getty Museum," October 23, 2006. http://www.getty.edu/about/governance/pdfs/acquisitions_policy.pdf.
20. "Indianapolis Museum of Art Declares Moratorium on Antiquities Acquisitions," *Archaeological Institute of America*, April 16, 2007. https://www.archaeological.org/news/advocacy/96.
21. In 2009, the Cultural Policy Institute surveyed archaeological and ancient materials in private hands and found between 67,500 and 111,900 "unprovenanced" Greek, Roman, and Etruscan objects in private American hands.

explored the provision of a time-limited moratorium on its 2008 imposition of a 1970 bright line. The premise of temporarily erasing the bright line for objects that entered the United States before 2008 is that now that almost a decade has passed, the acquisition of unprovenanced works by museums would not provide a material incentive to looting. And unless these works enter public collections, they will end up back on the art market, stimulating more demand for ancient artworks.

As for those unprovenanced works lacking provenance after 2008, the road ahead is uncertain. The art market is the likeliest destination for objects in this category, which are unlikely to enter public museums of any stature, condemning them to a permanent state of limbo in the private sphere. Over time their fate may be rewritten, but for the time being, the risks of potential claims are judged by most museums not to be worth the rewards of possession.

15

THE PROSPECT OF AN ENLARGED LEGAL MARKET

Will the legal antiquities market ever expand to include source countries?

The licit, or legal, trade in antiquities is effectively confined to market nations in Europe and North America. Source countries view cultural heritage discovered in their territorial limits as state property, ineligible for sale.[1] Once cultural property laws and export restrictions are enacted in a given nation, customs officials, law enforcement officials, and courts abroad will often recognize their legitimacy, and are in some cases prepared to intervene on behalf of a claimant seeking restitution of a stolen or looted artifact.[2] State parties overseeing a vast cultural inheritance for the most part view the sale of antiquities to be anathema to their overarching responsibility to protect what they view as national patrimony. For a legal antiquities market to expand to archaeologically rich nations, the decision to permit the sale of cultural heritage would have to

1. See chapters 6 and 7 for a more in-depth discussion of these views.
2. In one case, after a sixth-century mosaic was looted from a church in war-torn Cyprus in the 1970s, the Cypriot government and the church successfully brought suit in a United States court after learning that an American art dealer had attempted to sell four pieces of the mosaic. Autocephalous Church v. Goldberg & Feldman Arts, 917 F. 2d 278 (Court of Appeals, 7th Circuit 1990).

be preceded by a philosophical shift. That shift would be away from viewing antiquities as the inviolate expression of national identity, and toward the perspective that permitting the sale and export of artifacts would represent an incremental, not an existential change.

To date there have been few in positions of civic leadership in source countries who have expressed a willingness to consider such an expansion. One recent exception has been the Indian Minister of Culture, Mahesh Shrama, who in 2015 advanced the possibility of altering the Antiquities and Art Treasures Act, 1772, to allow the sale and export of objects over one hundred years old. The goal of amending the Act to legalize a market, according to Shrama, is to combat smuggling.[3]

The proposal has predictably been met with strong resistance from multiple quarters, including from the international archaeological community, many of whose leading voices fear that this step would in fact only encourage *further* looting and smuggling.[4] While proposed changes to the law might be years off even if they are favorably received by Indian officials and courts, the Modi government's openness to the creation of a legal market represents a seismic shift in attitude in a powerful, populous, and influential nation with enormous reserves of ancient heritage. Very few other nations with significant ancient heritage already have legal markets for antiquities, including Israel, Japan, and the United Kingdom. But no sovereign nation has seriously entertained the prospect of joining them since Israel altered its laws in 1978.[5] Were India to take

3. Autocephalous Church v. Goldberg & Feldman Arts, 917 F. 2d 278 (7th Cir.1990).
4. Kathleen Caulderwood, "India Looks To Create 'Open Market' For Antiquities; Critics Say It Will Encourage Looting," *International Business Times*, May 26, 2015. http://www.ibtimes.com/india-looks-create-open-market-antiquities-critics-say-it-will-encourage-looting-1938698.
5. Antiquities Law, Law No. 5738-1978 (1978). Israel Antiquities Authority. http://www.antiquities.org.il/article_eng.aspx?sec_id=29&subj_id=234.

this step, it might well encourage other source countries to follow suit.

What are the arguments for and objections to enlarging the licit antiquities market?

Some liken the prospect of a legalized antiquities market to the prospect of a legalized market in narcotics—a way of flushing out the criminal element by creating a more efficient and safer platform for circulation.[6]

But while the supply of narcotics and weapons is theoretically inexhaustible, the record of our past is finite, and regulating the sale of artifacts would do little to suppress illicit digging or removal of archaeological material from previously undisturbed contexts.

Objections to a licit market generally rest on the assumption that ill-gotten gains will simply have fabricated provenance attached, thereby speeding their way to sale. The intersection of organized criminal factions and the illicit trade yields what has been called a "gray" market—one in which it is frequently impossible to establish whether a given work's history is accurate or invented.[7]

Objects with good provenance are increasingly harder to obtain, since fewer and fewer legally exported works are available for sale as the dates of restrictive national laws and statutes continue to recede into the past. For that reason, the prices

6. See William G. Pearlstein, "Claims for the Repatriation of Cultural Property: Prospects for a Managed Antiquities Market," *Law and Policy in International Business 28*, no. 1 (1996): 123–150. For a dismissal of this analogy see Michael Kimmelman, "Regarding Antiquities, Some Changes, Please," *The New York Times*, December 8, 2005. http://www.nytimes.com/2005/12/08/arts/regarding-antiquities-some-changes-please.html.
7. Jessica Dietzler, "On 'Organized Crime' in the Illicit Antiquities Trade: Moving beyond the Definitional Debate," *Trends in Organized Crime* 16, no. 3 (2013): 329–342.

of objects with good provenance are now geometrically higher than those without.[8]

Patty Gerstenblith has examined several pathways to reducing the incentives for looting in connection with the market, from increasing regulations; to decreasing them; to codes of conduct by professional associations; and to altering tax law in the United States to couple good provenance with donors' ability to receive a charitable deduction. As she is the first to admit, these remedies, while theoretically reasonable, would do little to stem the tide of looting or the illicit trade internationally.[9]

What are the potential benefits to source countries in permitting a legal market?

Advocates of introducing a legal market in source countries suppose that the funds realized from sales could be of benefit to state parties, increasing resources necessary to police archaeological sites, interdict criminal activity, conduct excavations, document finds, research them, conserve them, and display them. A new funding stream for these purposes would doubtless be welcome. But cultural politics in source countries typically abjure the possibility of monetizing cultural heritage, regardless of potential benefits.

How do advocates of an expanded legal market suppose that it might develop?

William G. Pearlstein and other proponents of an expanded legal market focus less on the motivation for source countries to adopt legal markets, and more on the reasons that market

8. John Henry Merryman, "The Free International Movement of Cultural Property," *New York University Journal of International Law and Politics* 31, no. 1 (1999): 1–14.
9. Patty Gerstenblith, "Controlling the International Market in Antiquities: Reducing the Harm, Preserving the Past," *Chicago Journal of International Law* 8, no. 1 (2008).

nations should contest "found in the ground" laws to begin with. Citing the 1973 "Essay on the International Trade in Art," by Professor Paul Bator, Pearlstein correctly notes that US federal policy in the wake of the UNESCO accords was averse to ceding legal ground to state parties with restrictive cultural property regimes, citing US interests in an open market. During the last twenty years, however, since the emergence of antimarket case law and the dominance of an archaeological perspective in the U.S. Department of State, the hope for an expanded legal market has been dashed, and it would take a transformation like India's change of heart to reopen the debate.

16

EVOLVING PERSPECTIVES ON OWNERSHIP

*How are dealers and collectors coping
with increasing restrictions?*

The incremental successes of source nations and the archaeological community in restricting the trade in antiquities have had a material effect on the art market and on the practice of private collecting. Gone are the days when provenance questions went unasked by seller and buyer alike, and objects moved freely and aboveboard around the world. Today's increasingly attentive customs officials, vigilant prosecutors, and investigative journalists place any high-profile purchase by a private or public buyer in a bright light, as well as any gifts or bequests to museums. Dealers and their legal representatives and advocates are more cautious than ever, seeking to avoid embarrassment or even prosecution as a result of a claim.[1] Simultaneously advocates of collecting are vocally pressing for the liberalization of import restrictions and attitudes, with multiple conferences held annually by interested individuals and organizations.

The battle against restrictions on collecting plays out for the most part in the United States, where private ownership has a

1. Thane Peterson, "Hey, That's Our Art!" *Bloomberg Business*, May 15, 2006. http://www.bloomberg.com/bw/stories/2006-05-15/hey-thats-our-art.

venerable history, and where the federal government is historically indifferent to the fate of artworks made since European settlers first arrived. In other market nations including Great Britain, Germany, and Japan, collectors are on the whole less visible and organized in protesting what could rightly be seen as reversals of fortune in what had been an unfettered open market.

Which is not to say that collectors in Europe and Asia are not active in the market. The United States is among a few nations with a visible track record in prosecuting claims of cultural heritage. Apart from the notable exception of Italy, European state parties have shown less of a predilection to impose import restrictions or to investigate possible involvement in the illicit trade. Private collectors in European nations are therefore subject to less scrutiny than their American counterparts.

The German government has recently changed course. Having introduced enabling legislation for the 1970 UNESCO Convention only in 2007, it has now adopted strict import standards that require an export permit for works older than seventy years and valued over €300,000 ($326,000).[2] The new State Minister for Culture and Media, Monika Grütters, led the change, which has proved highly controversial within the collecting community.

What are collecting institutions advocating?

A small number of US museums, governed in many instances by boards including the same private collectors who oppose trade restrictions, continue to acquire archaeological material with a less than rigorous adherence to professional practices adopted by national membership organizations such as

2. "New Draft Act to Protect Cultural Property Published," *The Federal Government of Germany*, September 15, 2015. https://www.bundes regierung.de/Content/EN/Pressemitteilungen/BPA/2015/2015-09-15-bkm-kulturgut_en.html.

the Association of Art Museum Directors and the American Alliance of Museums. The majority of US museums are biding their time, looking down the road to a resolution of the fate of objects in limbo described in chapter 14, rather than being active in an increasingly problematic market.

Museums in other market nations are typically governed not by boards including collectors, but by Ministries of Culture populated by academics and archaeologists, as in Germany, Italy, and elsewhere. In such museums there is next to no appetite to participate in the trade, and any acquisitions focus is instead on cultivating extant private collections that may some day end up in a public institution.

Museums in source nations too are overseen by Ministries of Culture, and they are often called upon to serve as the repositories of restituted antiquities, even if their typically small professional staff may be overwhelmed by the routine obligations of what is already in their care.

What are the differences between ownership and stewardship?

Ownership implies having legal title to an object. Stewardship, by contrast, implies possession but is not typically permanent. Exceptions occur, as is the case when overseas claimants arrive at a mutually acceptable arrangement with a museum to leave works on permanent deposit, simply changing the label to reflect their ownership. But for the most part, stewardship can involve a very flexible premise, ranging from the short-term loan of an object to a long-term or even "permanent" loan.

As a result of increasing export and import restrictions facing the antiquities trade, ownership is fast becoming a high bar for collecting individuals and institutions. The 'permanent collection' is a longstanding concept, whereby regardless of the circumstances of an object's entry into a given museum, it is presumed to be forever a part of that institution's future. As we have noted above, the permanence of collections is no longer a given, with isolated successful claims calling into

question even long-standing ownership of contested artifacts. As technological advances continue, we will likely learn of forgeries freshly recognized even in institutions with the highest scholarly standards. And the pressure to share works in storage will mount as the market dries up. The potential exists for significant transfers of objects from museums with larger holdings to those seeking representative examples of an ancient culture.

The sharing of objects among institutions can take many forms. The most familiar is through long-term loans, which may entail the transfer of dozens of artifacts for multiple years from one museum to another.[3] In simpler times, such loans were typically not monetized; a would-be borrowing institution approached a potential lending institution, and the virtue of sharing otherwise stored material was often seen as an uncomplicated and worthy enterprise. In more recent years, demands for fees far exceeding the actual administrative costs are not unheard of, although these are more typically attached to shorter-term loans of objects that have been recently on display at the lending museum.

Almost thirty years ago, this author, on behalf of the Michael C. Carlos Museum (formerly the Emory University Museum of Art and Archaeology), set about organizing loans of unpublished archaeological material from the storerooms of some of the world's leading museums.[4] In collaboration with leading museums in Italy, France, Great Britain, and Mexico, the Carlos Museum identified antiquities in storage that might be restored, published, lent, and displayed for longer than the standard twelve-week run of special exhibitions. Each of seven

3. To encourage and facilitate this process, the Museum Loan Network provides a directory of more than twenty thousand artifacts from four hundred participating institutions that are available for long-term loans to museums and cultural institutions.
4. David Gill, "Archaeological Loans: Looking Back to EUMILOP," *Looting Matters*, June 30, 2008. http://lootingmatters.blogspot.com/2008/06/archaeological-loans-looking-back-to.html?view=magazine.

resulting loan displays was thematically coherent, with sub-
jects as varied as excavated Roman portraits from the National
Museum in Rome to the art of Roman North Africa in the col-
lections of the Louvre.

As museums look for viable ways of refreshing the public's
encounters with both renowned or recently discovered antiq-
uities, long-term loans continue to offer a promising avenue.
The rewards of long-term loans are comparable to those of out-
right ownership: the ability to present compelling objects for
a protracted period of time in concert with other holdings or
loans. The public's shortening attention span may in fact serve
to stimulate interest in impermanent displays, and the growth
in both sophisticated replicas and detailed digital imagery will
also contribute to the diminished value attached to ownership
over stewardship.

Why don't museums sell antiquities in storage?

From time to time the suggestion arises that museums with
bulging storerooms should consider selling 'excess' inventory,
or 'duplicate' objects—in this case antiquities.[5] After all, since
museums complain of the cost of caring for collections both
on view and in storage, and since there is a growing demand
for works with provenance, it seems reasonable that museums
would stand to benefit both logistically and financially from
the dispersal of artifacts not currently on view.

The reasons that source nation museums do not at pres-
ent consider this route is clear: cultural heritage is integral to
national identity, neither of which is for sale. With regard to
market nation museums, the objections are more complicated.
US museums arrived at an arrangement with the Financial

5. Duplicate objects may be described as works for which a single mold
 was used, or which originate from a common workshop or school,
 so closely resembling other versions that they appear effectively
 identical to all but the most tutored eye.

Accounting and Standards Board (FASB) in 1992, which allowed them to be exempted from annual appraisals of the fair market value of every work in their collection. The proviso was that their collections would not be recognized on their balance sheet as assets, and that they in turn could not be monetized. This agreement saves museums with large collections considerable costs annually, by eliminating the need to subject their holdings to time-consuming and expensive appraisals.[6]

As a result of the FASB agreement, US museums are enjoined from selling, or "deaccessioning" works from their collection for any purpose other than buying other works of art with the proceeds. This effectively prevents them from using collections as assets, or as collateral for loans, and requires extreme caution when deaccessioning works from the collection. Those museums, like the Delaware Art Museum, that have strayed from the convention of keeping their collection as an uncapitalized asset have paid a price in bad publicity and being censured and shunned by professional associations including the Association of Art Museum Directors and the American Alliance of Museums. They have been subjected to loan embargoes, expulsion from professional bodies, and public shaming.[7]

6. "Statement of Financial Accounting Standards No. 116," Financial Accounting Standards Board, June 1993. http://www.fasb.org/resources/ccurl/770/425/fas116.pdf.
7. In 2007, the Delaware Art Museum was sanctioned by the Association of American Museum Directors (AAMD) for selling off a William Hollman Hunt painting to both settle the Museum's debt and increase the Museum's endowment. The AAMD also requested that its other members abstain from lending any artwork to the Delaware Art Museum or assisting the Museum with any exhibitions. In spite of this public reprimand, the Delaware Art Museum announced plans to deaccession two other works. Deborah Solomon, "Censured Delaware Art Museum Plans to Divest More Works," The New York Times, August 7, 2014. http://www.nytimes.com/2014/08/10/arts/design/censured-delaware-art-museum-plans-to-divest-more-works.html.

Other grounds for avoiding the sale of collection contents are more nuanced. Many of the works in US collections came as gifts, and their sale can elicit understandable irritation on the part of influential donors and their heirs. In addition, most museum professionals agree that the vagaries of taste are ever-changing, and the decision to sell an object in 2016 might correctly be decried as short-sighted in 2056. Furthermore, the monetary gains from selling lesser objects are often modest, while reputational harm can be considerable, leading to divisiveness among the many stakeholders that museums rely on for support.

Even more fundamentally, art museum collections typically enjoy the distinction of being research institutions. Objects in storage may be away from view for any number of reasons, ranging from a need for conservation, the implied costs of presentation as a result of fragility, a lack of space, curatorial judgment that they're of lesser interest, or doubt about their authenticity. Having works in storage that are comparable to those on view is believed to be integral to the scholarly mandate of art museums, since researchers and students can make comparisons yielding useful judgments about greater and lesser examples of a given artistic convention.

In market nation museums outside the United States, the concept of selling from collections is often seen as abhorrent and sometimes even illegal. The British Parliament enjoins national museums from selling from collections,[8] and in general most European museums acquired objects with the understanding that there are simply no grounds for selling what is effectively the nation's property.

8. For example, the British Museum Act of 1963 only allows the British Museum to deaccession an artifact if it is a duplicate or if, in the opinion of the Trustees, the object is "unfit to be retained." British Museum Act of 1963, c24 (Section 5). *See also* Museums and Galleries Act 1992, c. 44 (Eng.) outlining the controls on transfer by and between British National Galleries, including the Tate, National Portrait Gallery, and Wallace Collection.

The pressure to sell from storage will not abate any time soon. As mounting costs force museums to economize in unpalatable and inefficient ways, from staff reductions to reductions in hours and public service, the monetization of collections will be a recurring question in years to come.

Is leasing antiquities a viable alternative?

Since the sale of antiquities from museums is for the most part off limits today, the concept of leasing collections has been promoted in some quarters.[9] With regard to US museums, the FASB agreement discourages monetization of collections in any form. Source nations might find the possibility of leasing less unattractive in time, since it is a short step from charging high fees for collection-based special exhibitions to charging for loans of individual objects.

One predicament facing museums that have been approached about such schemes is that the market for leased artworks does not as yet exist, and museums have not shown a willingness to mine collections in this way. Leasing to private collectors would seem to be off the table out of reasonable concerns that objects held in the public trust should not be used to benefit private individuals. In addition, overarching concerns about the climate control and security measures required would prevent all but the most professionally managed private collections from being eligible for such an arrangement.

As a result of the traditions, regulations, and prejudices affecting museum practice, the likeliest path ahead for circulating antiquities remains short-term special exhibitions and long-term loans. In the future, the sale or leasing of artifacts from collections might become accepted practice, but much would have to change in the worldviews of museum professionals and lawmakers for that to transpire.

9. Silvia Beltrametti, "Museum Strategies: Leasing Antiquities," *Journal of Law and the Arts* 36, no. 2 (2013): 203–260.

17

LOOKING AHEAD

Are claims likely to increase in the coming years?

Isolated cultural property claims advanced by a few source nations—most notably Italy, Turkey, India, and Cambodia—have been in the headlines over the last decade.[1] An increase in successful claims, illustrated databases of museum acquisitions, and nationalist sentiments will have an impact in coming years. These factors will in turn prompt multiple nations in the Middle East, North and sub-Saharan Africa, Asia, and Latin and South America to be both more vigilant in protecting cultural property and more active in pursuing claims.

Many of these claims will likely extend to objects long in the care of market nation museums, as was the case with Peru's successful 2010 claim against Yale University for a group of artifacts excavated in Machu Picchu in 1911.[2] A century after their removal to New Haven, they were returned to Peru as

1. See e.g. Corte App., Roma, Sez. II Pen., 15 Luglio 2009, n.5359; Cass. Pen., Sez. II, Sent., (ud. 07-12-2011) 22-12-2011, N. 47918. (It.); Republic of Turkey v. Metropolitan Museum of Art, 762 F. Supp. 44 (S.D.N.Y. 1990); United States v. A 10th Century Cambodian Sandstone Sculpture (Southern District of New York 2013) (dismissed Dec. 12, 2013).
2. Republic of Peru v. Yale University, No. 1:08-Cv-02109 (D. D.C. July 30, 2009) transferring Case to Connecticut; Republic of Peru v. Yale University, No. 3:09-Cv-01332 (D. Conn. Oct. 9, 2009); Settlement Agreement, No. 3:09-Cv-01332 (D. Conn. Dec. 23, 2010).

part of a settlement agreement following a contentious few years of debate.[3] If successful claims can be lodged against artifacts dormant overseas for a century, it is reasonable to assume that other nations will see the opportunity to reclaim objects after a comparable length of time or even longer.

What new technologies might safeguard antiquities from harm?

In chapter 12 we touched on the potential value of invisible marking of artifacts through microdots, sealants, or other materials that allow for recognition by handheld devices of one kind or another. Another solution is currently being explored at Auburn University's College of Veterinary Medicine.[4] It is a technology with its oldest known roots recorded as early as AD 210, when hunters would bury hares to train their dogs to track scents.[5,6] Auburn faculty are exploring the possibility of marking individual antiquities or entire archaeological sites with scents that could be recognized by dogs, thereby improving the chance of interdicting stolen antiquities that are spirited away in shipping containers or hidden among shipments of other goods.

How will remote sensing affect the care and study of antiquities?

As satellites proliferate in the skies, the provision of real-time images of archaeological sites has greatly increased. The

3. "Peru-Yale Partnership for the Future of Machu Picchu Artifacts," *Yale News*, June 4, 2015. http:// news.yale.edu/ 2015/ 06/ 04/ peru- yale- partnership- future- machu- picchu- artifacts.
4. Janet McCoy, "Canine Performance Sciences Breeds, Trains and Produces Elite Detection Dogs," *Auburn University: The Newsroom*, July 27, 2015.
5. N. W. H. Fairfax, "The Story of Police Dogs," *Police Journal* 37 (1964): 113.
6. Oppian, *Cynegetica, Book 1*. Loeb Classical Library, 1928. http:// penelope.uchicago.edu/Thayer/E/Roman/Texts/Oppian/ Cynegetica/1*.html.

rampant looting of sites in Iraq and Syria over the last few years has been dramatically documented through satellite images.[7]

Another application of remote sensing is as a survey tool, leading to the identification of unexcavated terrain that shows promise for exploration. Unfortunately this application is of potential value both to professional archaeologists and to organized criminal factions prospecting for the next targets of opportunity.[8]

How much more is there to be discovered underground?

The discipline of archaeology is only two hundred years old, while the remains of humankind stretch back millennia. While many sites have been identified and explored, even those that have been the subject of inquiry and excavation most likely have older remains located below pits and trenches emptied of ancient material. It is difficult to generalize about the proportion of archaeological sites that have been fully excavated, but it is safe to assume that in many cases whatever has come to light is in all likelihood a fraction of what remains below ground.

In addition, sites and contexts that have remained untouched by modern hands may be assumed to vastly outnumber those that have been identified. In archaeologically rich regions around the world, the places revealed through state-sanctioned and illegal excavation constitute a small portion of what awaits us beneath the surface.

7. Ralph Blumenthal and Tom Mashberg, "TED Prize Goes to Archaeologist Who Combats Looting With Satellite Technology," *The New York Times*, November 8, 2015. http://www.nytimes.com/2015/11/09/arts/international/ted-grant-goes-to-archaeologist-who-combats-looting-with-satellite-technology.html.
8. Ariel Schwartz, "You Can Now Explore Ancient Archaeological Sites from Your Computer," *Tech Insider*, February 16, 2016. http://www.techinsider.io/how-to-find-ancient-archaeological-sites-from-your-computer-2016-2.

Will underwater excavation become more prevalent?

Underwater archaeology is so new that it presents the greatest frontier in the field. With water covering over 70% of the earth's surface, and over three million shipwrecks on the ocean floor, the ocean frontier is among archaeology's most exciting. The technology needed for deep-sea exploration, especially in the field of robotics, is advancing rapidly. What once seemed like science fiction will soon become a reality, with exploratory probes underwater not only transmitting images, but operating retrieval devices equipped to reveal artifacts and remove them to the ocean surface. Archaeologists have also begun using DNA analysis on artifacts discovered on shipwrecks in the Mediterranean, which can reveal information ranging from the contents of bowls to the home port of the sunken ship.[9]

Will source nations ever adequately police archaeological sites?

Drones have revolutionized many industries, and archaeological site protection is an ideal application for this technology. The advanced application of drones as proxies for law enforcement promises a less costly, less dangerous, and more accurate means to patrol vulnerable locations, allowing law enforcement to arrive on the scene in a timely way, prepared with adequate people power to intervene in illicit digging or retrieval.

Will attitudes to the antiquities market shift?

As noted above, India is today expressing interest in revisiting the wholesale prohibition of the sale of archaeological material. It is too soon to predict whether that interest will translate into changes in the legal framework of cultural protection. But

9. Philip Chrysopoulos, "Police Forensic Science Uncovers Ancient DNA From Greek Shipwrecks," *Greek Reporter*, March 27, 2016. http://greece.greekreporter.com/2016/03/27/police-forensic-science-uncovers-ancient-dna-from-greek-shipwrecks/.

we have seen in many fields that sudden changes in attitude are possible in a new world of instantaneous communication. Germany's recent adoption of a strict law governing art imports represents a significant shift; India's proposed legislation to liberalize market regulations would set that nation on an opposite course.

In 2016, the Egyptian government extended an unexpected olive branch to the United Kingdom, proposing purchase and joint possession of an Old Kingdom sculpture depicting Sekhemka that had been sold by the Northampton Museum in 2014. Egyptian authorities introduced a novel scheme, according to which the Egyptian Museum in Cairo would assume title, but alternate the work's display between Cairo and London's British Museum. The work was ultimately the subject of a private sale.[10]

The proposed joint possession was a novel idea, particularly in light of Egypt's longstanding objection to the presence of Egyptian masterworks in London, foremost among them the Rosetta Stone. Whether the offer of joint possession represents a fresh attitude in Cairo or a canny move to advance the possibility of Egyptian ownership of works abroad is yet to be established.[11]

Will digital emulation and simulation of ancient contexts become more acceptable?

It is inevitable that increasingly convincing replicas of ancient sites and contexts will draw more and more interest

10. Ian Johnston, "Ancient Egyptian Statue of Sekhemka Disappears into Private Collection in 'Moral Crime against World Heritage,'" *The Independent,* May 9, 2016. http://www.independent.co.uk/ news/uk/home-news/ancient-egyptian-statue-of-sekhemka-disappears-into-private-collection-in-moral-crime-against-world-a7019946.html.

11. Martin Bailey, "Egyptian Ambassador Proposes Plan to Share Sekhemka," *The Art Newspaper,* March 8, 2016. http://theartnews paper.com/news/museums/ambassador-proposes-plan-to-share-sekhemka/.

from the general public. As virtual contexts are added to original sites in a compromised condition, the advantage of simulation adjacent to the actual context is obvious. Reducing carbon monoxide from exhalation and eliminating wear and tear from footfalls promises to extend the life of ancient sites from Pompeii to the tombs of Egypt and temples of Southeast Asia.

How many forgeries might be revealed in major museum collections?

In 1921, the Metropolitan Museum of Art purchased three spectacular Etruscan terracotta warriors, one of which was a colossal head, and placed them in view to the astonishment of the public. Only in 1960, after a battery of scientific analysis, were they revealed to be forgeries when their makers, Riccardo Riccardi and Alfredo Fioravanti, came forward with the missing thumb of one of the figures. Today it seems inexplicable that this deception passed unnoticed for two generations. They were among the largest objects in the Museum's collection, and commanded immediate notice from any visitor for decades.[12]

There is no question that major museums today have multiple forgeries on prominent display, awaiting discovery as did the Etruscan warriors. Just as chemical analysis confirmed doubts about the warriors, new evaluative techniques will doubtless unmask other pretenders in years to come, both depriving us of long-appreciated objects and compelling us to ask what might be next. The relentless detective work of archaeology and art history can be alternatively exciting and disillusioning—but is in both cases of great interest to the public and scholars alike.

12. David Sax, *Unmasking the Forger: The Dossena Deception* (London: Unwin Hyman, 1987).

Is the appetite for present distractions displacing interest in the past?

Perhaps the greatest challenge to the field of antiquities is society's absorption with the present. When all the world's information is accessible in the palm of the hand, the relevance, romance, and attraction of far-flung places from the distant past don't automatically command the interest of younger cultural consumers any more than other stimuli. For many, the passive contemplation of objects is no longer as compelling as it once was. The 'selfie' recorded at a monument or before a statue may be as memorable as the experience of the original.

That said, the aura presented by an antiquity continues to exercise its magic.[13] And a world awash with simulation is one which in time will come to appreciate the authentic. Thus the labors of scholars, archaeologists, museum professionals, law enforcement officials, and others committed to the preservation and elucidation of the past will not be in vain. And we can all look forward to a future filled with astonishing discoveries of the past that will help us make sense of our place in the human experiment across time and space.

13. But interest in archaeology in younger generations is perhaps manifesting in new ways. An emerging trend called "archaeogaming," seeks to "explor[e] the intersections of archaeology and video games." "Archaeogaming." Accessed April 4, 2016. http://archaeogaming.com/.

BIBLIOGRAPHY

Chapter 1

"About the Palace Museum." *The Palace Museum*. Accessed May 30, 2016. http://en.dpm.org.cn/about/about-museum/.

Alsop, Joseph. *The Rare Art Traditions: The History of Art Collecting and Its Linked Phenomena Wherever These Have Appeared*. New York: Harper & Row, 1982.

Amineddoleh, Leila. "Protecting Cultural Heritage by Strictly Scrutinizing Museum Acquisitions." *Fordham Intellectual Property, Media & Entertainment Law Journal* 24, no. 3 (2014): 729–781.

"Antiquity, N." *Oxford English Dictionary*. Oxford University Press, first published 1885.

"Ask the Experts: AIA Archaeology FAQ." *Archaeological Institute of America*. Accessed March 22, 2016. https://www.archaeological.org/education/askexpertsfaq.

Attoui, Redha, ed. *When Did Antiquity End? Archaeological Case Studies in Three Continents: The Proceedings of an International Seminar Held at the University of Trento on April 29-30, 2005 on Late Antique Societies, Religion, Pottery and Trade in Germanica, Northern Africa, Greece, and Asia Minor*. Oxford: Archaeopress, 2011.

Brodie, Neil. "Provenance and Price: Autoregulation of the Antiquities Market?" *European Journal on Criminal Policy and Research* 20, no. 4 (2014): 427–444.

Convention on Cultural Property Implementation Act (CPIA) of 1983, 19 U.S.C. § 2601(2)(C)(i)(I)–(III) (1983). https://eca.state.gov/files/bureau/97-446.pdf.

Drewett, Peter. *Field Archaeology: An Introduction*. London: UCL Press, 1999.

Herodotus. *The Histories*. Translated by Robin Waterfield. New York: Oxford University Press, 2008.

Hunt, L.B. "The Long History of Lost Wax Casting." *Gold Bulletin* 13, no. 2 (June 1980): 63–79.

Livy 34. *The History of Rome*, chapter 4, Sections 3–4.

Livy 39. *The History of Rome*, chapters 6 and 7.

Marlowe, Elizabeth. *Shaky Ground: Context, Connoisseurship and the History of Roman Art*. London: Bloomsbury, 2013.

Maschner, Herbert D. G., and Christopher Chippindale. *Handbook of Archaeological Methods*. Lanham, MD: Alta Mira, 2005.

Merryman, John Henry. *Thinking about the Elgin Marbles: Critical Essays on Cultural Property, Art, and Law*. Boston: Wolters Kluwer Law & Business, 2009.

Muckle, Robert J. *Introducing Archaeology*. 2nd ed. Toronto: University of Toronto Press, 2014.

"Nation-State." *United Nations Educational, Scientific and Cultural Organization*. Accessed April 22, 2016. http://www.unesco.org/new/en/social-and-human-sciences/themes/international-migration/glossary/nation-state/.

Pachauri, S. K. "Plunder of Cultural and Art Treasures — the Indian Experience." In *Illicit Antiquities: The Theft of Culture and the Extinction of Archaeology*, edited by Neil Brodie and Katherine Walker Tubb, 268–279. London; New York: Routledge, 2002.

Perloff-Giles, Alexandra. "Artifacts Take Their Rightful Place as Art." *The Harvard Crimson*, March 30, 2010. http://www.thecrimson .com/article/2010/3/30/art-museum-objects-peabody/.

Sheridan, Alison. "Unearthing the Secrets of East Anglia's Bronze Age Settlers." *Apollo Magazine*, January 26, 2016. http://www.apollo-magazine.com/unearthing-the-secrets-of-east-anglias-bronze-age-settlers/.

Silberman, Neil Asher, ed. *The Oxford Companion to Archaeology*. New York: Oxford University Press, 2012.

Squire, Michael. "Conceptualizing the (Visual) 'Arts.' " In *A Companion to Ancient Aesthetics*, edited by Pierre Destrée and Penelope Murray, 308–312. New York: John Wiley & Sons, 2015.

"Strengthened Guidelines on the Acquisition of Archaeological Material and Ancient Art Issued by Association of Art Museum Directors." *Association of Art Museum Directors*, Press Releases and Statements,

January 30, 2013. https://aamd.org/for-the-media/press-release/
strengthened-guidelines-on-the-acquisition-of-archaeological-
material.

Szczepanowska, Hanna M. *Conservation of Cultural Heritage: Key
Principles and Approaches*. London: Routledge, 2013.

Tanner, Jeremy. *The Invention of Art History in Ancient Greece: Religion,
Society and Artistic Rationalisation*. Cambridge, UK: Cambridge
University Press, 2006.

Task Force on Archaeological Material and Ancient Art. "Memorandum
to Members of the Association of Art Museum Directors: Definition
of 'In Antiquity,'" *Association of Art Museum Directors*, July 31, 2015.
https://aamd.org/sites/default/files/document/Antiquity%20
Definitions%20Memo.pdf.

Trigger, Bruce G. *A History of Archaeological Thought*.
New York: Cambridge University Press, 1989.

"Weary Herakles ('Herakles Farnese' Type)." *Museum of Fine Arts,
Boston*. Accessed April 22, 2016. http://www.mfa.org/collections/
object/weary-herakles-herakles-farnese-type-149765.

Chapter 2

"About TNM: History of the TNM," *Tokyo National Museum*. Accessed
February 24, 2016. http://www.tnm.jp/modules/r_free_page/
index.php?id=140.

Aubert, M., A. Brumm, and M. Ramli, et al. "Pleistocene Cave Art from
Sulawesi, Indonesia." *Nature* 514, no. 7521 (October 9, 2014): 223–227.

Baskett, John. *The Horse in Art*. New Haven, CT: Yale University
Press, 2006.

Bradsher, Keith. "China and Taiwan to Confer on Imperial Art
Treasures Split by History." *The New York Times*, February 11,
2009. http://www.nytimes.com/2009/02/12/arts/design/
12pala.html.

Brendel, Otto, and Francesca R. Serra Ridgway. *Etruscan Art*. New
Haven, CT: Yale University Press, 1995.

"Brief Chronology." *National Palace Museum*, February 22, 2016. http://
www.npm.gov.tw/en/Article.aspx?sNo=03001502.

Brodie, N. "Uncovering the Antiquities Market." In *The Oxford
Handbook of Public Archaeology*, edited by R. Skeates, C. McDavid,
and J. Carman, 230–252. Oxford: Oxford University Press, 2012.

Burke, John E. *Never Enough: Confessions of a Capricious Collector*.
iUniverse, 2015.

Cameron, Averil, and Judith Herrin. *Constantinople in the Early Eighth Century: The Parastaseis Syntomoi Chronikai: Introduction, Translation, and Commentary*. Leiden, The Netherlands: E.J. Brill, 1984.

Cartwright, Mark. "Atahualpa." *Ancient History Encyclopedia*, March 17, 2016. http://www.ancient.eu/Atahualpa/.

Diamond, Jared. *1000 Events That Shaped the World*. Washington, DC: National Geographic, 2008.

Dossin, Catherine, Béatrice Joyeux-Prunel, and Thomas DaCosta Kaufmann, eds. *Circulations in the Global History of Art*. Farmham, UK: Ashgate, 2015.

Eakin, Hugh. "Marion True on Her Trial and Ordeal." *The New Yorker*, October 14, 2010. http://www.newyorker.com/news/news-desk/marion-true-on-her-trial-and-ordeal.

Edgers, Geoff. "One of the World's Most Respected Curators Vanished from the Art World. Now She Wants to Tell Her Story." *The Washington Post*, August 22, 2015. https://www.washingtonpost.com/entertainment/museums/the-curator-who-vanished/2015/08/19/d32390f8-459e-11e5-846d-02792f854297_story.html.

Falser, Michael, ed. *Cultural Heritage as Civilizing Mission: From Decay to Recovery*. Cham, Switzerland: Springer, 2015.

Forrest, Craig. *International Law and the Protection of Cultural Heritage*. London: Routledge, 2012.

Freeman, Charles. *The Horses of St. Mark's: A Story of Triumph in Byzantium, Paris, and Venice*. New York: Overlook, 2010.

Friedland, Elise A., Melanie Grunow Sobocinski, and Elaine K. Gazda. *The Oxford Handbook of Roman Sculpture*. New York: Oxford University Press, 2015.

Gahtan, Maia, and Donatella Pegazzano. *Museum Archetypes and Collecting in the Ancient World*. Boston: Brill, 2014.

Galliazzo, Vittorio. "I cavalli di San Marco: Una quadriga greca o romana?" *Faventia* 6, no. 2, (1984): 99–126.

Gill, David W.J. "Looting Matters: Is the AAMD Policy Having an Impact on Private Collectors?" *Looting Matters*. Accessed April 22, 2016. http://lootingmatters.blogspot.com/2009/08/is-aamd-policy-having-impact-on-private.html.

Greenhalgh, Michael. *Survival of Roman Antiquities in the Middle Ages*. 1st ed. London: Duckworth, 1989.

Herscher, Ellen. "The Antiquities Market." *Journal of Field Archaeology* 14, no. 2 (1987): 213–223.

Higham, Charles. *Encyclopedia of Ancient Asian Civilizations*. New York: Facts on File, 2004.

"History." *Topkapı Palace Museum Official Web Site*. Accessed February 24, 2016. http://topkapisarayi.gov.tr/en/history.

Holland, Glenn S. *Gods in the Desert: Religions of the Ancient Near East*. Lanham, MD: Rowman & Littlefield, 2009.

Intergovernmental Committee for Promoting the Return of Cultural Property to Its Countries of Origin or Its Restitution in Case of Illicit Appropriation. "Return and Restitution of Cultural Property— A Brief Resume." Athens and Delphi Greece: *United Nations Educational, Scientific and Cultural Organization*, April 2, 1985. http://unesdoc.unesco.org/images/0006/000632/063270eo.pdf.

Kahn, Jeremy. "ART; Is the U.S. Protecting Foreign Artifacts? Don't Ask." *The New York Times*, April 8, 2007. http://query.nytimes.com/gst/fullpage.html.

Kasfir, Sidney Littlefield. *African Art and the Colonial Encounter: Inventing a Global Commodity*. Bloomington: Indiana University Press, 2007.

Kinney, Dale, and Richard Brilliant. *Reuse Value: Spolia and Appropriation in Art and Architecture from Constantine to Sherrie Levine*. Farmham, UK: Ashgate, 2012.

Lamp, Kathleen S. *A City of Marble: The Rhetoric of Augustan Rome*. Columbia: Univ of South Carolina Press, 2013.

Levine, Gregory P. A. *Daitokuji: The Visual Cultures of a Zen Monastery*. Seattle: University of Washington Press, 2005.

McGeough, Kevin M. *The Romans: New Perspectives*. Santa Barbara, Calif.: ABC-CLIO, 2004.

McManamon, Francis P. "The Archaeological Resources Protection Act of 1979 (ARPA)." In *Archaeological Method and Theory: An Encyclopedia*, edited by Linda Ellis. New York and London: Garland, 2000. www.nps.gov/archeology/tools/Laws/arpa.htm.

Mead, William Edward. *The Grand Tour in the Eighteenth Century*. Boston and New York: Houghton Mifflin, 1914.

Mehta, Sulogna. "Heritage Lovers Question Mode of Renovation of Buddhist Sites." *The Times of India*, March 22, 2016. http://timesofindia.indiatimes.com//articleshow/51516570.cms.

Merryman, John Henry. *Thinking about the Elgin Marbles: Critical Essays on Cultural Property, Art and Law*. Austin: Wolters Kluwer Law & Business, 2009.

"Museum History." *National Museum of Cambodia*, 2013. http://www.cambodiamuseum.info/museum_history.html.

Nafziger, James A. R. "Repose Legislation: A Threat to the Protection of the World." *California Western International Law Journal* 17, no. 1 (1987): 250–265.

O'Toole, Rachel Sarah. "Religion, Society, and Culture in the Colonial Era." In *A Companion to Latin American History*, edited by Thomas H. Holloway, 162–177. Chichester, UK: John Wiley & Sons, 2011.

Picón, Carlos A., and Seán Hemingway. *Pergamon and the Hellenistic Kingdoms of the Ancient World*. New Haven, CT: Yale University Press, 2016. http://yalebooks.com/book/9781588395870/pergamon-and-hellenistic-kingdoms-ancient-world.

Pollitt, Jerome Jordan. *Art in the Hellenistic Age*. New York: Cambridge University Press, 1986.

Prott, Lyndel V. "UNESCO and UNIDROIT: A Partnership against Trafficking in Cultural Objects." UNIDROT, 1996. http://www.unidroit.org/english/conventions/1995culturalproperty/articles/s70-prott-1996-e.pdf.

Quarcoopome, Nii O., Veit Arlt, Detroit Institute of Arts, and Nelson-Atkins Museum of Art. *Through African Eyes: The European in African Art, 1500 to Present*. Detroit, MI: Detroit Institute of Arts, 2010.

Riggs, Christina. *Ancient Egyptian Art and Architecture: A Very Short Introduction*. New York: Oxford University Press, 2014.

Sala, Ilaria Maria. "Forbidding City: Trouble in China's Imperial Residence." *Art News*, July 31, 2013. http://www.artnews.com/2013/07/31/trouble-in-forbidden-city-of-china/.

Sauer, Eberhard. *The Archaeology of Religious Hatred: In the Roman and Early Medieval World*. Charleston, SC: Tempus, 2003.

"Sculpture (Part of the Limestone Beard of the Sphinx at Giza)." *British Museum*. Accessed March 15, 2016. http://www.britishmuseum.org/research/collection_online/collection_object_details.aspx?objectId=111369&partId=1&searchText=sphinx+beard&page=1.

Stanley-Price, Nicholas. "The Reconstruction of Ruins: Principles and Practice." In *Conservation: Principles, Dilemmas and Uncomfortable Truths*, edited by Alison Richmond and Alison Bracker, 32–46. Amsterdam: Butterworth-Heinemann in association with the Victoria and Albert Museum, 2009. http://www.archaeological.org/news/sitepreservation/81.

Strouse, Jean. "J. Pierpont Morgan: Financier and Collector." *The Metropolitan Museum of Art Bulletin* 57, no. 3 (2000): 1–64.

Sullivan, Sharon. *Archaeological Sites: Conservation and Management*. Los Angeles: Getty Publications, 2012.

"The Getty Villa: History." *The Getty*, 2011. https://www.getty.edu/news/press/getty_villa/gv2.pdf.

The Metropolitan Museum of Art. *The Legacy of Genghis Khan: Courtly Art and Culture in Western Asia, 1256–1353.* Metropolitan Museum of Art, 2002.

The Ulmer Museum. "Der Löwenmensch." Accessed January 21, 2016. http://www.loewenmensch.de/lion_man.html.

Ward-Perkins, John Bryan. *Roman Imperial Architecture.* New Haven, CT: Yale University Press, 1994.

Waterbury, John. *The Egypt of Nasser and Sadat: The Political Economy of Two Regimes.* Princeton, NJ: Princeton University Press, 2014.

Webber, Esther. "Scottish Independence: What Will Happen to the Queen?" *BBC News*, September 11, 2014. http://www.bbc.com/news/uk-29126569.

Weis, H.A. "Gaius Verres and the Roman Art Market: Consumption and Connoisseurship in Verrine II, 4." In *O Tempora, O Mores! Römische Werte Und Römische Literatur in Den Letzten Jahrzehnten Der Republik*, edited by A. Haltenhoff, A. Heil, and F.H. Mutschler, 355–400. Munich: K. G. Saur, 2003.

Weitz, Ankeney. "Notes on the Early Yuan Antique Art Market in Hangzhou." *Ars Orientalis* 27 (1997): 27–38.

Wilton-Ely, John, and Valerie Wilton-Ely. *The Horses of San Marco; Venice.* Translated by John and Valerie Wilton-Ely. Milan: Olivetti, 1979.

Chapter 3

Blumenthal, Ralph, and Tom Mashberg. "The Curse of the Outcast Artifact." *The New York Times*, July 12, 2012. http://www.nytimes.com/2012/07/15/arts/design/antiquity-market-grapples-with-stricter-guidelines-for-gifts.html.

Bohlen, Celestine. "Major Museums Affirm Right To Keep Long-Held Antiquities." *The New York Times.* December 11, 2002.

Brodie, Neil. "An Archaeologist's View of the Trade in Unprovenanced Antiquities." In *Art and Cultural Heritage: Law, Policy and Practice*, edited by Barbara T. Hoffman, 52–63. New York: Cambridge University Press, 2006.

Brodie, Neil, and Kathryn Walker Tubb, eds. *Illicit Antiquities: The Theft of Culture and the Extinction of Archaeology.* New York: Routledge, 2002.

Carassava, Anthee. "Greek Court Dismisses Case Against Ex-Curator." *The New York Times*, November 28, 2007. http://www.nytimes.com/2007/11/28/arts/design/28true.html.

Chapman, Catherine. "To Fight ISIS, Art Dealers &
 Archaeologists Join Forces." *The Creators Project*. March
 11, 2016. http://thecreatorsproject.vice.com/blog/
 art-dealers-archaeologists-join-fight-against-isis.
Cuno, James. *Who Owns Antiquity? Museums and the Battle over Our
 Ancient Heritage*. Princeton, NJ: Princeton University Press, 2010.
Cuno, James, ed. *Whose Culture? The Promise of Museums and the Debate
 over Antiquities*. Princeton, NJ: Princeton University Press, 2012.
"Declaration on the Importance of the Universal Museum." *Elginism*.
 December 11, 2002. http://www.elginism.com/similar-cases/
 declaration-on-the-importance-of-the-universal-museum/
 20021211/4620/.
Eakin, Hugh. "Marion True on Her Trial and Ordeal." *The New Yorker*,
 October 14, 2010. http://www.newyorker.com/news/news-desk/
 marion-true-on-her-trial-and-ordeal.
Fincham, Derek. "The Fundamental Importance of Archaeological
 Context." In *Art and Crime: Exploring the Dark Side of the Art World*,
 edited by Noah Charney, 3–13. Santa Barbara, CA: Praeger, 2009.
Fitz Gibbon, Kate. *Who Owns the Past? Cultural Policy, Cultural Property,
 and the Law*. New Brunswick, NJ: Rutgers University Press, 2005.
Gladstone, Rick, and Maher Samaan. "ISIS Destroys More Artifacts
 in Syria and Iraq." *The New York Times*, July 3, 2015. http://www
 .nytimes.com/2015/07/04/world/middleeast/isis-destroys-
 artifacts-palmyra-syria-iraq.html.
Harris, M. June. "Who Owns the Pot of Gold at the End of the
 Rainbow? A Review of the Impact of Cultural Property on Finders
 and Salvage Laws." *Arizona Journal of International and Comparative
 Law* 14, no. 1 (1997): 223–253.
Hegel, Georg Wilhelm Friedrich. *Aesthetics: Lectures on Fine Art*.
 Translated by Thomas Knox. Vol. 1. Oxford: Clarendon, 1998.
Hegel, Georg Wilhelm Friedrich, and Heinrich Gustav Hotho.
 Vorlesungen über die Aesthetik. Berlin: Duncker U. Humblot, 1838.
Hufnagel, Dr Saskia, and Professor Duncan Chappell, eds.
 *Contemporary Perspectives on the Detection, Investigation and
 Prosecution of Art Crime: Australasian, European and North American
 Perspectives*. Farnham, UK: Ashgate, 2014.
"ICE Seizes Roman Sarcophagus Lid Linked to Convicted
 Art Smuggler." *U.S. Immigration and Customs Enforcement*,
 February 27, 2014. https://www.ice.gov/news/releases/
 ice-seizes-roman-sarcophagus-lid-linked-convicted-art-smuggler.

"Indianapolis Museum of Art Declares Moratorium on Antiquities Acquisitions." *Archaeological Institute of America*, April 16, 2007. https://www.archaeological.org/news/advocacy/96.

Izuel, Leeanna. "Property Owners' Constructive Possession of Treasure Trove: Rethinking the Finders Keepers Rule." *UCLA Law Review* 38 (1990–1991): 1658.

Kersel, Morag M. "A Focus on the Demand Side of the Antiquities Equation." *Near Eastern Archaeology* 71, no. 4 (December 1, 2008): 230–233.

Lobay, Gordon. "Border Controls in Market Countries as Disincentives to Antiquities Looting at Source." In *Criminology and Archaeology: Studies in Looted Antiquities*, edited by Simon Mackenzie and Penny Green, 59–77. Portland, OR: Hart, 2009.

Lucas, Gavin. *The Archaeology of Time*. London; New York: Routledge, 2005.

Mackenzie, Simon, and Penny Green. *Criminology and Archaeology: Studies in Looted Antiquities*. Portland, OR: Hart, 2009.

Merryman, John Henry. "Thinking about the Elgin Marbles." *Michigan Law Review* 83, no. 8 (1985): 1880–1923.

"Metropolitan Museum's Collection Management Policy (Revised November 2008)." *The Metropolitan Museum of Art*. January 6, 2009. http://www.metmuseum.org/about-the-museum/press-room/news/2009/metropolitan-museums-collection-management-policy-revised-november-2008.

Miller, Paul. "Continuity and Change in Etruscan Domestic Architecture: A Study of Building Techniques and Materials from 800–500 BC." *Edinburgh Research Archive*, 2015. https://www.era.lib.ed.ac.uk/handle/1842/11708.

Muscarella, Oscar White. "Archaeologists and Acquisitionists." *International Journal of the Classical Tradition* 18, no. 3 (September 14, 2011): 449–463.

Muscarella, Oscar White. "The Fifth Column within the Archaeological Realm: The Great Divide." In *Studies in Honour of Altan Çilingiroğlu: A Life Dedicated to Urartu on the Shores of the Upper Sea*, edited by by Haluk Sağlamtimur, Altan Çilingiroğlu, and Eşref Abay, 395–406. Istanbul: Arkeoloji ve Sanat Yayınları, 2009.

Nafziger, James A. R., Robert Kirkwood Paterson, and Alison Dundes Renteln. *Cultural Law: International, Comparative, and Indigenous*. Cambridge, MA: Cambridge University Press, 2010.

"New Report on Acquisition of Archaeological Materials and Ancient Art Issued by Association of Art Museum Directors." *Association of Art Museum Directors*, June 4, 2008. https://aamd.org/sites/default/files/document/Antiquities%20Guidelines%20with%20Intro%2006.08.pdf.

Palmer, Allison Lee. *Historical Dictionary of Architecture*. Lanham, MD: Scarecrow, 2008.

Pearlstein, William G. "Claims for the Repatriation of Cultural Property: Prospects for a Managed Antiquities Market." *Law and Policy in International Business* 28, no. 1 (1996): 123–150.

"Policy Statement: Acquisitions by the J. Paul Getty Museum," October 23, 2006. http://www.getty.edu/about/governance/pdfs/acquisitions_policy.pdf.

Press Release. The Getty. "J. Paul Getty Museum Announces Revised Acquisitions Policy," October 26, 2006. http://www.getty.edu/news/press/center/revised_acquisition_policy_release_102606.html.

"Press Release: The 2016 World Monuments Watch Includes 50 At-Risk Cultural Heritage Sites in 36 Countries" | World Monuments Fund. October 15, 2015. https://www.wmf.org/press-release/2016-world-monuments-watch-includes-50-risk-cultural-heritage-sites-36-countries.

Professional Responsibilities Committee. "Principles for Museum Acquisitions of Antiquities." *Archaeological Institute of America*. March 2006. https://www.archaeological.org/pdfs/archaeologywatch/museumpolicy/AIA_Principles_Musuem_Acquisition.pdf.

Renfrew, Colin. *Loot, Legitimacy, and Ownership: The Ethical Crisis in Archaeology*. London: Duckworth, 2000.

Romeo, Nick. "Strapped for Cash, Some Greeks Turn to Ancient Source of Wealth." *National Geographic*, August 17, 2015. http://news.nationalgeographic.com/2015/08/150817-greece-looting-artifacts-financial-crisis-archaeology/.

Romeo, Nick. "These 50 Treasured Places Are At Risk of Disappearing." *National Geographic*, October 15, 2015. http://news.nationalgeographic.com/2015/10/151015-threatened-sites-places-cultural-heritage-archaeology/.

Sawaged, Tamie, "The Collecting Culture: An Exploration of the Collector Mentality and Archaeology's Response." *Nebraska Anthropologist* 15 (2000).

Stanley, Alessandra. "Italians Welcome the Return Of an Ancient Gold Platter." *The New York Times*, March 1, 2000. http://www.nytimes

.com/2000/03/01/arts/italians-welcome-the-return-of-an-ancient-gold-platter.html.

The British Museum. "British Museum Policy Acquisitions," April 24, 2007. http://www.britishmuseum.org/pdf/Acquisitions.pdf.

United States v. An Antique Platter of Gold, 991 F. Supp. 222 (S.D.N.Y. 1997), aff'd, 184 F.3d 131 (2d Cir. 1999), cert. denied, 528 U.S. 1136 (2000).

United States v. Schultz, 178 F. Supp. 445 (S.D.N.Y. 2002), aff'd, 333 F.3d (2d Cir. 2003), cert. denied, 540 U.S. 1106 (2004).

Vikan, Gary. "The Case For Buying Antiquities To Save Them." Wall Street Journal, August 19, 2015. http://www.wsj.com/articles/the-case-for-buying-antiquities-to-save-them-1440024491.

Vlasic, Mark. "Stamping out the Illicit Trade in Cultural Artifacts." The Guardian, August 7, 2011. http://www.theguardian.com/commentisfree/cifamerica/2011/aug/07/egypt-antiquities-trade.

Watson, Andrea. "Islamic State and the 'Blood Antique' Trade." BBC, April 2, 2015. http://www.bbc.com/culture/story/20150402-is-and-the-blood-antique-trade.

Watt, J. C. Y. "Antiquities and the Importance—and Limitations—of Archaeological Contexts." In Whose Culture? The Promise of Museums and the Debate over Antiquities, edited by James B. Cuno, 89–106. Princeton, NJ: Princeton University Press, 2012.

Chapter 4

Archaeological Resources Protection Act of 1979. 16 U.S.C. §§ 470aa–470mm.

Arsu, Sebnem. "Thefts Focus Attention on Lax Security at Turkey's Museums." The New York Times, Arts, June 13, 2006. http://www.nytimes.com/2006/06/13/arts/13muse.html.

Association of Art Museum Directors. "New Report on Acquisition of Archaeological Materials and Ancient Art Issued by Association of Art Museum Directors," June 4, 2008. https://aamd.org/sites/default/files/document/Antiquities%20Guidelines%20with%20Intro%2006.08.pdf.

Calhoun, Craig. "Cosmopolitanism in the Modern Social Imaginary." Daedalus 137, no. 3 (July 1, 2008): 105–114.

Cuno, James. " 'Give Us Back Our Antiquities!' " The New York Times, January 21, 2015. http://www.nytimes.com/roomfordebate/2015/01/21/when-should-antiquities-be-repatriated-to-their-country-of-origin.

Cuno, James. Museums Matter: In Praise of the Encyclopedic Museum. Reprint edition. Chicago: University of Chicago Press, 2011.

Cuno, James. *Who Owns Antiquity? Museums and the Battle over Our Ancient Heritage*. Princeton, NJ: Princeton University Press, 2010.

Duncan, Carol, and Alan Wallach. "The Universal Survey Museum." *Art History* 3, no. 4 (December 1, 1980): 448–469.

Eakin, Hugh. "Who Should Own the World's Antiquities?" *The New York Review of Books*. May 14, 2009. Accessed April 28, 2016. http://www.nybooks.com/articles/2009/05/14/who-should-own-the-worlds-antiquities/.

Edkins, Jenny, and Adrian Kear. *International Politics and Performance: Critical Aesthetics and Creative Practice*. New York: Routledge, 2013.

Gill, David W.J. Review of *Who Owns Antiquity? Museums and the Battle Over Our Ancient Heritage*. *American Journal of Archaeology Online* 113, no. 1 (January 2009). http://www.ajaonline.org/online-review-book/591.

Hewison, Robert. "Should Museums Be Ideology-Free?" *Apollo Magazine*, April 11, 2016. http://www.apollo-magazine.com/should-museums-be-ideology-free/.

Jakubowski, Andrzej. *State Succession in Cultural Property*. Oxford: Oxford University Press, 2015.

Jenkins, Tiffany. *Keeping Their Marbles: How the Treasures of the Past Ended Up in Museums—And Why They Should Stay There*. New York: Oxford University Press, 2016.

Kleingeld, Pauline, and Eric Brown. "Cosmopolitanism." In *The Stanford Encyclopedia of Philosophy*, edited by Edward N. Zalta. Stanford, CA: Stanford University, 2013. http://plato.stanford.edu/archives/fall2014/entries/cosmopolitanism/.

Layton, R., P. Stone, and J. Thomas. *Destruction and Conservation of Cultural Property*. London: Routledge, 2001.

Lucas, Gavin. *Critical Approaches to Fieldwork: Contemporary and Historical Archaeological Practice*. London: Routledge, 2002.

Merryman, John Henry. "The Nation and the Object." *International Journal of Cultural Property* 3, no. 1 (1994): 61–76.

Mirza, Munira. *The Politics of Culture: The Case for Universalism*. 2012 edition. Houndmills, Basingstoke, UK: Palgrave Macmillan, 2011.

Nicholas Thomas. "We Need Ethnographic Museums Today—Whatever You Think of Their History." *Apollo Magazine*, March 29, 2016. http://www.apollo-magazine.com/we-need-ethnographic-museums-today-whatever-you-think-of-their-past/.

"Policy Statement: Acquisitions by the J. Paul Getty Museum," October 23, 2006.

Renfrew, Colin. "Review." *The Burlington Magazine* 150, no. 1268 (November 1, 2008): 768. http://burlington.org.uk/archive/back-issues/200811.

Robert Hewison. "Should Museums Be Ideology-Free?" *Apollo Magazine*, April 11, 2016. http://www.apollo-magazine.com/should-museums-be-ideology-free/.

Watt, J. C. Y. "Antiquities and the Importance—and Limitations—of Archaeological Contexts." In *Whose Culture?: The Promise of Museums and the Debate over Antiquities*, edited by James B. Cuno, 89–106. Princeton, NJ: Princeton University Press, 2012.

Winter, Irene J. *Review of Who Owns Antiquity? Museums and the Battle over Our Ancient Heritage*. By James Cuno, *The Art Bulletin* 91, no. 4 (December 1, 2009): 522–526. http://www.collegeart.org/pdf/artbulletin/Art%20Bulletin%20Vol%2091%20No%204%20Winter.pdf.

Chapter 5

Agbe-Davies, Anna S., Jillian E. Galle, Mark W. Hauser, and Fraser D. Neiman. "Teaching with Digital Archaeological Data: A Research Archive in the University Classroom." *Journal of Archaeological Method and Theory* 21, no. 4 (2013): 837–861.

Apley, Alice. "African Lost-Wax Casting." *The Metropolitan Museum of Art*. October 2001. https://www.metmuseum.org/toah/hd/wax/hd_wax.htm.

Asfour, Nahel N. "Art and Antiquities: Fraud." In *Encyclopedia of Transnational Crime and Justice*, edited by Margaret E. Beare. Thousand Oaks, CA: SAGE, 2012.

Attanasio, Donato. *Ancient White Marbles: Analysis and Identification by Paramagnetic Resonance Spectroscopy*. Rome: L'Erma Di Bretschneider, 2003.

Bakaraji, Elias H., Nada Boutros, and Rana Abboud. "Thermoluminescence (TL) Dating of Ancient Syrian Pottery from Six Different Archaeological Sites." *Geochronometria* 41, no. 1 (2014): 24–29.

Barnard, Noel. "The Incidence of Forgery Amongst Archaic Chinese Bronzes: Some Preliminary Notes." *Monumenta Serica* 27 (1968): 91–168.

Barr, Evan. "From Open-Air Bazaar to Buyer Beware: Evolution of the Antiquities Trade." *Museum News (AAM)* 85, no. 6 (December 2006): 48–53.

Bohlen, Celestine. "Antiquities Dealer Is Sentenced To Prison." *The New York Times*, June 12, 2002, sec. Arts. http://www.nytimes.com/2002/06/12/arts/antiquities-dealer-is-sentenced-to-prison.html.

Brilliant, Richard. "Roman Copies: Degrees of Authenticity."
 Source: Notes in the History of Art 24, no. 2 (2005): 19–27.

Brown, Jonathan. "British Couple Released as Priceless Artifacts
 They Were 'Smuggling' Out of Egypt Turn Out To Be Cheap
 Market Fakes." *The Independent*, February 27, 2012. http://www
 .independent.co.uk/news/world/africa/british-couple-released-
 as-priceless-artifacts-they-were-smuggling-out-of-egypt-turn-out-
 to-be-cheap-7447085.html.

Caldwell, John, Oswaldo Rodriguez Roque, and Dale T. Johnson.
 *American Paintings in The Metropolitan Museum of Art: A Catalogue
 of Works by Artists Born by 1815.* Vol. 1. New York: Metropolitan
 Museum of Art, 1994.

Carò, Federico. "From Quarry to Sculpture: Understanding Provenance,
 Typologies, and Uses of Khmer Stones." The Metropolitan Museum
 of Art, June 2009.

"Caveat Emptor." *The Economist*, September 16, 1999. http://www
 .economist.com/node/240838.

Cherry, Deborah, ed. *The Afterlives of Monuments.*
 London: Routledge, 2015.

Cox, Rupert. *The Culture of Copying in Japan: Critical and Historical
 Perspectives.* London: Routledge, 2007.

Craddock, Paul T. *Scientific Investigation of Copies, Fakes and Forgeries.*
 Amsterdam: Elsevier, 2009.

Cuno, James. *Museums Matter: In Praise of the Encyclopedic Museum.*
 Reprint edition. Chicago: University of Chicago Press, 2013.

Department of Ancient Art. "Shang and Zhou Dynasties: The Bronze
 Age of China." *The Metropolitan Museum of Art*, October 2004.
 https://www.metmuseum.org/toah/hd/shzh/hd_shzh.htm.

Department of Greek and Roman Art. "Roman Copies of Greek
 Statues." *The Metropolitan Museum of Art*, October 2002. http://
 www.metmuseum.org/toah/hd/rogr/hd_rogr.htm.

Department of Greek and Roman Art. "Roman Portrait
 Sculpture: Republican through Constantinian." *The Metropolitan
 Museum of Art*, October 2003. http://www.metmuseum.org/toah/
 hd/ropo/hd_ropo.htm.

Details on the Trial: "Selling the Past: United States v. Frederick
 Schultz." *Archaeology Magazine Archive*, April 22, 2002. http://
 archive.archaeology.org/online/features/schultz/.

Dillon, Sheila. *Ancient Greek Portrait Sculpture: Contexts, Subjects, and
 Styles.* Cambridge, MA: Cambridge University Press, 2006.

Dumarçay, Jacques, and Pascal Royère. *Cambodian Architecture: Eighth to Thirteenth Centuries*. Boston: Brill, 2001.

Emanuele, D. "'Aes Corinthium': Fact, Fiction, and Fake." *Phoenix* 43, no. 4 (1989): 347–358.

Fergusson, James, and Richard Phené Spiers. *A History of Architecture in All Countries, from the Earliest Times to the Present Day*. Vol. 1. London: J. Murray, 1893.

Friedland, Elise A., and Melanie Grunow Sobocinski, eds. *The Oxford Handbook of Roman Sculpture*. New York: Oxford University Press, 2015.

Frösén, Jaakko. *Early Hellenistic Athens: Symptoms of a Change*. Helsinki, Finland: Suomen Ateenan-instituutin säätiö (Finnish Institute at Athens), 1997.

Gerstenblith, Patty. "Controlling the International Market in Antiquities: Reducing the Harm, Preserving the Past." *Chicago Journal of International Law* 8, no. 1 (2008).

"Gods of Angkor: Bronzes from the National Museum of Cambodia." The J. Paul Getty Museum, August 22, 2011. http://www.getty .edu/art/exhibitions/gods_angkor/.

Gopnik, Blake. "In Praise of Art Forgeries." *The New York Times*, November 2, 2013. http://www.nytimes.com/2013/11/03/ opinion/sunday/in-praise-of-art-forgeries.html.

Grossman, Janet Burnett, Jerry Podany, and Marion True, eds. *History of Restoration of Ancient Stone Sculptures: Papers Delivered at a Symposium Organized by the Departments of Antiquities and Antiquities Conservation of the J. Paul Getty Museum and Held at the Museum, 25–27 October, 2001*. Los Angeles: Getty Museum, 2003.

Hartwig, Melinda K., ed. *A Companion to Ancient Egyptian Art*. Chichester, UK: John Wiley & Sons, 2015.

Hemingway, Colette, and Seán Hemingway. "The Technique of Bronze Statuary in Ancient Greece." Heilbrunn Timeline of Art History. The Metropolitan Museum of Art. October 2003. https://www .metmuseum.org/toah/hd/grbr/hd_grbr.htm.

Herz, Norman, and Marc Waelkens, eds. *Classical Marble: Geochemistry, Technology, Trade*. Boston: Kluwer Academic Publishers, 1988.

Hirt, Alfred Michael. *Imperial Mines and Quarries in the Roman World: Organizational Aspects 27 BC–AD 235*. Oxford: Oxford University Press, 2010.

Hunt, L. B. "The Long History of Lost Wax Casting." *Gold Bulletin* 13, no. 2 (June 1980): 63–79.

Hurwit, Jeffrey M. *Artists and Signatures in Ancient Greece.* New York: Cambridge University Press, 2015.

Huxtable, J., J. A. J. Gowlett, G. N. Bailey, P. L. Carter, and V. Papaconstantinou. "Thermoluminescence Dates and a New Analysis of the Early Mousterian From Asprochaliko." *Current Anthropology* 33, no. 1 (1992): 109–114.

Koerner, Brendan. "Fake Out! How Forgers Made Grime Seem Ancient." *Slate*, December 30, 2004. http://www.slate.com/articles/news_and_politics/explainer/2004/12/fake_out.html.

Lazzarini, Lorenzo. "Archaeometric Aspects of White and Coloured Marbles Used in Antiquity: The State of the Art." *Periodico Di Mineralogia* 73, no. 3 (2003): 113–25.

Liritzis, Ioannis, Ashok Kumar Singhvi, and James K. Feathers, et al. *Luminescence Dating in Archaeology, Anthropology, and Geoarchaeology: An Overview.* New York: Springer Science & Business Media, 2013.

Maeda, Y., J. Morioka, and Y. Tsujino, et al. "Material Damage Caused by Acidic Air Pollution in East Asia." *Water, Air, and Soil Pollution* 130, no. 1–4 (August 2001): 141–150. doi:10.1023/A:1012263822014.

Mattusch, Carol C. *Classical Bronzes: The Art and Craft of Greek and Roman Statuary.* Ithaca, NY: Cornell University Press, 1996.

Mattusch, Carol C. *Greek Bronze Statuary: From the Beginnings Through the Fifth Century B.C.* Ithaca, NY: Cornell University Press, 1988.

Medelyan, Valerie. "Says Who? The Futility of Authenticating Art in the Courtroom." *Hastings Communications and Entertainment Law Journal* 36, no. 1 (2014).

Merryman, John Henry. In *Thinking about the Elgin Marbles: Critical Essays on Cultural Property, Art and Law.* By John Merryman, 24–65. Boston: Kluwer Law International, 2009.

Muscarella, Oscar White. "The Veracity of 'Scientific' Testing by Conservators." In *Archaeology, Artifacts and Antiquities of the Ancient Near East*, by Oscar Muscarella, 931–952, Leiden, The Netherlands: Brill, 2013.

Nici, John. *Famous Works of Art—And How They Got That Way.* Lanham, MD: Rowman & Littlefield, 2015.

Oppenheim, Adela, Dorothea Arnold, Dieter Arnold, and Kei Yamamoto. *Ancient Egypt Transformed: The Middle Kingdom.* New York: Metropolitan Museum of Art, 2015.

Pal, Shalmali. "Scan Artist: Radiologist Uses CT to Reveal Mystery of Antiquities." *AuntMinnie.com*, August 25, 2005. http://www.auntminnie.com/index.aspx?sec=ser&sub=def&pag=dis&itemid=67513.

"Rembrandt Research Project." October 8, 2014. Accessed January 11, 2016. http://www.rembrandtresearchproject.org/.

Robins, Gay, and Ann S. Fowler. *Proportion and Style in Ancient Egyptian Art.* Austin: University of Texas Press, 1994.

Schwenninger, Jean-Luc. "Luminescence." School of Archaeology, University of Oxford. http://www.arch.ox.ac.uk/luminescence .html.

Sease, Catherine. "Faking Pre-Columbian Artifacts." Objects Specialty Group Postprints. *American Institute for Conservation of Historic & Artistic Works* 14 (2007): 146–160.

Stanish, Charles. "Forging Ahead—How I Learned to Stop Worrying and Love eBay—Archaeology Magazine Archive." *Archaeology Magazine* 62, no. 3 (June 2009). http://archive.archaeology.org/ 0905/etc/insider.html.

Stocks, Denys A. *Experiments in Egyptian Archaeology: Stoneworking Technology in Ancient Egypt.* London: Routledge, 2013.

"'The Times' on Forgeries." *The Burlington Magazine for Connoisseurs* 42, no. 239 (1923): 61–62.

UNESCO International Scientific Committee for the Drafting of a General History of Africa. *Methodology and African Prehistory.* Edited by Jacqueline Ki-Zerbo. Berkeley: University of California Press, 1990.

US v. Schultz, 333 F. 3d 393 (2d. Cir. 2003).

Woodford, Susan. *An Introduction to Greek Art: Sculpture and Vase Painting in the Archaic and Classical Periods.* London: Bloomsbury, 2015.

Yates, Donna. "'Value and Doubt': The Persuasive Power of 'Authenticity' in the Antiquities Market." *PARSE* 2 (2015): 71–84.

Chapter 6

Afghanistan, Law of May 20, 2004 (Law on the Preservation of the Historical and Cultural Heritage).

Anderson, Maxwell L. "How to Save Art From Islamic State." *Wall Street Journal,* October 20, 2015. http://www.wsj.com/articles/ how-to-save-art-from-islamic-state-1445376423.

Antiquities Law, Law No. 5738-1978 (1978) (Isr.).

Blum, Orly. "The Illicit Antiquities Trade: An Analysis of Current Antiquities Looting in Israel." Illicit Antiquities Research Centre. June 2003. http://www2.mcdonald.cam.ac.uk/projects/iarc/ culturewithoutcontext/issue11/blum.htm.

Burke, Karen T. "International Transfers of Stolen Cultural
 Property: Should Thieves Continue to Benefit from Domestic Laws
 Favoring Bona Fide Purchasers?" *Loyola of Los Angeles International
 and Comparative Law Journal* 13, no. 2 (1990): 427–466.

Código Penal, [Cód. Penal] [Criminal Code], as Amended, El Peruano,
 Diario Oficial [E.P.p Art. 226], Abril 9, 1991 (Peru).

Constitución Politica Del Peru [C.P.], Art. 21, El Peruano, Diario Oficial,
 Diciembre 30, 1993 (Peru).

Decreto Supreme No. 011-2006-ED, Junio 1, 2006, El Peruano, Diario
 Oficial, Art. 54 (Peru).

"Directive 2014/60/EU of the European Parliament and of the Council
 of 15 May 2014 on the Return of Cultural Objects Unlawfully
 Removed from the Territory of a Member State and Amending
 Regulation EU No. 1024/2012 (Recast)." *Official Journal of the
 European Union*, May 28, 2015.

Emergency Protection for Iraqi Cultural Antiquities Act of 2004, 19
 C.F.R. § 12.104j (2004).

Federal Office of Culture. "New Rules for the Art Trade: A Guide on the
 Cultural Property Transfer Act for the Art Trade and Auctioning
 Business." Federal Department of Home Affairs (FDHA), May 2014.
 http://www.bak.admin.ch/kulturerbe/04371/?lang=en.

Fincham, Derek. "Towards a Rigorous Standard for the Good Faith
 Acquisition of Antiquities." *Syracuse Journal of International Law and
 Commerce* 37, no. 1 (August 14, 2009): 145–206.

Friedland, Elise A., and Melanie Grunow Sobocinski. *The Oxford
 Handbook of Roman Sculpture*. New York: Oxford University
 Press, 2015.

Gerstenblith, Patty. "International Art and Cultural Heritage." *The
 International Lawyer* 44, no. 1 (n.d.): 395–408.

Gruber, Stefan. "Protecting China's Cultural Heritage Sites in Times of
 Rapid Change: Current Developments, Practice and Law." *Asia Pacific
 Journal of Environmental Law* 10, nos. 3 & 4 (August 20, 2008): 253–301.

Iraq. Law No. 59 of 1936, as Amended by Law No. 120 of 1974

Law No. 164 of 1975 (Antiquities Law No. 59 of 1936) (Iraq).

Law Concerning Archaeological Monuments, Museums, and
 Documents, Libyan Arab Jamahiriya. Law No. 2 (March 3,
 1983) (Libya).

Law of the Israel Antiquities Authority, Law No. 5749-1989 (July 24,
 1989) (Isr.)

Law of the People's Republic of China on the Protection of Cultural Relics, (1982) (China).

Law on the Protection of Cultural Heritage, NS/RKM/0196/26 of Jan. 25, 1996 (Cambodia).

Legislative Decree No. 42 of 22 January 2004— Code of the Cultural and Landscape Heritage (It.). http://www.unesco.org/culture/natlaws/media/pdf/italy/it_cult_landscapeheritge2004_engtof.pdf.

Merryman, John Henry. "The Good Faith Acquisition of Stolen Art." Stanford, CA: Stanford Public Law and Legal Theory Working Paper Series. Research Paper No. 1025515. October 29, 2007. http://law.stanford.edu/wp-content/uploads/sites/default/files/publication/258675/doc/slspublic/Merryman%20Good%20Faith.pdf.

Merryman, John Henry. "Two Ways of Thinking about Cultural Property." *American Journal of International Law* 80, no. 4 (1986): 831.

National Heritage Resources Act, Act No. 25 of 1999 (S. Afr.).

"New Act to Protect Cultural Property." *Bundesregierung Deutschland*, July 17, 2015. https://www.bundesregierung.de/Content/EN/Artikel/2015/07_en/2015-07-17-protecting-culture-property_en.html.

Protection of the Archaeological and Paleontological Heritage, Act No. 25743 of June 25, 2003 (Arg.).

Puhze, Galerie Günter, and Michael Henker, "Is the German Cultural Property Protection Act to Be Welcomed?" *Apollo Magazine*, December 21, 2015. http://www.apollo-magazine.com/is-the-german-cultural-property-protection-act-to-be-welcomed/.

"Return of Cultural Goods." Directive 2014/60/EU. *European Commission*. Accessed March 14, 2016. http://ec.europa.eu/growth/single-market/goods/free-movement-sectors/return-cultural-goods/index_en.htm.

Sheftel, Aleksandra. "Looting History: An Analysis of the Illicit Antiquities Trade in Israel." *Journal of Art Crime* 7 (2012): 28–37.

UNESCO Convention for the Protection of Cultural Property in the Event of Armed Conflict with Regulations for the Execution of the Convention 1954, May 14, 1954. http://portal.unesco.org/en/ev.php-URL_ID=13637&URL_DO=DO_TOPIC&URL_SECTION=201.html.

UNESCO Convention on the Means of Prohibiting and Preventing the Illicit Import, Export and Transfer of Ownership of Cultural Property. November 14, 1970. http://portal.unesco.org/en/ev.php-URL_ID=13039&URL_DO=DO_TOPIC&URL_SECTION=201.html.

Chapter 7

Arsu, Sebnem. "Art Thefts Highlight Lax Security In Turkey." *The New York Times*, June 13, 2006. http://query.nytimes.com/gst/abstract.html?res=9403EEDC1331F930A25755C0A9609C8B63.

Autocephalous Greek Orthodox Church of Cyprus v. Goldberg & Feldman Arts, 917 F. 2d 278 (Court of Appeals, 7th Circuit 1990).

Bilefsky, Dan. "Seeking Return of Art, Turkey Jolts Museums." *The New York Times*, September 30, 2012. http://www.nytimes.com/2012/10/01/arts/design/turkeys-efforts-to-repatriate-art-alarm-museums.html.

Boehm, Mike. "Norton Simon's 'Temple Wrestler' Statue Heading Home to Cambodia." *Latimes.com*. Accessed January 9, 2016. http://www.latimes.com/entertainment/arts/la-et-cm-norton-simon-statue-20140521-story.html.

"Case Summary-Italy v. Giacomo Medici." *International Foundation for Art Research*. Accessed January 9, 2016. http://www.ifar.org/case_summary.php?docid=1184603958.

Chechi, Alessandro, Anne Laure Bandle, and Marc-André Renold. "Case Nataraja Idol — India and the Norton Simon Foundation." Platform ArThemis, October 2011. https://plone.unige.ch/art-adr/cases-affaires/nataraja-idol-2013-india-and-norton-simon-foundation-1.

Corte App., Roma, Sez. II Pen., 15 luglio 2009, n.5359; Cass. Pen., Sez. II, Sent., (ud. 07-12-2011) 22 dicembre 2011, n. 47918 (It.).

"Country Summary—Greece." Database. *International Foundation for Art Research*. Accessed January 9, 2016. http://www.ifar.org/country_title.php?docid=1180079975.

"#CultureUnderThreat: Recommendations for the U.S. Government." Antiquities Coalition, Asia Society, and Middle East Institute, April 2016. http://taskforce.theantiquitiescoalition.org/wp-content/uploads/2015/01/Task-Force-Report-April-2016-Complete-Report.pdf.

"Déclaration des États ACP sur le retour ou la restitution des biens culturels," December 15, 1989. http://www.unesco.org/culture/natlaws/media/pdf/africa_regional_leg/afr_declaration_acp_retour_restitution_freorof.pdf.

Engel, Eliot. Actions—H.R.1493—Protect and Preserve International
 Cultural Property Act, 2016. Public Law No: 114-151. https://www
 .congress.gov/bill/114th-congress/house-bill/1493/all-actions.

Ferri, Paolo Giorgio. "Certificates of Exportation of Cultural Property
 and Foreign Acceptance of Their Value." *The European Review of
 Organised Crime* 2, no. 1 (2015): 97–114.

FSC Majority and Minority Staff. "Memorandum to the Members of
 the Committee on Financial Services: April 19, 2016, Task Force to
 Investigate Terrorism Financial Hearing Titled 'Preventing Cultural
 Genocide: Countering the Plunder and Sale of Priceless Cultural
 Antiquities by ISIS,'" April 19, 2016. https://www.scribd.com/
 doc/309713940/041916-Tf-Supplemental-Hearing-Memo.

Gerlis, Melanie. "Calls to Open Looted-Art Archives Grow Louder." *The
 Art Newspaper*. June 2, 2015. http://theartnewspaper.com/comment/
 comment/calls-to-open-looted-art-archives-grow-louder-/.

Gill, David W.J., and Christos Tsirogiannis. "Polaroids from the
 Medici Dossier: Continued Sightings on the Market." *Art Crime*
 (2016): 229–239.

"Hearing Entitled 'Preventing Cultural Genocide: Countering the
 Plunder and Sale of Priceless Cultural Antiquities by ISIS,'"
 | House Committee on Financial Services, April 19, 2016.
 http://financialservices.house.gov/calendar/eventsingle
 .aspx?EventID=400550.

International Foundation for Art Research. "International Cultural
 Property Ownership & Export Legislation (ICPOEL)." Accessed
 December 31, 2015. https://www.ifar.org/icpoel.php.

Kaliampetsos, Ira. "Combating Looting and Illicit Trafficking of
 Cultural Objects in Greece –Administrative Structure and New
 Legislation." Paper presented at the Ninth Mediterranean Research
 Programme - European University Institute Florence 12-13 March
 2008. Edited by Robert Schuman Centre for Advanced Studies.
 Florence: Hellenic Society for Law and Archaeology, 2008. http://
 www.law-archaeology.gr/ClientFiles/Downloads/1205732028_
 florence.web.vesrion.pdf.

Law No. 5226 for the Conservation of Cultural and Natural Property,
 (July 14, 2004) (Turk.)

Mashberg, Tom. "Another Gallery Is Raided in Antiquities Case." *The
 New York Times*, March 18, 2016. http://www.nytimes.com/2016/03/
 19/arts/design/another-gallery-is-raided-in-antiquities-case.html.

National Stolen Property Act. 18 U.S.C. §§ 2314–2315, 1934.

On Measures for the Protection of Cultural Goods, Law No. 3658/2008 of Apr. 22, 2008 (Greece).

On the Protection of Antiquities and of the Cultural Heritage in General, Law No. 3028/2002 of June 28, 2002 (Greece).

Operational Guidelines for the Implementation of the Convention on the Means of Prohibiting and Preventing the Illicit Import, Export and Transfer of Ownership of Cultural Property (UNESCO, Paris, 1970). United Nations Educational, Scientific and Cultural Organization, May 2015. http://www.unesco.org/new/en/culture/themes/illicit-trafficking-of-cultural-property/operational-guidelines/.

Özel, Sibel. "Under the Turkish Blanket Legislation: The Recovery of Cultural Property Removed from Turkey." *International Journal of Legal Information* 38, no. 2 (July 1, 2010). http://scholarship.law.cornell.edu/ijli/vol38/iss2/10.

Petr, Mark J. "Trading Places: Illicit Antiquities, Foreign Cultural Patrimony Laws, and the U.S. National Stolen Property Act after United States v. Schultz." *Hastings International and Comparative Law Review* 28 (2005): L Rev. 503.

Povoledo, Elisabetta. "Photographs of Getty Griffins Shown at Antiquities Trial in Rome." *The New York Times*, June 1, 2006, sec. Arts. http://www.nytimes.com/2006/06/01/arts/01gett.html.

Pringle, Heather. "New Evidence Ties Illegal Antiquities Trade to Terrorism, Violent Crime." *National Geographic News*, June 13, 2014. http://news.nationalgeographic.com/news/2014/06/140613-looting-antiquities-archaeology-cambodia-trafficking-culture/.

Protect and Preserve International Cultural Property Act, Pub. L. 114–151 (2016).

Putnam, John E., II. "Common Markets and Cultural Identity: Cultural Property Export Restrictions in the European Economic Community." *University of Chicago Legal Forum* 1992, no. 1 (1992).

Republic of Turkey v. Metropolitan Museum of Art, 762 F. Supp. 44 (S.D.N.Y. 1990).

Roodt, Christ. "Cultural Heritage Jurisprudence and Strategies for Retention and Recovery." *Comparative and International Law Journal of Southern Africa* 35, no. 2 (2002): 157–181.

Shyllon, Folarin. "Looting and Illicit Traffic in Antiquities in Africa." In *Crime in the Art and Antiquities World: Illegal Trafficking in Cultural Property*, eds. Stefano Manacorda and Duncan Chappell, 135–142. New York: Springer Science & Business Media, 2011.

Shyllon, Folarin. "The Nigerian and African Experience on Looting and Trafficking in Cultural Objects." In *Art and Cultural Heritage: Law,*

Policy and Practice, edited by Barbara T. Hoffman, 137–145.
 Cambridge, MA: Cambridge University Press, 2006.
Smith, Helena. "Greece Drops Option of Legal Action in British
 Museum Parthenon Marbles Row." *The Guardian,* May 13, 2015, sec.
 Art and design. https://www.theguardian.com/artanddesign/
 2015/may/13/greece-drops-option-legal-action-british-museum-
 parthenon-marbles-row.
"Statement from the Norton Simon Museum and the
 Norton Simon Art Foundation Concerning the 'Temple
 Wrestler.'" Norton Simon Museum, May 6, 2014.
 http://www.nortonsimon.org/assets/Uploads/
 Norton-Simon-MuseumBhima-Press-Release-05-06-14.pdf.
"Thailand Claim Against Art Institute of Chicago for Khmer
 Temple Lintel." *International Foundation for Art Research.* Settled
 in 1988.
UNESCO. "UNESCO Database of National Cultural Heritage Laws."
 Accessed December 31, 2015. http://www.unesco.org/culture/
 natlaws/.
United States v. A 10th Century Cambodian Sandstone Sculpture,
 (S.D.N.Y. 2013).
United States v. Hollinshead, 495 F. 2d 1154 (9th Cir. 1974).
United States v. McClain, 545 F. 2d 988 (5th Cir. 1977).
United States v. McClain, 551 F. 2d 52 (5th Cir. 1977).
United States v. McClain, 593 F. 2d 658 (5th Cir. 1979).
United States v. Schultz, 178 F. Supp. 445 (S.D.N.Y. 2002), *aff'd,* 333 F.3d
 (2d Cir. 2003), Cert. Denied, 540 U.S. 1106 (2004).
Wallace, Judith. "New York's Distinctive Rule Regarding Recovery
 of Misappropriated Art After the Court of Appeals' Decision
 in Mirvish v. Mott." *Spencer's Art Law Journal* 3, no. 1 (June
 2012). http://www.artnet.com/magazineus/news/spencer/
 spencers-art-law-journal-7-18-12.asp.
Walsh, Mary. "A Grecian Treasure: Back From the Grave?" *Los Angeles
 Times,* August 12, 1996. http://articles.latimes.com/1996-08-12/
 news/mn-33617_1_aidonia-treasure.
Waxman, Sharon. "Chasing the Lydian Hoard." *Smithsonian Magazine,*
 November 14, 2008. http://www.smithsonianmag.com/history/
 chasing-the-lydian-hoard-93685665/.

Chapter 8
Alberge, Dalya. "Sevso Treasure Items Repatriated by Hungarian
 Government after UK Sale." *The Guardian,* March 27, 2014. http://

www.theguardian.com/world/2014/mar/27/sevso-treasure-items-repatriated-hungarian-government-roman-silver.

Amnon Ben-Tor. "The Sad Fate of Statues and the Mutilated Statues of Hazor." In *Confronting the Past: Archaeological and Historical Essays on Ancient Israel in Honor of William G. Dever*, edited by William G. Dever, Seymour Gitin, J. Edward Wright, and J. P. Dessel, 5–16. Winona Lake, IN: Eisenbrauns, 2006.

Barak, Michael. "ISIS and the Destruction of Antiquities." *E-International Relations*. October 10, 2015. Accessed January 11, 2016. http://www.e-ir.info/2015/10/10/isis-and-the-destruction-of-antiquities/.

Baratte, François. *Die Römer in Tunesien Und Libyen: Nordafrika in Römischer Zeit*. Darmstadt/Mainz, Germany: Verlag Philipp von Zabern, 2012.

Barker, Philip W. *Religious Nationalism in Modern Europe: If God Be for Us*. London: Routledge, 2008.

Beswick, Jaine. *Regional Nationalism in Spain: Language Use and Ethnic Identity in Galicia*. Buffalo, NY: Multilingual Matters, 2007.

Brodie, Neil. "Sevso Treasure." *Trafficking Culture*. March 28, 2014. http://traffickingculture.org/encyclopedia/case-studies/sevso-treasure/.

Bunson, Matthew. *Encyclopedia of the Roman Empire*. New York: Facts on File, 2002.

Cambanis, Thanassis. "Why ISIS' Destruction of Antiquities Hurts so Much—The Boston Globe." *BostonGlobe.com*, March 10, 2015.

Colley, Linda. *Britons: Forging the Nation, 1707–1837*. New Haven, CT: Yale University Press, 2005.

Elsner, Jaś. *Imperial Rome and Christian Triumph: The Art of the Roman Empire AD 100–450*. Oxford; New York: Oxford University Press, 1998.

Gerstenblith, Patty. "International Art and Cultural Heritage." *International Lawyer* 45, no. 1 (Spring 2011): 395–408.

Gerstenblith, Patty. "Turkey Has Good Claim to Gold of Troy." *The New York Times*, October 9, 1993. http://www.nytimes.com/1993/10/09/opinion/l-turkey-has-good-claim-to-gold-of-troy-242493.html.

Grant, Michael. *Art in the Roman Empire*. New York: Routledge, 2013.

Harrison, Rodney, ed. "Heritage and the 'Problem' of Memory." In *Heritage: Critical Approaches*, edited by Rodney Harrison, 166–203. New York: Routledge, 2013.

Heaslet, Juliana Pennington. "The Red Guards: Instruments of
Destruction in the Cultural Revolution." *Asian Survey* 12, no. 12
(1972): 1032–1047.

Hemingway, Colette, and Seán Hemingway. "Ancient Greek Colonization
and Trade and Their Influence on Greek Art." Heilbrunn Timeline of
Art History. *The Metropolitan Museum of Art*, July 2007. http://www
.metmuseum.org/toah/hd/angk/hd_angk.htm/.

International Foundation for Art Research. "International Cultural
Property Ownership & Export Legislation (ICPOEL)." Accessed
December 31, 2015.

Jakubowski, Andrzej. *State Succession in Cultural Property.*
Oxford: Oxford University Press, 2015.

Jian, Guo, Yongyi Song, and Yuan Zhou. *Historical Dictionary of the
Chinese Cultural Revolution.* Lanham, MD: Scarecrow, 2006.

Journal, A. B. A. "How Countries Are Successfully Using the Law to
Get Looted Cultural Treasures Back." *ABA Journal.* July 1, 2014.
Accessed January 2, 2016. http://www.abajournal.com/magazine/
article/how_countries_are_successfully_using_the_law_to_get_
looted_cultural_treasur/.

Kimmelman, Michael. "ART REVIEW; Trojan Gold, Lost and Found, on
View in Moscow." *The New York Times,* April 16, 1996. http://www
.nytimes.com/1996/04/16/arts/art-review-trojan-gold-lost-and-
found-on-view-in-moscow.html.

Koesel, Karrie J. *Religion and Authoritarianism: Cooperation, Conflict, and
the Consequences.* New York: Cambridge University Press, 2014.

Kohn, Hans. *The Idea of Nationalism: A Study in Its Origins and
Background.* New York: Macmillan, 1961.

Marzouk, Lawrence. "Montenegro's Hidden Historical Treasures."
Balkan Insight, November 6, 2009. http://www.balkaninsight.com/
en/article/montenegro-s-hidden-historical-treasures.

May, Natalie Naomi, ed. *Iconoclasm and Text Destruction in the Ancient
Near East and Beyond.* Chicago, IL: The Oriental Institute of the
University of Chicago, 2012.

Meyer, Karl E. "Editorial Notebook; Who Owns the Gold of Troy?" *The
New York Times,* September 26, 1993. http://www.nytimes.com/
1993/09/26/opinion/editorial-notebook-who-owns-the-gold-of-
troy.html.

Moreno, Luis, and Ana Arriba. "Multiple Identities in Decentralized
Spain: The Case of Catalonia." *Regional and Federal Studies* 8, no. 3
(1988): 65–88.

Murphy, Alexander B., Terry G. Jordan-Bychkov, and Bella Bychkova Jordan. *The European Culture Area: A Systematic Geography*. 6th ed. Lanham, MD: Rowman & Littlefield, 2014.

Özel, Sibel. "Under the Turkish Blanket Legislation: The Recovery of Cultural Property Removed from Turkey." *International Journal of Legal Information* 38, no. 2 (July 1, 2010). http://scholarship.law .cornell.edu/ijli/vol38/iss2/10.

Painter, Borden. *Mussolini's Rome: Rebuilding the Eternal City*. New York: Macmillan, 2007.

Republic of Lebanon v. Sotheby's, 167 A.D. 2d 142 (1990).

"'Revolutionary' Court Victory against Antiquity Thieves." *Arutz Sheva*. Accessed December 29, 2016. http://www.israelnationalnews .com/News/News.aspx/205649.

Rinke, Andreas. "Merkel Tells Putin Germany Wants Looted Art Returned." *Reuters*, June 21, 2013. http://www.reuters.com/ article/us-germany-russia-merkel-art-idUSBRE95K0OG20130621.

Scott, Kenneth. "Mussolini and the Roman Empire." *The Classical Journal* 27, no. 9 (1932): 645–657.

Shaheen, Kareem. "Isis Attacks on Ancient Sites Erasing History of Humanity, Says Iraq." *The Guardian*, March 9, 2015, sec. World news. http://www.theguardian.com/world/2015/mar/09/ iraq-condemns-isis-destruction-ancient-sites.

Simpson, Andrew, ed. *Language and National Identity in Asia*. 1st ed. New York: Oxford University Press, 2007.

Spielvogel, Jackson. *Western Civilization: Volume B: 1300–1815*. New York: Cengage Learning, 2014.

Stephens, S. Shawn. "The Hermitage and Pushkin Exhibits: An Analysis of the Ownership Rights to Cultural Properties Removed from Occupied Germany." *Houston Journal of International Law* 18, no. 1 (1995): 59–112.

Stone, Marla Susan. *The Patron State: Culture and Politics in Fascist Italy*. Princeton, NJ: Princeton University Press, 1998.

Thompson, Suzanne. "Trojan Gold Stirs Claims by 3 Nations." *The Moscow Times*, April 16, 1996. http://www.themoscowtimes.com/ news/article/trojan-gold-stirs-claims-by-3-nations/325596.html.

Traill, David A. "Schliemann's Discovery of 'Priam's Treasure': A Reexamination of the Evidence." *The Journal of Hellenic Studies* 104 (1984): 96–115.

Tribune News Services. "Russia Unveils Trojan Treasures." *The Chicago Tribune*, April 16, 1996. http://articles

.chicagotribune.com/1996-04-16/news/9604160105_1_
trophy-art-trojan-gold-major-treasures.

Tschudi, Victor Plahte. "Plaster Empires: Italo Gismondi's Model of
Rome." *Journal of the Society of Architectural Historians* 71, no. 3
(2012): 386–403.

UNESCO. "UNESCO Database of National Cultural Heritage Laws."
Accessed December 31, 2015. http://www.unesco.org/culture/
natlaws/.

Wood, Graeme, Akbar Ahmed, and William McCants. "The Islamic
State's Destruction of Antiquities And How it Fits With A Broader
Strategy For Power." August 26, 2015. http://thedianerehmshow
.org/shows/2015-08-26/the-islamic-states-destruction-of-
antiquities-and-how-it-fits-with-a-broader-strategy-for-power.

Chapter 9

Bederman, David J. "UNESCO Draft Convention on Underwater
Cultural Heritage: A Critique and Counter-Proposal." *Journal of
Maritime Law and Commerce* 30, no. 2 (1999): 331–354.

Beltrametti, Silvia, and James V. Marrone. "Market Responses to
Changing Legal Standards: Evidence from Antiquities Auctions."
SSRN Scholarly Paper. Rochester, NY, January 31, 2016.

Blau, Uri, and Amiram Barkat. "Police Probe Corruption at Antiquities
Authority." *Haaretz*, May 19, 2006. http://www.haaretz.com/
police-probe-corruption-at-antiquities-authority-1.188062.

Boehm, Mike. "2010 Ruling in 'Getty Bronze' Case under Review
by Italian Court." *Latimes.com*, June 17, 2014. http://www
.latimes.com/entertainment/arts/culture/la-et-cm-getty-bronze-
victorious-youth-italian-court-20140616-story.html.

Boehm, Mike. "The Getty's 'Victorious Youth' Is Subject of a Custody
Fight." *Los Angeles Times*, May 7, 2014. http://www.latimes.com/
entertainment/arts/la-et-cm-getty-bronze-20140507-story.html.

Borodkin, Lisa J. "The Economics of Antiquities Looting and a
Proposed Legal Alternative." *Columbia Law Review* 95, no. 2
(1995): 377–417.

Bresge, Adina. "Archeologist Calls for National Strategy to Protect
Shipwrecks from Looting." *680 News*, April 12, 2016. http://
www.680news.com/2016/04/12/archeologist-calls-for-national-
strategy-to-protect-shipwrecks-from-looting/.

Brodie, Neil. "Historical and Social Perspective on the Regulation of
the International Trade in Archaeological Objects: The Examples

of Greece and India." *Vanderbilt Journal of Transnational Law* 38 (2005): 1051–1066.

Daly, John. "Exploration of Ill-Fated SS Gairsoppa Reveals Treasure from the Deep." *The Irish Examiner*, August 3, 2013. http://www .irishexaminer.com/lifestyle/features/exploration-of-ill-fated-ss-gairsoppa-reveals-treasure-from-the-deep-238719.html.

Fincham, Derek. "Transnational Forfeiture of the Getty Bronze." *Cardozo Arts & Entertainment Law Journal* 32, no. 2 (2014): 471–500.

Forrest, Craig. "Finishing the Interrupted Voyage: Papers of the UNESCO Asia-Pacific Workshop on the Protection of the Underwater Cultural Heritage." Edited by Lyndel Prott. *International Journal of Cultural Property* 13, no. 2 (May 2006): 247–251.

Frost, Robyn. "Underwater Cultural Heritage Protection." *Australian Year Book of International Law* 23 (2004): 25–50.

Gerstenblith, Patty. "International Art and Cultural Heritage." *International Lawyer* 45, no. 1 (Spring 2011): 395–408.

Green, Stuart P. "Looting, Law, and Lawlessness." *Tulane Law Review* 81 (2007): 1129.

Hardy, Sam. "How the West Buys 'Conflict Antiquities' from Iraq and Syria (and Funds Terror)." *Reuters Blogs*, October 27, 2014. http:// blogs.reuters.com/great-debate/2014/10/27/how-the-west-buys-conflict-antiquities-from-iraq-and-syria-and-funds-terror/.

Hardy, Sam. "Virtues Impracticable and Extremely Difficult: The Human Rights of Subsistence Diggers." In *Ethics and the Archaeology of Violence*, edited by Alfredo González-Ruibal and Gabriel Moshenska, 229–239. New York: Springer, 2014.

Harris, Gareth. "EU Law Rejects Getty Lysippos Restitution Verdict." *The Art Newspaper*, December 30, 2015. http://theartnewspaper .com/news/eu-law-rejects-getty-lysippos-restitution-verdict/.

Jewish News Service. "2,000-Year-Old Jewish Ritual Bath Discovered Under Jerusalem Home's Floor—Israel News." *Breaking Israel News*, July 2, 2015. http://www.breakingisraelnews.com/44492/2000-year-old-jewish-ritual-bath-discovered-under-jerusalem-homes-floor/.

Maarleveld, Thijs J., Ulrike Guérin, and Barbara Egger, et al., eds. *Manual for Activities Directed at Underwater Cultural Heritage: Guidelines for Activities Directed at Underwater Cultural Heritage*. United Nations Educational, Scientific and Cultural Organization, Paris: 2013.

Martinez, Alanna. "FBI Warns US Art Dealers: ISIL-Looted Antiquities Are Hitting the Market." *Observer*. August 27, 2015. Accessed January 18, 2016. http://observer.com/2015/08/fbi-warns-us-art-dealers-isil-looted-antiquities-are-hitting-the-art-market/.

Mattusch, Carol C. *Greek Bronze Statuary: From the Beginnings Through the Fifth Century B.C*, Ithaca, NY: Cornell University Press, 1988.

Nadeau, Barbie. "Rome Subway Dig Yields Surprises." *Newsweek*, March 18, 2008. http://www.newsweek.com/rome-subway-dig-yields-surprises-83981.

Ng, David. "Getty's 'Victorious Youth' Bronze Gets Another Legal Detour." *Latimes.com*, December 31, 2015. http://www.latimes.com/entertainment/arts/culture/la-et-cm-getty-bronze-victorious-youth-sculpture-20151231-story.html.

Pringle, Heather. "New Evidence Ties Illegal Antiquities Trade to Terrorism, Violent Crime." *National Geographic News*, June 13, 2014. http://news.nationalgeographic.com/news/2014/06/140613-looting-antiquities-archaeology-cambodia-trafficking-culture/.

Rapson, Jasmine. "Marlow's History at Risk after Increase in Illegal Metal Detecting." *Bucks Free Press*, April 1, 2016. http://www.bucksfreepress.co.uk/news/14395786.Town_s_history_at_risk_after_increase_in_illegal_metal_detecting/.

Richardson, Giles, and Alexandra Sofroniew. "Who Owns the Wreckage of the San José, and What Should Be Done with It?" *Apollo Magazine*. January 4, 2016. Accessed January 18, 2016. http://www.apollo-magazine.com/who-owns-the-wreckage-of-the-san-jose-and-what-should-be-done-with-it/.

Roldán, Nayeli. "El INAH Olvida Conservar Las Zonas Arqueológicas Del País: Auditoría." *Animal Politico*, March 9, 2016. http://www.animalpolitico.com/2016/03/el-inah-olvida-conservar-las-zonas-arqueologica-del-pais-auditoria/.

Rush, Laurie W. "Illicit Trade in Antiquities: A View 'From the Ground.'" In *Enforcing International Cultural Heritage Law*, edited by Francesco Francioni and James Gordley, 65–76. Oxford: Oxford University Press, 2013.

Rush, Laurie, and Luisa Benedettini Millington. *The Carabinieri Command for the Protection of Cultural Property: Saving the World's Heritage*. Woodbridge, UK: Boydell & Brewer, 2015.

Sea Search Armada v. Republic of Colombia, 821 F. Supp. 2d 268 (D.C. Dist. Ct. 2011).

Sease, Catherine. "Conservation and the Antiquities Trade." *Journal of the American Institute for Conservation* 36, no. 1 (1997): 49–58.

Shabi, Rachel. "Looted in Syria—and Sold in London: The British Antiques Shops Dealing in Artefacts Smuggled by Isis." *The Guardian*, July 3, 2015. http://www.theguardian.com/world/2015/jul/03/antiquities-looted-by-isis-end-up-in-london-shops.

Shyllon, Folarin. "Looting and Illicit Traffic in Antiquities in Africa." In *Crime in the Art and Antiquities World: Illegal Trafficking in Cultural Property*, edited by Stefano Manacorda and Duncan Chappell, 135–142. New York: Springer Science & Business Media, 2011.

Taylor, Kate. "Smithsonian Sunken Treasure Show Poses Ethics Questions." *The New York Times*, April 24, 2011. http://www.nytimes.com/2011/04/25/arts/design/smithsonian-sunken-treasure-show-poses-ethics-questions.html.

The Associated Press. "Colombia Finds What May Be World's Largest Sunken Treasure." *The New York Daily News*, December 5, 2015. http://www.nydailynews.com/news/world/.Colombia-finds-world-largest-sunken-treasure-article-1.2456361.

"The Illicit Antiquities Trade as a Transnational Criminal Network: Characterizing and Anticipating Trafficking of Cultural Heritage." Accessed December 26, 2015.

"Tomb-Raiding Gang Leader Faces Death." *ShanghaiDaily.com*, April 15, 2016. http://www.shanghaidaily.com/national/Tombraiding-gang-leader-faces-death/shdaily.shtml.

Trescott, Jacqueline. "Sackler Gallery Cancels Controversial Exhibit of Tang Dynasty Treasures from Shipwreck." *The Washington Post*, December 15, 2011. https://www.washingtonpost.com/lifestyle/style/sackler-gallery-cancels-controversial-exhibit-of-tang-dynasty-treasures-from-shipwreck/2011/12/15/gIQAnlyjwO_story.html.

Ulph, Janet, and Ian Smith. *The Illicit Trade in Art and Antiquities: International Recovery and Criminal and Civil Liability. Edinburgh Law Review* 17, no. 2 (2013): 266–267.

UNESCO. Intergovernmental Oceanographic Commission. "Underwater Cultural Heritage Convention on the Protection of the Underwater Cultural Heritage Will Enter into Force in January 2009," October 14, 2008. http://www.ioc-unesco.org/index.php?option=com_content&view=article&id=83:underwater-cultural-heritage&catid=14&Itemid=100063.

United Nations Convention on the Law of the Sea, December 10, 1982, 1833 U.N.T.S. 31363.

Wantuch-Thole, Mara. *Cultural Property in Cross-Border Litigation: Turning Rights into Claims*. Berlin: de Gruyter, 2015.

Watts, Jonathan, and Stephen Burgen. "Holy Grail of Shipwrecks Caught in Three-Way Court Battle." *The Guardian*, December 6, 2015. http://www.theguardian.com/world/2015/dec/06/holy-grail-of-shipwrecks-in-three-way-court-battle.

"Where Do ISIS-Looted Antiquities Go?" *Motherboard*. September 30, 2015. Accessed January 18, 2016. http://motherboard.vice.com/read/where-do-isis-looted-antiquities-go.

Wong, Catherine. "Chinese Man Arrested on Suspicion of Planning to Sell Ancient Artefacts He Found in Tomb Buried in Backyard." *South China Morning Post*, March 25, 2016. http://www.scmp.com/news/china/society/article/1930570/chinese-man-arrested-suspicion-planning-sell-ancient-artefacts-he?utm_source=&utm_medium=&utm_campaign=SCMPSocialNewsfeed.

Worrall, Simon. "The Treasure Trove Making Waves." *BBC*, October 18, 2008. http://news.bbc.co.uk/2/hi/programmes/from_our_own_correspondent/7675866.stm.

Zamora, Tatiana Villegas. "The Impact of Commercial Exploitation on the Preservation of Underwater Cultural Heritage." *Museum International* 60, no. 4 (December 1, 2008): 18–30.

Chapter 10

Agence France-Presse. "Stolen Artefacts Stashed by British Art Dealer Are Returned to Italy." *The Guardian*, March 22, 2016. http://www.theguardian.com/world/2016/mar/22/stolen-artefacts-stashed-british-art-dealer-returned-italy.

Albertson, Lynda. "Do You Know Where Your Art Has Been? When the Licit Antiquities Trade Masks an Illicit Criminal Enterprise." *ARCA Blog*. Accessed March 23, 2016. http://art-crime.blogspot.com/2016/03/do-you-know-where-your-art-has-been.html.

Alderman, Kimberly L. "The Ethical Trade in Cultural Property: Ethics and Law in the Antiquity Auction Industry." *ILSA Journal of International & Comparative Law* 14, no. 3 (2008): 549–570.

Alderman, Kimberly. "Honor Amongst Thieves: Organized Crime and the Illicit Antiquities Trade." *Indiana Law Review* 45, no. 3 (2012): 601–627.

"Belgian Federal Police Eliminating Its Art Crime Police Squad Due to Reported Budgetary Constraints." *ARCA Blog*, April 16, 2016.

http://art-crime.blogspot.com/2016/04/belgian-federal-police-eliminating-its.html.

Beltrametti, Silvia, and James V. Marrone. "Market Responses to Changing Legal Standards: Evidence from Antiquities Auctions." SSRN Social Science Research Network. Rochester, NY, January 31, 2016.

Bogdanos, Matthew, Tess Davis, and Atheel Al-Nujaifi. "Save Statues, Save Lives." *The Antiquities Coalition*. June 2, 2015. https://theantiquitiescoalition.org/ac-news/save-statues-save-lives/.

Brodie, Neil. "Auction Houses and the Antiquities Trade." In *3rd International Conference of Experts on the Return of Cultural Property*, ed. S. Choulia-Kapeloni, 71–82. Athens: Archaeological Receipts Fund, 2014.

Brodie, Neil. "The Concept of Due Diligence and the Antiquities Trade." McDonald Institute for Archaeological Research, March 2000. http://www2.mcdonald.cam.ac.uk/projects/iarc/culturewithoutcontext/issue5/brodie.htm.

Brodie, Neil. "Robin Symes Loses His Heads." Blog. *Market of Mass Destruction*, February 4, 2016.

Christie's Auction & Private Sale. "Conditions of Sale." Accessed February 2, 2016. https://www.christies.com/LotFinder/AbsenteeBidding/ImportantInfo.aspx?docCode=COB&saleid=24758.

Commission to the Council and the EU Parliament. "EU Anti-Corruption Report," February 3, 2014. http://ec.europa.eu/dgs/home-affairs/e-library/documents/policies/organized-crime-and-human-trafficking/corruption/docs/acr_2014_en.pdf.

" 'Contro Di Me Articolo Farneticante.' Gianfranco Becchina Querela 'La Repubblica.' " *Castelvetrano News*, May 7, 2015. http://castelvetranonews.it/notizie/?r=8TM.

"Curbing Corruption in Public Procurement." *Transparency International*. Accessed February 1, 2016. http://www.transparency.org/whatwedo/activity/curbing_corruption_in_public_procurement.

Dietzler, Jessica. "On 'Organized Crime' in the Illicit Antiquities Trade: Moving beyond the Definitional Debate." *Trends in Organized Crime* 16, no. 3 (2013): 329–342.

Elkins, Nathan. "Good Faith, Due Diligence, and Market Activities." *SAFE: Saving Antiquities for Everyone*, July 1, 2008. http://

savingantiquities.org/good-faith-due-diligence-and-market-activities/.

Feigenbaum, Gail, and Inge Reist, eds. *Provenance: An Alternate History of Art*. Santa Barbara, CA: Getty Research Institute, 2012.

Fincham, Derek. "Towards a Rigorous Standard for the Good Faith Acquisition of Antiquities." *Syracuse Journal of International Law and Commerce* 37, no. 1 (August 14, 2009): 145–206.

Grant, Daniel. "Is It Possible to 'Collect' Antiquities These Days?" *The Huffington Post*, April 5, 2011. http://www.huffingtonpost.com/daniel-grant/antiquities-collecting-due-diligence_b_844838.html.

Haken, Jeremy. "Transnational Crime in the Developing World." Global Financial Integrity, February 2011. http://www.gfintegrity.org/wp-content/uploads/2014/05/gfi_transnational_crime_high-res.pdf.

Hammerstein, Konstantin von. "Lucrative Loot: The Murky World of the Ancient Artifact Market." *Spiegel Online*. Accessed April 18, 2016. http://www.spiegel.de/international/business/the-dubious-market-for-ancient-artifacts-a-1086597.html.

Jewish News Service. "2,000-Year-Old Jewish Ritual Bath Discovered Under Jerusalem Home's Floor—Israel News." *Breaking Israel News*, July 2, 2015. http://www.breakingisraelnews.com/44492/2000-year-old-jewish-ritual-bath-discovered-under-jerusalem-homes-floor/.

Johnston, Ian. "Ancient Egyptian Statue of Sekhemka Disappears into Private Collection in 'Moral Crime against World Heritage.'" *The Independent*. May 9, 2016. http://www.independent.co.uk/news/uk/home-news/ancient-egyptian-statue-of-sekhemka-disappears-into-private-collection-in-moral-crime-against-world-a7019946.html.

Kimmelman, Michael. "Regarding Antiquities, Some Changes, Please." *The New York Times*, December 8, 2005. http://www.nytimes.com/2005/12/08/arts/regarding-antiquities-some-changes-please.html.

Kumar, Vijay. "Is India Serious about Retrieving Its Stolen Antiques?" *MyIndMakers*, April 29, 2016. https://www.myind.net/india-serious-about-retrieving-its-stolen-antiques.

Levine, Jane A. "The Importance of Provenance Documentations in the Market for Ancient Art and Artifacts: The Future of the Market May Depend on Documenting the Past." *DePaul Journal of Art, Technology and Intellectual Property Law* 19, no. 2 (2009): 219.

Mackenzie, Simon. "The Market as Criminal and Criminals in the Market: Reducing Opportunities for Organised Crime in the

International Antiquities Market." In *Crime in the Art and Antiquities World: Illegal Trafficking in Cultural Property*, edited by S. Manacorda and D. Chappell, 69–85. New York: Springer Science and Business Media, 2011.

Mashberg, Tom. "Federal Agents Seize What They Called an Illicit Antiquity Headed for Asia Week." *The New York Times*, NYTimes .com, March 15, 2016. http://www.nytimes.com/2016/03/16/arts/ design/federal-agents-seize-what-they-called-an-illicit-antiquity-headed-for-asia-week.html?nytmobile=0.

Mashberg, Tom. "Sale of Pre-Columbian Art Falls Short of Expectations." *The New York Times*, March 25, 2013. http://artsbeat .blogs.nytimes.com/2013/03/25/sale-of-pre-columbian-art-falls-short-of-expectations/.

Myers, Steven Lee, and Nicholas Kulish. " 'Broken System' Allows ISIS to Profit From Looted Antiquities." *The New York Times*, January 9, 2016. http://www.nytimes.com/2016/01/10/world/europe/iraq-syria-antiquities-islamic-state.html.

National Stolen Property Act. 18 U.S.C. §§ 2314–215, 1934.

Povoledo, Elisabetta. "Antiquities Trial Fixes on Collectors' Role." *The New York Times*, June 9, 2007. http://www.nytimes.com/2007/06/ 09/arts/design/09gett.html.

Schram, Jamie. "Antique Dealer Arrested for Smuggling Ancient Sculpture." *New York Post*, March 22, 2016. http://nypost.com/2016/ 03/22/antique-dealer-arrested-for-smuggling-ancient-sculpture/.

Tarmy, James. "How Is the Art Market Really Doing?" *Bloomberg*, February 29, 2016. http://www.bloomberg.com/news/articles/ 2016-02-29/how-is-the-art-market-really-doing.

The Associated Press. "Record €50m Hoard of Looted Italian Antiquities Unveiled by Police." *The Guardian*, January 21, 2015. http://www.theguardian.com/world/2015/jan/21/ looted-italian-antiquities-museums-switzerland.

Tully, Kathryn. "How to Buy Antiquities." *Financial Times*, September 4, 2015. http://www.ft.com/intl/cms/s/ d0784c78-50b0-11e5-b029-b9d50a74fd14,Authorised=false .html?siteedition=intl&_i_location=http%3A%2F%2Fwww .ft.com%2Fcms%2Fs%2F0%2Fd0784c78-50b0-11e5-b029-b9d50a74fd14.html%3Fsiteedition%3Dintl&_i_referer=&classificati on=conditional_standard&iab=barrier-app#axzz3vT4RPIgp.

"Unités de Police Spécialisées." *UNESCO*. Accessed April 22, 2016. http://www.unesco.org/new/fr/culture/themes/

illicit-trafficking-of-cultural-property/partnerships/specialized-
police-forces/.
Wiser, Daniel. "The Link Between the Islamic State and the Western
Art Trade." *Washington Free Beacon*, September 14, 2015. http://
freebeacon.com/culture/the-link-between-the-islamic-state-and-
the-western-art-trade/.

Chapter 11

"Archeology and Historic Preservation: Secretary of the Interior's
Standards and Guidelines [As Amended and Annotated]," n.d.
http://www.nps.gov/history/local law/arch_stnds_7.htm.
Beltrametti, Silvia. "Museum Strategies: Leasing Antiquities."
Columbia Journal of Law and the Arts 36, no. 2 (2013). http://
lawandarts.org/article/museum-strategies-leasing-
antiquities?article=museum-strategies-leasing-antiquities&post_
type=article&name=museum-strategies-leasing-antiquities.
Bennes, Crystal. "What's in Store at the State Hermitage Museum."
Apollo Magazine, March 17, 2016. http://www.apollo-magazine
.com/whats-in-store-at-the-state-hermitage-museum/.
Bouquet, Mary. *Museums: A Visual Anthropology*. London: Berg, 2013.
Burn, Lucilla. *Hellenistic Art: From Alexander the Great to Augustus*. Los
Angeles: Getty Museum, 2004.
Christensen, Wendy. *Empire of Ancient Egypt*. New York: Infobase
Publishing, 2009.
Clavir, Miriam. "The Social and Historic Construction of Professional
Values in Conservation." *Studies in Conservation* 43, no. 1 (1998): 1–8.
"Corpus Vasorum Antiquorum." Accessed February 9, 2016. http://
www.cvaonline.org/cva/project.htm.
"DataDot Technology Overview." DataDot. Accessed February 9, 2016.
http://www.datadotusa.com/technology.htm.
Dean, David. *Museum Exhibition: Theory and Practice*.
London: Routledge, 2002.
Elnaggar, Abdelrazek. "Storage of Egyptian Heritage: Risk Assessment,
Conservation Needs and Policy Planning." Institute of Archaeology
Annual Conference, April 13, 2013. https://www.ucl.ac.uk/
archaeology/research/directory/material_culture_wengrow/
Abdelrazek_Elnaggar.pdf.
Fabrikant, Geraldine. "The Good Stuff In The Back Room." *The
New York Times*, March 12, 2009. http://www.nytimes.com/2009/
03/19/arts/artsspecial/19TROVE.html.

Farren-Bradley, Alice. "What Makes a Museum Secure?" *Apollo Magazine*, March 1, 2016. http://www.apollo-magazine.com/what-makes-a-museum-secure/.

Grant, Daniel. "What Happens When Museums Return Antiquities?" *Hyperallergic*. March 18, 2014. Accessed October 19, 2015. http://hyperallergic.com/115015/what-happens-when-museums-return-antiquities/.

Groskopf, Christopher. "Museums Are Keeping a Ton of the World's Most Famous Art Locked Away in Storage." *Quartz*, January 20, 2016. http://qz.com/583354/why-is-so-much-of-the-worlds-great-art-in-storage/.

ICOM. "About Object ID." Accessed February 9, 2016. http://archives.icom.museum/objectid/about.html.

"Inventory and Documentation: An Important Tool for the Protection of Cultural Heritage." *The Antiquities Coalition*. October 24, 2008. https://theantiquitiescoalition.org/problems-and-solutions/databases/.

Ji-sook, Bae. "Academic Advocates Global Cooperation in Return of Cultural Properties." *The Korea Herald*, October 17, 2012. http://www.koreaherald.com/view.php?ud=20121017000898.

Kimmelman, Michael. "ART VIEW; Sorting Out Who Was Who in Rome." *The New York Times*, August 28, 1988. http://www.nytimes.com/1988/08/28/arts/art-view-sorting-out-who-was-who-in-rome.html.

Levitt, Peggy. *Artifacts and Allegiances: How Museums Put the Nation and the World on Display*. Oakland: Univ. of California Press, 2015.

Lord, Barry, and Maria Piacente, eds. *Manual of Museum Exhibitions*. Lanham, MD: Rowman & Littlefield, 2014.

Manacorda, Stefano, and Duncan Chappell, eds. *Crime in the Art and Antiquities World: Illegal Trafficking in Cultural Property*. New York: Springer Science & Business Media, 2011.

Preston, Holly Hubbard. "The Fine Art of Shipping Art—At Home Abroad—International Herald Tribune." *The New York Times*, April 26, 2008. http://www.nytimes.com/2006/04/28/style/28iht-apaint.1624603.html?_r=1&.

"Professional Practices in Art Museums." Association of Art Museum Directors, 2011. https://aamd.org/sites/default/files/document/2011ProfessionalPracticesinArtMuseums.pdf.

Pullella, Philip. "Vatican Marks Anniversary of 1972 Attack on Michelangelo's Pieta." *Reuters*, May 21, 2013. http://www.reuters.com/article/us-vatican-pieta-idUSBRE94K0KU20130521.

"Royal Duck Vessels from Saqqara." *Supreme Council of Antiquities—Recovering Stolen Treasures.* Accessed March 16, 2016. http://www.sca-egypt.org/eng/RST_Duck_Vessels.htm.

Sharpe, Emily. "Conservators Prove an Unlikely Gateway to More Museum Loans." *The Art Newspaper*, March 15, 2015. http://old.theartnewspaper.com/articles/Conservators-prove-an-unlikely-gateway-to-more-museum-loans/37258.

"Sir John Beazley." The Classical Art Research Centre. University of Oxford. Accessed February 9, 2016. http://www.beazley.ox.ac.uk/tools/pottery/collection/johnbeazley.htm.

Stewart, Richard Michael. *Archaeology: Basic Field Methods.* Dubuque, IA: Kendall Hunt, 2002.

"St. Louis Museum Proud of Its Ancient Mask Purchase, but Egypt Calls It a Steal." *The New York Times*, October 24, 2008. http://www.nytimes.com/2008/11/24/world/africa/24iht-loot.1.18094900.html.

Sutherland, Amanda. "Perceptions of Marine Artefact Conservation and Their Relationship to Destruction and Theft." In *Illicit Antiquities: The Theft of Culture and the Extinction of Archaeology*, edited by Neil Brodie and Kathryn Walker Tubb, 162–178. New York: Routledge, 2002.

Szczepanowska, Hanna M. *Conservation of Cultural Heritage: Key Principles and Approaches.* London: Routledge, 2013.

Wantuch-Thole, Mara. *Cultural Property in Cross-Border Litigation: Turning Rights into Claims.* Berlin: de Gruyter, 2015.

Chapter 12

Anderson, Maxwell L. *The Quality Instinct: Seeing Art Through a Museum Director's Eye.* Washington, DC: American Association of Museums, 2013.

Bagley, Robert W., Max Loehr, and Bernhard Karlgren. *Max Loehr and the Study of Chinese Bronzes: Style and Classification in the History of Art.* Ithaca, NY: East Asia Program, Cornell University, 2008.

Barker, Philip. *Techniques of Archaeological Excavation.* New York: Routledge, 2003.

Bennes, Crystal. "Open the Stores: Conservation, Collections and the Museum of the Future." *Apollo Magazine*, June 13, 2014. http://www.apollo-magazine.com/conservation-accessible-stores-museum-future/.

Bisht, Anand Singh, and Kamal K. Jain. *Conservation of Cultural Heritage: Essays in Honour of Shri A.S. Bisht.* Delhi: Agam Kala Prakashan, 2009.

Blumenthal, Ralph, and Tom Mashberg. "TED Prize Goes to
Archaeologist Who Combats Looting With Satellite Technology."
The New York Times. November 8, 2015. http://www.nytimes.com/
2015/11/09/arts/international/ted-grant-goes-to-archaeologist-
who-combats-looting-with-satellite-technology.html.

Boehm, Mike. "Getty to Show Exact Replicas of Art-Filled Buddhist
Caves in China." *Latimes.com*. Accessed February 16, 2016. http://
www.latimes.com/entertainment/arts/culture/la-et-cm-getty-
mogao-buddhist-cave-art-china-20150713-story.html.

Bogle, Ariel. "Good News: Replicas of 16th-Century Sculptures Are Not
Off-Limits for 3-D Printers." *Slate*. Future Tense. January 26, 2015.
http://www.slate.com/blogs/future_tense/2015/01/26/_3_d_
printing_and_copyright_replicas_of_16th_century_sculptures_are_
not.html.

Brooks, Katherine. "Chinese Art Reproduction Website Sells Cezanne
And Monet For $20." *The Huffington Post*. August 2, 2012. Accessed
February 16, 2016. http://www.huffingtonpost.com/2012/08/02/
chinese-art-reproduction-_n_1733455.html.

Carroll, Dana H. *Illustrated Catalogue of the Remarkable Collection
of Ancient Chinese Bronzes: Beautiful Old Porcelains, Amber
and Stone Carvings, Sumptuous Eighteenth Century Brocades,
Interesting Old Paintings on Glass and Fine Old Carpets, Rugs and
Furniture, from Ancient Palaces and Temples of China Comprising the
Private Collection of a Chinese Nobleman of Tien-Tsin*. New York:
American Art Association, 1914. https://archive.org/details/
illustratedcatal00amer08.

Eveleth, Rose. "The Elusiveness of Stolen Art." *The Atlantic*, August 29,
2014. http://www.theatlantic.com/technology/archive/2014/08/
tracking-stolen-art-is-harder-than-it-seems/379353/.

Fabrikant, Geraldine. "The Good Stuff In The Back Room." *The
New York Times*, March 12, 2009. http://www.nytimes.com/2009/
03/19/arts/artsspecial/19TROVE.html.

"Five Marble Architectural Fragments." *The Metropolitan Museum of
Art*. Accessed May 1, 2016. http://www.metmuseum.org/art/
collection/search/247174.

Gazda, Elaine K. *The Ancient Art of Emulation: Studies in Artistic
Originality and Tradition from the Present to Classical Antiquity*. Ann
Arbor: University of Michigan Press, 2002.

Groskopf, Christopher. "Museums Are Keeping a Ton of the World's
Most Famous Art Locked Away in Storage." *Quartz*, January 20,

2016. http://qz.com/583354/why-is-so-much-of-the-worlds-great-art-in-storage/.

Halepis, Harriette. "Tracking Fine Art." *GPS News by Rocky Mountain Tracking*. April 5, 2009. http://www.rmtracking.com/blog/2009/04/05/tracking-fine-art/.

Hammerstein, Konstantin von. "Dubious Provenance: Pressure Grows for Museums to Return Stolen Objects." *Spiegel Online*. December 10, 2014. Accessed February 16, 2016. http://www.spiegel.de/international/world/pressure-grows-for-museums-to-return-stolen-objects-a-1007523.html.

Hemingway, Colette, and Seán Hemingway. "The Technique of Bronze Statuary in Ancient Greece." *The Metropolitan Museum of Art*. October 2003. https://www.metmuseum.org/toah/hd/grbr/hd_grbr.htm.

Hranicky, William Jack. *Archaeological Concepts, Techniques, and Terminology for American Prehistoric Lithic Technology*. Bloomington, IN: AuthorHouse, 2013.

Hunt, L. B. "The Long History of Lost Wax Casting." *Gold Bulletin* 13, no. 2 (June 1980): 63–79.

ICOM, "Fighting Illicit Traffic: Object ID." http://icom.museum/programmes/fighting-illicit-traffic/object-id/.

Isager, Jacob. *Pliny on Art and Society: The Elder Pliny's Chapters on the History of Art*. New York: Routledge, 2013.

Janes, Dominic. *God and Gold in Late Antiquity*. Cambridge; New York: Cambridge University Press, 1998.

Keene, Suzanne, et al. "Collections for People: Museums Stored Collections as a Public Resource." London: UCL Institute of Archaeology, 2008. http://discovery.ucl.ac.uk/13886/.

Keene, Suzanne. *Fragments of the World: Uses of Museum Collections*. 1st ed. Amsterdam: Elsevier, 2005.

Kleiner, Fred S. *Gardner's Art through the Ages: The Western Perspective*. New York: Cengage Learning, 2009.

Lynn, Kecia. "3D Replicas Of Famous Sculptures, Printed At Home." *Big Think*, July 2, 2013. http://bigthink.com/ideafeed/3d-replicas-of-famous-sculptures-printed-at-home.

Maloney, Jennifer. "The Deep Freeze in Art Authentication." *Wall Street Journal*, April 25, 2014. http://www.wsj.com/articles/SB10001424052702304279904579518093886991908.

Moore, Molly. "Debate Over Moldy Cave Art Is a Tale of Human Missteps." *The Washington Post*, July 1, 2008. http://www

.washingtonpost.com/wp-dyn/content/article/2008/06/30/
AR2008063002363.html.

Neild, Barry. "King Tut Replica Tomb Opens to Public in Egypt." CNN
.com. May 2, 2014. Accessed February 16, 2016. http://www.cnn
.com/2014/05/01/travel/tutankhamuns-replica-tomb-egypt/
index.html.

Pullella, Philip. "Vatican Marks Anniversary of 1972 Attack on
Michelangelo's Pieta." *Reuters*, May 21, 2013. http://www.reuters
.com/article/us-vatican-pieta-idUSBRE94K0KU20130521.

Rouse, Irving. "The Classification of Artifacts in Archaeology." *American
Antiquity* 25, no. 3 (1960): 313–323.

"SANbox." *DecArch*, September 21, 2014. http://www.decarch.it/wiki/
index.php?title=Sanbox#Roma.2C_palazzo_di_Domiziano_sul_
Palatino.2C_81-92_d.C.

Scott, David A. "Bronze Disease: A Review of Some Chemical Problems
and the Role of Relative Humidity." *Journal of the American Institute
for Conservation* 29, no. 2 (1990): 193–206.

"Sir John Beazley." *The Classical Art Research Centre.* University of
Oxford. http://www.beazley.ox.ac.uk/index.htm.

Smith, Philip. *The Ancient History of the East: From the Earliest Times to the
Conquest by Alexander the Great: Including Egypt, Assyria, Babylonia,
Media, Persia, Asia Minor, and Phoenicia.* New York: Harper &
Bros., 1871.

Stewart, Richard Michael. *Archaeology: Basic Field Methods.* Dubuque,
IA: Kendall Hunt, 2002.

"Terracotta Statue of a Young Woman." *The Metropolitan Museum of
Art.* Accessed March 15, 2016. http://www.metmuseum.org/art/
collection/search/249091.

Thornes, Robin, Peter Dorrell, and Henry Lie. "Introduction to Object
ID: Guidelines for Making Records That Describe Art, Antiques,
and Antiquities." *Getty Publications Virtual Library*, 1999. http://
www.getty.edu/publications/virtuallibrary/0892365722.html.

Undeen, Don. "3D Scanning, Hacking, and Printing in Art Museums,
for the Masses." October 15, 2013. *The Metropolitan Museum of Art.*
Accessed February 16, 2016. http://www.metmuseum.org/about-
the-museum/museum-departments/office-of-the-director/digital-
media-department/digital-underground/posts/2013/3d-printing.

Williams, A. R. "Replica of King Tut's Tomb to Open in Egypt." *National
Geographic News*, October 24, 2013. http://news.nationalgeographic
.com/news/2013/10/131026-king-tut-tomb-replica-ancient-egypt-
pharaoh-archaeology-science/.

Yates, Donna. "'Value and Doubt': The Persuasive Power of 'Authenticity' in the Antiquities Market." *PARSE* 2 (2015): 71–84.

Chapter 13

"A Short History of Plaster Casts." *Cornell University Library*. Accessed April 28, 2016. https://antiquities.library.cornell.edu/casts/a-short-history.

Barthe, Georges-Louis. *Le Plâtre: L'art et la matière*. Paris: Créaphis, 2002.

Belk, Russell. *Collecting in a Consumer Society*. Hoboken, NJ: Taylor and Francis, 2013.

Biebuyck, Daniel P. *Tradition and Creativity in Tribal Art*. Berkeley: University of California Press, 1969.

Burn, Lucilla. *Hellenistic Art: From Alexander the Great to Augustus*. Los Angeles: Getty Museum, 2004.

Department of the Arts of Africa, Oceania, and the Americas. "Ancient Maya Sculpture." The Metropolitan Museum of Art. April 2016. http://www.metmuseum.org/toah/hd/mayas/hd_mayas.htm.

Frederiksen, Rune, and Eckart Marchand, eds. *Plaster Casts: Making, Collecting and Displaying from Classical Antiquity to the Present*. Berlin: Walter de Gruyter, 2010.

Galeazzi, Fabrizio, Paola Di Giuseppantonio Di Franco, and Justin L. Matthews. "Comparing 2D Pictures with 3D Replicas for the Digital Preservation and Analysis of Tangible Heritage." *Museum Management and Curatorship* 30, no. 5 (October 20, 2015): 462–483.

Henley, Jon. "Graffitists Who Leave Their Mark on History May Have Had Their Time." *The Guardian*, March 4, 2014. http://www.theguardian.com/culture/shortcuts/2014/mar/04/graffiti-leave-mark-on-ancient-monuments.

Isager, Jacob. *Pliny on Art and Society: The Elder Pliny's Chapters on the History of Art*. London; New York: Routledge, 2013.

Janes, Dominic. *God and Gold in Late Antiquity*. New York: Cambridge University Press, 1998.

Kimmelman, Michael. "Elgin Marble Argument in a New Light." *The New York Times*, June 23, 2009. http://www.nytimes.com/2009/06/24/arts/design/24abroad.html.

"Learning Resources." *The Acropolis Museum*. Accessed February 16, 2016. http://www.theacropolismuseum.gr/en/content/learning-resources.

Leibold, Cheryl. "The Historic Cast Collection at the Pennsylvania Academy of Fine Arts." *Pennsylvania Antiques and Fine Arts*, 2010,

186–191. https://www.pafa.org/sites/default/files/documents/
 press-kits/Cast%20Collection%20by%20Cheryl%20Liebold.pdf.

"Look Out Below! 3D Pavement Art around the World—in
 Pictures." *The Guardian*, October 2, 2015. http://www
 .theguardian.com/artanddesign/gallery/2015/oct/02/
 look-out-below-3d-pavement-art-around-the-world-in-pictures.

Merryman, John Henry. "Note on Counterfeit Art." In *Thinking about
 the Elgin Marbles: Critical Essays on Cultural Property, Art and
 Law*, by J. H. Merryman, 468. The Hague; Boston: Kluwer Law
 International, 2009.

Pasztory, Esther. *Thinking with Things: Toward a New Vision of Art.*
 Austin: University of Texas Press, 2005.

Pollitt, J. J. *The Art of Ancient Greece: Sources and Documents.* Cambridge,
 UK: Cambridge University Press, 1990.

Rutledge, Steven. *Ancient Rome as a Museum: Power, Identity, and the
 Culture of Collecting.* Oxford: Oxford University Press, 2012.

Shelton, Jim. "Grand Challenges for Cultural Heritage Databases, from
 Preservation to Best Practices." *Yale News*, April 14, 2016. http://
 news.yale.edu/2016/04/14/grand-challenges-cultural-heritage-
 databases-preservation-best-practices.

Steinbuch, Yaron. "Tourists Are Finishing What the Volcano Started in
 Pompeii." *New York Post*, February 24, 2016. http://nypost.com/2016/
 02/24/tourists-are-finishing-what-the-volcano-started-in-pompeii/.

"The Art Museum Image Consortium." *AMICO*, 2005. http://www
 .amico.org/home.html.

The British Museum. "Cypriot Limestone Head." *Sketchfab*, May 2, 2016.
 https://sketchfab.com/models/db8505565d034cda9c226f31076e2185/
 embed?ui_watermark=0&ui_stop=0&tracking=0&ui_snapshots=0&int
 ernal=1&autostart=1&ui_infos=0.

The Forensic Outreach Team. "From Egypt to Babylon and Beyond:
 Uncovering Ancient Fingerprints." *The Forensic Outreach Library*.
 2013. http://forensicoutreach.com/library/from-egypt-to-babylon-
 and-beyond-uncovering-ancient-fingerprints/.

Thornes, Robin, Peter Dorrell, and Henry Lie. *Introduction to Object
 ID: Guidelines for Making Records That Describe Art, Antiques, and
 Antiquities.* Los Angeles: Getty Information Institute, 1999.

Wilder, Charly. "Swiping a Priceless Antiquity . . . With a Scanner and a 3-D
 Printer." *The New York Times*. March 1, 2016. http://www.nytimes.com/
 2016/03/02/arts/design/other-nefertiti-3d-printer.html?nytmobile=0.

Chapter 14

Adamczyk, Ed. "Hollande Proposes That Syrian Antiquities Be Brought to France for Safekeeping." *UPI*, November 17, 2015. http://www.upi.com/Top_News/World-News/2015/11/17/Hollande-proposes-that-Syrian-antiquities-be-brought-to-France-for-safekeeping/6501447778123/.

Al-Youm, Al-Masry. "Arab League Draft Resolution to Protect Arab Antiquities: Araby." *Egypt Independent*, April 5, 2016. http://www.egyptindependent.com/news/arab-league-draft-resolution-protect-arab-antiquities-araby.

Amineddoleh, Leila. "How Western Art Collectors Are Helping to Fund Isis." *The Guardian*, February 26, 2016. http://www.theguardian.com/artanddesign/2016/feb/26/western-art-funding-terrorism-isis-middle-east?CMP=twt_gu#img-1.

Anderson, Maxwell L. "How to Save Art From Islamic State." *Wall Street Journal*, October 20, 2015. http://www.wsj.com/articles/how-to-save-art-from-islamic-state-1445376423?alg=y.

AP Archive. "Stolen Antiquities Returned from Britain." July 21, 2015. https://www.youtube.com/watch?v=ePfOBB7rW5U.

Appiah, Kwame Anthony. "There Is No National Home for Art." *The New York Times*. January 22, 2015. http://www.nytimes.com/roomfordebate/2015/01/21/when-should-antiquities-be-repatriated-to-their-country-of-origin/there-is-no-national-home-for-art.

Arsu, Sebnem, and Campbell Robertson. "Treasure, Repatriated by Met, Stolen From Turkish Museum." *The New York Times*, May 30, 2006. http://query.nytimes.com/gst/fullpage.html.

Association of American Art Museum Directors. "Statement of the Association of Art Museum Directors re: H.R. 1493," April 22, 2015. https://aamd.org/sites/default/files/key-issue/FINAL%20STATEMENT7471527_4.pdf.

Blumenthal, Ralph, and Tom Mashberg. "The Curse of the Outcast Artifact." *The New York Times*, July 12, 2012. http://www.nytimes.com/2012/07/15/arts/design/antiquity-market-grapples-with-stricter-guidelines-for-gifts.html.

British Museum Act 1963 (Amendment) Bill [H.L.] (Hansard 27 October 1983). Accessed April 22, 2016. http://hansard.millbanksystems.com/lords/1983/oct/27/british-museum-act-1963-amendmentbill-hl.

"British Museum 'Guarding' Object Looted from Syria."
 BBC News, June 5, 2015. http://www.bbc.com/news/
 entertainment-arts-33020199.

Capon, Alex. "Restituted Works Headline Impressionist and Modern
 Art Auction Series." *Antiques Trade Gazette*, June 29, 2015. http://
 www.antiquestradegazette.com/news/2015/jun/29/restituted-
 works-headline-impressionist-and-modern-art-auction-series/.

Cascone, Sarah. "Benin Bronzes Looted By the
 British Returned to Nigeria." *Artnet News*, June
 23, 2014. https://news.artnet.com/art-world/
 benin-bronzes-looted-by-the-british-returned-to-nigeria-46550.

Choulia-Kapeloni, Suzanna. "Long-Term Loans: A Proposal within the
 Framework of Collections Management." In *Encouraging Collections
 Mobility—A Way Forward for Museums in Europe*, edited by Susanna
 Pettersson, Monika Hagedorn-Saupe, Teijmari Jyrkkiö, and Astrid
 Weij, 197–202. Finnish National Gallery, 2010.

Collado, Kelvin D. "A Step Back for Turkey, Two Steps Forward in the
 Repatriation Efforts of Its Cultural Property." *Case Western Reserve
 Journal of Law, Technology, and the Internet* 5, no. 1 (2014): 1–24.

Collin, Robin Morris. "The Law and Stolen Art, Artifacts, and
 Antiquities." *Howard Law Journal* 36, no. 1 (1993): 17.

Cultural Policy Research Institute. "Project on Unprovenanced
 Ancient Objects in Private US Hands." *Cultural Policy
 Research Institute*, November 10, 2009. https://sites
 .google.com/a/cprinst.org/www/Home/issues/
 project-on-unprovenanced-ancient-objects-in-private-us-hands.

Cuno, James. "Artifacts as Instruments of Nationalism." *The
 New York Times*. January 21, 2015. Accessed April 28, 2016.
 http://www.nytimes.com/roomfordebate/2015/01/21/when-
 should-antiquities-be-repatriated-to-their-country-of-origin/
 artifacts-as-instruments-of-nationalism.

Cuno, James. "Who Owns the Past?" *Yale Global Online*, April 21, 2008.
 http://yaleglobal.yale.edu/content/who-owns-past.

De Montebello, Philippe "And What Do You Propose Should Be Done
 with Those Objects?" In *Whose Culture? The Promise of Museums and
 the Debate over Antiquities*, edited by James Cuno, 55–70. Princeton,
 NJ: Princeton University Press, 2012.

Duray, Dan. "Cambodian Warrior Comes Home: Denver Art
 Museum Returns Khmer Statue." *The Art Newspaper*. February
 26, 2016. http://theartnewspaper.com/news/museums/

cambodian-warrior-comes-home-denver-art-museum-to-return-
khmer-statue/.

Eakin, Hugh. "The Great Giveback." *The New York Times*, January 26,
2013. http://www.nytimes.com/2013/01/27/sunday-review/the-
great-giveback.html.

Eakin, Hugh. "Who Should Own the World's Antiquities?" *The
New York Review of Books*. May 14, 2009. Accessed April 28, 2016.
http://www.nybooks.com/articles/2009/05/14/who-should-own-
the-worlds-antiquities/.

Forrest, Craig. *International Law and the Protection of Cultural Heritage*.
London: Routledge, 2012.

"Forum: Could the Antiquities Trade Do More to Combat Looting?"
Apollo Magazine. September 28, 2015. Accessed October 27, 2015.
http://www.apollo-magazine.com/forum-could-the-antiquities-
trade-do-more-to-combat-looting/.

Hammerstein, Konstantin von. "Dubious Provenance: Pressure
Grows for Museums to Return Stolen Objects." *Spiegel Online*,
December 10, 2014. http://www.spiegel.de/international/
world/pressure-grows-for-museums-to-return-stolen-objects-a-
1007523.html.

H.R. 1493 - Protect and Preserve International Cultural Property Act,
2016. https://www.congress.gov/bill/114th-congress/house-bill/
1493.

"Indianapolis Museum of Art Declares Moratorium on Antiquities
Acquisitions." *Archaeological Institute of America*, April 16, 2007.
https://www.archaeological.org/news/advocacy/96.

Jenkins, Tiffany. *Keeping Their Marbles: How the Treasures of the
Past Ended Up in Museums—And Why They Should Stay There*.
New York: Oxford University Press, 2016.

Kahn, Jeremy. "Is the U.S. Protecting Foreign Artifacts? Don't Ask." *The
New York Times*, April 8, 2007. http://www.nytimes.com/2007/04/
08/arts/design/08kahn.html.

Kontes, Zoë. "Repatriation Reinforces International Collaboration."
The New York Times, January 22, 2015. http://www
.nytimes.com/roomfordebate/2015/01/21/when-should-
antiquities-be-repatriated-to-their-country-of-origin/
repatriation-reinforces-international-collaboration.

"Kouros." *The J. Paul Getty Museum*. Accessed April 28, 2016. http://
www.getty.edu/art/collection/objects/10930/unknown-maker-
kouros-greek-about-530-bc-or-modern-forgery/.

Kurtz, Michael J. *America and the Return of Nazi Contraband: The Recovery of Europe's Cultural Treasures*. Cambridge, MA: Cambridge University Press, 2006.

Mashberg, Tom. "Cambodia Presses U.S. Museums to Return Antiquities." *The New York Times*, May 15, 2013. http://www .nytimes.com/2013/05/16/arts/design/cambodia-presses-us-museums-to-return-antiquities.html.

Mashberg, Tom. "Museums Begin Returning Artifacts to India in Response to Investigation." *The New York Times*, April 7, 2015. http://www.nytimes.com/2015/04/08/arts/design/museums-begin-returning-artifacts-to-india-in-response-to-investigation.html.

Mashberg, Tom. "Returning the Spoils of World War II, Taken by Americans." *The New York Times*, May 5, 2015. http://www .nytimes.com/2015/05/06/arts/design/returning-the-spoils-of-world-war-ii-taken-by-our-side.html.

Mashberg, Tom, and Ralph Blumenthal. "The Met Plans to Return Statues to Cambodia." *The New York Times*, May 3, 2013. http:// www.nytimes.com/2013/05/04/arts/design/the-met-to-return-statues-to-cambodia.html.

Merryman, John Henry. *Imperialism, Art and Restitution*. Cambridge, MA: Cambridge University Press, 2006.

Merryman, John Henry. "The Retention of Cultural Property." *U.C. Davis Law Review* 21, no. 3 (1987–1988): 477.

Merryman, John Henry. "Two Ways of Thinking about Cultural Property." *American Journal of International Law* 80, no. 4 (1986): 831–853.

Miles, Margaret M. "Greek and Roman Art and the Debate about Cultural Property." In *The Oxford Handbook of Greek and Roman Art and Architecture*, edited by Clemente Marconi and Deborah Steiner, 500–516. New York: Oxford University Press, 2015.

Myers, Steven Lee. "Looted Treasures Return to Iraq." *The New York Times*. September 7, 2010. http://www.nytimes.com/2010/09/08/world/middleeast/08iraq.html.

Naylor, R. T. *Patriots and Profiteers: Economic Warfare, Embargo Busting, and State-Sponsored Crime*. Montreal: McGill-Queen's Press, 2008.

"Object Registry." *Association of Art Museum Directors*. Accessed February 27, 2016. https://aamd.org/object-registry.

"The Parthenon Sculptures." *British Museum*. Accessed April 22, 2016. http://www.britishmuseum.org/about_us/news_and_press/statements/parthenon_sculptures.aspx.

"Patria." *Oxford Dictionaries.* U.S. English. Accessed February 26, 2016. http://www.oxforddictionaries.com/us/definition/american_english/patria.

Pearlstein, William. "Rethinking Antiquities: Collecting in the Time of ISIS." Panel presented at Cardozo Law School, March 1, 2016. http://www.cardozo.yu.edu/events/rethinking-antiquities-collecting-age-isis.

Penn Museum. "The University Museum Acquisitions Policy." *Expedition Magazine* 22, no. 3, March 1980.

"Policy Statement: Acquisitions by the J. Paul Getty Museum," October 23, 2006. http://www.getty.edu/about/governance/pdfs/acquisitions_policy.pdf.

" 'Revolutionary' Court Victory against Antiquity Thieves." *Arutz Sheva.* December 29, 2015. Accessed January 1, 2016. http://www.israelnationalnews.com/News/News.aspx/205649.

SAFECORNER. "UK Adopts Resolution Prohibiting the Import of Antiquities from Syria." *SAFE: Saving Antiquities for Everyone.* August 27, 2014. http://savingantiquities.org/uk-adopts-resolution-prohibiting-import-antiquities-syria/.

Shapiro, Daniel. "Repatriation: A Modest Proposal." *New York University Journal of International Law and Politics* 31 (1998–1999): 95.

Sidibé, Samuel. "When Repatriation Is Clear-Cut." *The New York Times.* January 21, 2015. http://www.nytimes.com/roomfordebate/2015/01/21/when-should-antiquities-be-repatriated-to-their-country-of-origin/when-repatriation-is-clear-cut.

Smee, Sebastian. "MFA Expands Loans of Well-Known Works." *The Boston Globe,* August 3, 2014. https://www.bostonglobe.com/arts/2014/08/02/museum-fine-arts-controversial-lending-program-keeps-works-off-walls/9dsHEU1Faxh8AbKbGRN6LL/story.html.

Smith, Helena. "Greece Looks to International Justice to Regain Parthenon Marbles from UK." *The Guardian.* May 8, 2016. http://www.theguardian.com/artanddesign/2016/may/08/greece-international-justice-regain-parthenon-marbles-uk.

Stamatoudi, Irini A. *Cultural Property Law and Restitution: A Commentary to International Conventions and European Union Law.* Cheltenham, UK: Edward Elgar, 2011.

Tharoor, Kanishk. "Museums and Looted Art: The Ethical Dilemma of Preserving World Cultures." *The Guardian,* June 29, 2015. http://www.theguardian.com/culture/2015/jun/29/museums-looting-art-artefacts-world-culture.

Tompa, Peter, and Kate Fitz Gibbon. "Protect and Preserve International Cultural Property Act, H.R. 1493/S.1887: Saving Syrian Antiquities or Crushing the Legitimate Art Trade?" *Committee for Cultural Policy.* November 30, 2015. http://committeeforculturalpolicy.org/protect-and-preserve-international-cultural-property-act-h-r-1493s-1887-saving-syrian-antiquities-or-crushing-the-legitimate-art-trade/.

United Nations Educational, Scientific and Cultural Organization. "Intergovernmental Committee (ICPRCP)." *Restitution of Cultural Property.* Accessed February 26, 2016. http://www.unesco.org/new/en/culture/themes/restitution-of-cultural-property/.

Urice, Stephen K. "Between Rocks and Hard Places: Unprovenanced Antiquities and the National Stolen Property Act." *New Mexico Law Review* 40, no. 1 (2010): 123–161.

Vikan, Gary. "The Case For Buying Antiquities To Save Them." *Wall Street Journal.* August 19, 2015. http://www.wsj.com/articles/the-case-for-buying-antiquities-to-save-them-1440024491.

Vikan, Gary. "A Former Director's Perspective on Provenance Research and Unprovenanced Cultural Property." *Collections: A Journal for Museums and Archives Professionals Provenance Research in American Museums,* n.d. Benjamin Cardozo School of Law. https://cardozo.yu.edu/sites/default/files/VIKAN_article.pdf.

Weale, Sally. "Benin Bronze Row: Cambridge College Removes Cockerel." *The Guardian.* March 8, 2016. http://www.theguardian.com/education/2016/mar/08/benin-bronze-row-cambridge-college-removes-cockerel.

Welsh, Peter H. "Repatriation and Cultural Preservation: Potent Objects, Potent Pasts." *University of Michigan Journal of Law Reform* 25, no. 3–4 (1992): 837–865.

Wolkoff, Joshua S. "Transcending Cultural Nationalist and Internationalist Tendencies: The Case for Mutually Beneficial Repatriation Agreements." *Cardozo Journal of Conflict Resolution* 11.2 (2010): 709–738.

Chapter 15

Ahuja, Naman P. "Why Is Liberalised India Smuggling Its Heritage Abroad?" *The Hindu,* July 29, 2012. http://www.thehindu.com/arts/why-is-liberalised-india-smuggling-its-heritage-abroad/article3666911.ece.

Antiquities Law, Law No. 5738-1978 (1978). Israel Antiquities Authority. http://www.antiquities.org.il/article_eng.aspx?sec_id=29&subj_id=234.

Autocephalous Greek Orthodox Church of Cyprus v. Goldberg & Feldman Arts, 917 F. 2d 278 (Court of Appeals, 7th Circuit 1990).

Bator, Paul. "An Essay on the International Trade in Art." *Stanford Law Review* 34, no. 2 (1982): 275–384.

Borodkin, Lisa J. "The Economics of Antiquities Looting and a Proposed Legal Alternative." *Columbia Law Review* 95, no. 2 (1995): 377–417. doi:10.2307/1123233.

Brodie, Neil. "Provenance and Price: Autoregulation of the Antiquities Market?" *European Journal on Criminal Policy and Research* 20, no. 4 (March 22, 2014): 427–444.

Brodie, Neil. "Uncovering the Antiquities Market." In *The Oxford Handbook of Public Archaeology*, edited by Robin Skeates, Carol McDavid, and John Carman, 230–252. Oxford: Oxford University Press, 2012.

Brodie, Neil, Dan Contreras, John Merryman, Paul Harrison, Tom Seligman, and Lynn Meskell. "Buying, Selling, Owning the Past." *Stanford University: Multisdisciplinary Teaching and Research.* January 28, 2009. http://news.stanford.edu/news/multi/features/heritage/.

Caulderwood, Kathleen. "India Looks To Create 'Open Market' For Antiquities; Critics Say It Will Encourage Looting." *International Business Times.* May 26, 2015. http://www.ibtimes.com/india-looks-create-open-market-antiquities-critics-say-it-will-encourage-looting-1938698.

Chapman, Catherine. "To Fight ISIS, Art Dealers & Archaeologists Join Forces." *The Creators Project*, March 11, 2016. http://thecreatorsproject.vice.com/blog/art-dealers-archaeologists-join-fight-against-isis.

Collin, Robin Morris. "The Law and Stolen Art, Artifacts, and Antiquities." *Howard Law Journal* 36 (1993): 17–42.

"Could the Antiquities Trade Do More to Combat Looting?" *Apollo Magazine.* September 28, 2015. Accessed October 27, 2015. http://www.apollo-magazine.com/forum-could-the-antiquities-trade-do-more-to-combat-looting/.

Datta, Saurav. "How an 'Antique' Law Has Become a Boon for Artefact Smugglers." *CatchNews.com*, April 21, 2016. www.catchnews.com/india-news/how-an-antique-law-has-become-a-boon-for-artefact-smugglers-1461250312.html.

Dietzler, Jessica. "On 'Organized Crime' in the Illicit Antiquities Trade: Moving beyond the Definitional Debate." *Trends in Organized Crime* 16, no. 3 (2013): 329–342.

Gerstenblith, Patty. "Controlling the International Market in Antiquities: Reducing the Harm, Preserving the Past." *Chicago Journal of International Law* 8, no. 1 (2008): 169–195.

Hawkins, Ashton, Richard A. Rothman, and David B. Goldstein. "A Tale of Two Innocents: Creating an Equitable Balance between the Rights of Former Owners and Good Faith Purchasers of Stolen Art." *Fordham Law Review* 64 (1995): 49.

Kimmelman, Michael. "Regarding Antiquities, Some Changes, Please." *The New York Times.* December 8, 2005. http://www.nytimes.com/2005/12/08/arts/regarding-antiquities-some-changes-please.html.

Merryman, John Henry. "The Free International Movement of Cultural Property." *New York University Journal of International Law and Politics* 31, no. 1 (1999): 1–14.

Merryman, John Henry. "Two Ways of Thinking about Cultural Property." *American Journal of International Law* 80 (1986): 831.

Miller, Michele A. "Introduction: Looting and the Antiquities Market." *Athena Review* 4, no. 3 (2007). http://www.athenapub.com/15-intro-looting.htm.

"Modi Government Plans to Legalise Antiquities Trade to Stop Smuggling." *The Economic Times*, May 25, 2015. http://economictimes.indiatimes.com//articleshow/47415828.cms.

Moore, Jonathan S. "Enforcing Foreign Ownership Claims in The Antiquities Market." *The Yale Law Journal* 97, no. 3 (1988): 466–487.

Pearlstein, William G. "Claims for the Repatriation of Cultural Property: Prospects for a Managed Antiquities Market." *Law and Policy in International Business* 28, no. 1 (1996): 123–150.

Szczepanowska, Hanna M. *Conservation of Cultural Heritage: Key Principles and Approaches.* London: Routledge, 2013.

Tribble, Jennfier. "Antiquities Trafficking and Terrorism: Where Cultural Wealth, Political Violence, and Criminal Networks Intersect." MonTREP, 2014.

Tully, Kathryn. "How to Buy Antiquities." *Financial Times*, September 4, 2015.

Williams, Phil. "Crime, Illicit Markets, and Money Laundering." In *Managing Global Issues: Lessons Learned*, edited by Chantal de Jonge Oudraat and P.J. Simmons, 106–150. Washington D.C.: Carnegie Endowment for International Peace, 2001.

Chapter 16

"AAMD Policy on Decaccessioning." Association of Art Museum Directors. June 9, 2010. https://aamd.org/sites/default/files/

document/AAMD%20Policy%20on%20Deaccessioning%20 website.pdf.

"Act on the Return of Cultural Property of 1993 (Germany)," last amended 2007. International Foundation for Art Research.

Anderson, Maxwell L. "Gather, Steward, and Converse." *The Art Newspaper*. June 8, 2010.

Anderson, Maxwell L. "Ownership Isn't Everything: The Future Will Be Shared." *The Art Newspaper*. September 15, 2010.

Beltrametti, Silvia. "Museum Strategies: Leasing Antiquities." *Columbia Journal of Law and the Arts* 36, no. 2 (2013): 203–260.

Blair, Elizabeth. "As Museums Try To Make Ends Meet, 'Deaccession' Is The Art World's Dirty Word." *National Public Radio*. August 11, 2014. http://www.npr.org/2014/08/11/339532879/as-museums-try-to-make-ends-meet-deaccession-is-the-art-worlds-dirty-word.

Blumenthal, Ralph, and Tom Mashberg. "The Curse of the Outcast Artifact." *The New York Times*. July 12, 2012. http://www.nytimes .com/2012/07/15/arts/design/antiquity-market-grapples-with-stricter-guidelines-for-gifts.html.

British Museum Act 1963, c.24 (Eng.).

"Carlos Museum Mounts Major Exhibition of Ancient Egyptian Art." *Emory University*. January 30, 1995. http://www.emory .edu/EMORY_REPORT/erarchive/1995/January/ERjan.30/ 1.30.95mccm.mounts.exi.html.

Finkel, Jori. "When, If Ever, Can Museums Sell Their Works?" *The New York Times*. January 1, 2009. http://www.nytimes.com/2009/ 01/03/arts/03iht-finkel.1.19031384.html.

"German Law: Disaster for Collectors of Antiques and Ancient Art." *Committee for Cultural Policy*. July 25, 2015. http:// committeeforculturalpolicy.org/german-law-disaster-for-collectors-of-antiques-and-ancient-art/.

Gill, David. "Archaeological Loans: Looking Back to EUMILOP." *Looting Matters*. June 30, 2008. http://lootingmatters.blogspot .com/2008/06/archaeological-loans-looking-back-to.html? view=magazine.

Groskopf, Christopher. "Museums Are Keeping a Ton of the World's Most Famous Art Locked Away in Storage." *Quartz*. January 20, 2016. http://qz.com/583354/why-is-so-much-of-the-worlds-great-art-in-storage/.

"Is Sharing Artefacts the Future for Museums?" *Elginism*. November 4, 2010. http://www.elginism.com/british-museum/is-sharing-artefacts-the-future-for-museums/20101104/3194/.

Kampmann, Ursula. "Ministerial Draft Updating the Legislation on the Protection of Cultural Heritage." Translated by Annika Backe. *Coins Weekly*. July 15, 2015. http://coinsweekly.com/index.php?pid=4&id=3535.

Kimmelman, Michael. "ART VIEW; The High Cost of Selling Art." *The New York Times*. April 1, 1990. http://www.nytimes.com/1990/04/01/arts/art-view-the-high-cost-of-selling-art.html.

Kremer, Michael, and Tom Wilkening. "Protecting Antiquities: A Role for Long-Term Leases?" August 28, 2014. http://www.tomwilkening.com/images/Antiquities_Kremer_Wilkening_Aug_2015.pdf.

Mackenzie, Simon, and Penny Green. "Criminalising the Market in Illicit Antiquities: An Evaluation of the Dealing in Cultural Objects (Offences) Act 2003 in England and Wales." In *Criminology and Archaeology: Studies in Looted Antiquities*, edited by Simon Mackenzie and Penny Green, 145–171. Oxford: Hart, 2009.

Museums and Galleries Act 1992. c. 44, (Eng.).

"Museum Loan Network." *Brown University*. Accessed March 6, 2016. https://news.brown.edu/articles/2007/12/mln-brown.

National Museum Directors' Conference. "Too Much Stuff? Disposal from Museums." National Museum Directors' Council. October 27, 2003. http://www.nationalmuseums.org.uk/resources/press_releases/pr_too_much_stuff/.

Neuendorf, Henri. "German Cabinet Approves Controversial Cultural Heritage Protection Law." *Artnet News*. November 6, 2015. https://news.artnet.com/art-world/german-cabinet-approves-cultural-protection-law-356912.

"New Draft Act to Protect Cultural Property Published." *The Federal Government of Germany*. September 15, 2015. https://www.bundesregierung.de/Content/EN/Pressemitteilungen/BPA/2015/2015-09-15-bkm-kulturgut_en.html.

Peterson, Thane. "Hey, That's Our Art!" *Bloomberg Business*. May 15, 2006. http://www.bloomberg.com/bw/stories/2006-05-15/hey-thats-our-art.

"Selling the Past: Collectors and Protectors." *Archaeology Magazine*. April 22, 2002. http://archive.archaeology.org/online/features/schultz/collectors.html.

Solomon, Deborah. "Censured Delaware Art Museum Plans to Divest More Works." *The New York Times*, August 7, 2014. http://www.nytimes.com/2014/08/10/arts/design/censured-delaware-art-museum-plans-to-divest-more-works.html.

"Statement of Financial Accounting Standards No. 116: Accounting for Contributions Received and Contributions Made." Financial Accounting Standards Board, June 1993. http://www.fasb.org/resources/ccurl/770/425/fas116.pdf.

Studio. "Opinion: There's More To Museum Storage." Innovation Studio. January 27, 2016. http://studio.carnegiemuseums.org/more-to-museum-storage/.

Tharoor, Kanishk. "Museums and Looted Art: The Ethical Dilemma of Preserving World Cultures." *The Guardian*. June 29, 2015. http://www.theguardian.com/culture/2015/jun/29/museums-looting-art-artefacts-world-culture.

Urice, Stephen K. "Deaccessioning: A Few Observations." University of Miami School of Law. American Law Institute-American Bar Association Continuing Legal Education. March 24–26, 2010. http://web.law.columbia.edu/sites/default/files/microsites/attorneys-general/deaccessioning_a_few_observations.pdf.

Vikan, Gary. "The Case For Buying Antiquities To Save Them." *Wall Street Journal*. August 19, 2015, sec. Opinion. http://www.wsj.com/articles/the-case-for-buying-antiquities-to-save-them-1440024491.

Chapter 17

"Archaeogaming." *Archaeogaming*. Accessed April 4, 2016. http://archaeogaming.com/.

Bailey, Martin. "Egyptian Ambassador Proposes Plan to Share Sekhemka." *The Art Newspaper*. March 8, 2016. http://theartnewspaper.com/news/museums/ambassador-proposes-plan-to-share-sekhemka/.

Blumenthal, Ralph, and Tom Mashberg. "TED Prize Goes to Archaeologist Who Combats Looting With Satellite Technology." *The New York Times*. November 8, 2015. http://www.nytimes.com/2015/11/09/arts/international/ted-grant-goes-to-archaeologist-who-combats-looting-with-satellite-technology.html.

Cascone, Sarah. "Benin Bronzes Looted By the British Returned to Nigeria." *Artnet News*. June 23, 2014. https://news.artnet.com/art-world/benin-bronzes-looted-by-the-british-returned-to-nigeria-46550.

Chrysopoulos, Philip. "Police Forensic Science Uncovers Ancient DNA From Greek Shipwrecks." *Greek Reporter*. March 27, 2016. http://greece.greekreporter.com/2016/03/27/police-forensic-science-uncovers-ancient-dna-from-greek-shipwrecks/.

Cole, Linda. "How Archaeologists Use the Power of a Dog's Nose." *Canidae Blog*. August 27, 2013. http://www.canidae.com/blog/ 2013/08/how-archaeologists-use-power-of-dogs.html.

Corte App., Roma, Sez. II Pen., 15 luglio 2009, n.5359; Cass. Pen., Sez. II, Sent., (ud. 07-12-2011) 22-12-2011, n. 47918 (It.).

"DataDot Technology Overview." *DataDot*. Accessed February 9, 2016. http://www.datadotusa.com/technology.htm.

Edwardes, Charlotte, and Catherine Milner. "Egypt Demands Return of the Rosetta Stone." *The Telegraph*. July 19, 2003. http://www. telegraph.co.uk/news/worldnews/africaandindianocean/egypt/ 1436606/Egypt-demands-return-of-the-Rosetta-Stone.html.

Fairfax, N. W. H. "The Story of Police Dogs." *Police Journal 37* (1964): 113–117.

Fiegl, Amanda. "Meet Migaloo, World's First 'Archaeology Dog.' " *National Geographic News*. December 11, 2012. http://news .nationalgeographic.com/news/2012/12/121210-archaeology- dogs-australia-conservation-canines/.

Holo, Selma, and Mari-Tere Alvarez, eds. *Remix: Changing Conversations in Museums of the Americas*. 1st ed. Berkeley: University of California Press, 2016.

Johnston, Ian. "Ancient Egyptian Statue of Sekhemka Disappears into Private Collection in 'Moral Crime against World Heritage.' " *The Independent*. May 9, 2016. http://www.independent.co.uk/news/ uk/home-news/ancient-egyptian-statue-of-sekhemka-disappears- into-private-collection-in-moral-crime-against-world-a7019946. html.

Kristiansen, Kristian. "The Discipline of Archaeology." In *The Oxford Handbook of Archaeology*, edited by Barry Cunliffe, Chris Godsen, and Rosemary A. Joyce. Oxford: Oxford University Press, 2009.

Kuo, Lily. "Cambridge Is Considering Returning a Stolen 100-Year- Old Bronze Cockerel to Nigeria." *Quartz*. March 9, 2016. http:// qz.com/634916/cambridge-is-considering-returning-a-stolen-100- year-old-bronze-cockerel-to-nigeria/.

LaFrance, Adrienne. "Archaeology's Information Revolution." *The Atlantic*. March 3, 2016. http://www.theatlantic.com/technology/ archive/2016/03/digital-material-worlds/471858/.

McCoy, Janet. "Canine Performance Sciences Breeds, Trains and Produces Elite Detection Dogs." *Auburn University: The Newsroom*, July 27, 2015. http://ocm.auburn.edu/newsroom/news_articles/

2015/07/canine-performance-sciences-breeds,-trains-and-produces-elite-detection-dogs.htm.

Neuendorf, Henri. "German Cabinet Approves Controversial Cultural Heritage Protection Law." *Artnet News*, November 6, 2015. https://news.artnet.com/art-world/german-cabinet-approves-cultural-protection-law-356912.

Ng, David. "Getty's 'Victorious Youth' Bronze Gets Another Legal Detour." *L.A. Times*, December 31, 2015. http://www.latimes.com/entertainment/arts/culture/la-et-cm-getty-bronze-victorious-youth-sculpture-20151231-story.html.

Oppian. *Cynegetica, Book 1*. Loeb Classical Library. 1928. http://penelope.uchicago.edu/Thayer/E/Roman/Texts/Oppian/Cynegetica/1*.html.

Oskin, Becky. "Deep-Sea Robot Explores Shipwrecks Thursday: Watch Live Online." *LiveScience.com*. April 23, 2014. http://www.livescience.com/45082-deep-sea-shipwrecks-okeanos-webcast.html.

Palet, Laura Secorun. "The World's Greatest Lost Treasures, Still Waiting To Be Found." *The Huffington Post*. January 29, 2015. http://www.huffingtonpost.com/2015/01/29/world-lost-treasures_n_6572784.html.

People of the State of New York v. Aaron Freedman, No. 13-091098, (N.Y. Sup. Ct., plea agreement, Dec. 4, 2013). https://www.ifar.org/case_summary.php?docid=1387476941.

"Peru-Yale Partnership for the Future of Machu Picchu Artifacts." *Yale News*. June 4, 2015. http://news.yale.edu/2015/06/04/peru-yale-partnership-future-machu-picchu-artifacts.

Republic of Peru v. Yale University, No. 1:08-Cv-02109 (D. D.C. July 30, 2009) (transferring Case to Connecticut); Republic of Peru v. Yale University, No. 3:09-Cv-01332 (D. Conn. Oct. 9, 2009); settlement agreement, No. 3:09-Cv-01332 (D. Conn. Dec. 23, 2010).

Republic of Turkey v. Metropolitan Museum of Art, 762 F. Supp. 44 (S.D.N.Y. 1990).

"Sarah Parcak, Archaeologist," Explorers/Bio. *National Geographic*. Accessed March 6, 2016. http://www.nationalgeographic.com/explorers/bios/sarah-parcak/.

Sax, David. *Unmasking the Forger: The Dossena Deception*. London: Unwin Hyman, 1987.

Schwartz, Ariel. "You Can Now Explore Ancient Archaeological Sites from Your Computer." *Tech Insider*. February 16, 2016. http://www.techinsider.io/how-to-find-ancient-archaeological-sites-from-your-computer-2016-2.

Shelton, Jim. "Grand Challenges for Cultural Heritage Databases, from Preservation to Best Practices." *Yale News*. April 14, 2016. http://news.yale.edu/2016/04/14/grand-challenges-cultural-heritage-databases-preservation-best-practices.

"Statement by the Metropolitan Museum of Art on Its Agreement with Italian Ministry of Culture." Metropolitan Museum of Art. February 21, 2006. http://www.metmuseum.org/press/news/2006/statement-by-the-metropolitan-museum-of-art-on-its-agreement-with-italian-ministry-of-culture.

Turner, Jari. "Estonian Turtle-Robot Searches for Shipwrecks and Treasure." Phys.org. December 9, 2015. http://phys.org/news/2015-12-estonian-turtle-robot-shipwrecks-treasure.html.

UNESCO. Intergovernmental Oceanographic Commission. "Underwater Cultural Heritage: Convention on the Protection of the Underwater Cultural Heritage Will Enter into Force in January 2009." October 14, 2008. http://www.ioc-unesco.org/index.php?option=com_content&view=article&id=83:underwater-cultural-heritage&catid=14&Itemid=100063.

United States v. A 10th Century Cambodian Sandstone Sculpture, No. 12-2600, (S.D.N.Y. April 9, 2013).

INDEX